GRAPHIC LIBERATION

GRAPHIC LIBERATION

IMAGE MAKING & POLITICAL MOVEMENTS

JOSH MACPHEE

COMMON NOTIONS

ISBN: 978-1-942173-87-8 | eBook ISBN: 978-1-945335-03-7
Library of Congress Number: 2023950447
10 9 8 7 6 5 4 3 2 1

Common Notions
c/o Interference Archive
314 7th St.
Brooklyn, NY 11215

Common Notions
c/o Making Worlds Bookstore
210 S. 45th St.
Philadelphia, PA 19104

www.commonnotions.org
info@commonnotions.org

Discounted bulk quantities of our books are available for organizing, educational, or fundrais-
ing purposes. Please contact Common Notions at the address above for more information.

Support for this publication came from the Christian A. Johnson Endeavor Foundation Art-
ist-in-Residence program at Colgate University. Special thanks to Purnima Palawat for their
editorial assistance.

Cover design, layout design, and typesetting by Josh MacPhee
Titles set in Committee, a font designed by Alec Dunn for the Justseeds Open Type Project.

Printed by union labor in Canada on acid-free paper

CONTENTS

Introduction 9

Avram Finkelstein 23
Tomie Arai 41
Emory Douglas 57
Daniel Drennan ElAwar/Jamaa Al-Yad 79
Sandy Kaltenborn 99
Alison Alder 123
Dignidad Rebelde/Melanie Cervantes and Jesus Barraza 145
Tings Chak 163
Judy Seidman 185
A3BC (Anti-war, Anti-nuclear and Arts of Block-Print Collective) 203

Index 223

About the Editor 228

About Common Notions 229

INTRODUCTION

Josh MacPhee

For a master's tools will never dismantle the master's house. They may allow us temporarily to beat him at his own game, but they will never enable us to bring about genuine change. —Audre Lorde[1]

In an enemy society, we cannot freely choose the means we use to fight it. And the weapons of proletarian revolt have always been taken from the bosses' arsenals. —Mario Tronti[2]

FOR MUCH OF MY LIFE AS a cultural producer I've been trying to find a place to belong. Neither formally trained in art or design, what I do and what I make have never felt truly at home in either domain. My art isn't art-y enough and my design isn't design-y enough; didactic political graphics, posters for movement actions, and calls for solidarity always feels a little awkward in either sphere. This likely would have mattered little if I had come up in a moment of social movement upheaval, or even one where political organizations valued culture. But I didn't. So, I've carried a chip on my shoulder for thirty years, trying to distance myself from the seeming frivolity, self-referentiality, and entrepreneurship of fine art as well as the commercial focus and aesthetic conventions of graphic design, all the while still needing to make money to live. The 1990s and early 2000s were a raucous time, trying to prove that what I was doing could be a valuable aspect of political struggle, usually feeling like my pleas (and work) were falling on the closed minds of union officials, community organizers, and leftist activists alike.

 Much has changed over the past twenty-five years. Everyone from the executive directors of social justice nonprofits to funding agencies to street-level activists are talking about art as central to social transformation. This concept moved quickly from underground mantra to mainstream gospel—I passed a woman on the street yesterday wearing a t-shirt that proudly proclaimed "I believe in the power of art." Yet few seem to have stopped to ask: if art is necessary for social change, how exactly does that change happen? And what role does art play in it? It is often claimed that art operates in the

realm of the affective, yet social change is best marked by a transformation of concrete material conditions. What actual role does culture play in this? If it has power, what is it?

In trying to navigate these questions, and research the historical roles culture has contributed to people organizing to transform their lives, I loosely developed a concept with Dara Greenwald which we called "social movement culture."[3] To return to the seeming contradictions of the epigraphs above, rather than trying to be art or design, why not both? Or neither? Maybe a binary is not effective at describing the actual conditions of the production of culture for political movements. Maybe this kind of movement culture is a distinct tradition from both art and design.

This is a relatively simple insight, but it has large implications for those of us who labor under the belief that our cultural work is part of a larger political process. All too often the work of an individual artist, expressing themselves around a subject, and the work of communities articulating their demands around that same subject, are conflated and flattened. They are treated as if they are the same, as if these two distinct forms of expression are doing the same work. The Whitney Museum of American Art's 2018 exhibition, *An Incomplete History of Protest: Selections from the Whitney's Collection, 1940–2017* is a great example of this.[4] A Gordon Parks photograph of Muhammad Ali rubs shoulders with paintings and prints by well-known contemporary artists, which sit next to a wall of political posters created for mass public distribution, which in turn share space with abstract sculptural installations never seen outside of a gallery or museum. Are all these things actually "protest?" Are they protesting comparable things in comparable ways? If "protest" is something worthy of organizing an exhibition around, one would think there would be some comparable desire to see that protest accomplish something. Yet time and time again, institutions (and individual artists and designers) willfully conflate their self-expression, or the possibility that someone will be inspired by their self-expression, with the organized voice of communities and groups of people in active political struggle.[5] People with strategies and goals, with theories of change and how to accomplish that change.

1. Audre Lorde, "The Master's Tools Will Never Dismantle the Master's House," in Sister Outsider, ed. Nancy K. Bereano (Berkeley: The Crossing Press, 1984), 110–113.

2. Mario Tronti, "A Course of Action" (1966), in Workers and Capital, trans. David Broder (London and New York: Verso, 2019).

3. See Dara Greenwald and Josh MacPhee (eds.), Signs of Change: Social Movement Cultures, 1960s to Now (Oakland: AK Press, 2010).

4. An Incomplete History of Protest: Selections from the Whitney's Collection, 1940–2017, curated by David Breslin with Jennie Goldstein, Rujeko Hockley, David Kiehl, and Margaret Kross, held at the Whitney Museum of American Art, August 18, 2017 through August 27, 2018. See https://whitney.org/exhibitions/an-incomplete-history-of-protest. I'm also not specifically picking on The Whitney, I could have chosen a dozen other examples of "political" exhibitions at major art institutions over the past decade.

5. And sadly, when their individual efforts not surprisingly fail, they use that as an argument for why protest or political action is ineffectual.

I call this the "Guernica disease." During the question-and-answer session of public talks and panel discussions I've been on, I've often been asked some version of, "what is the most effective piece of political art you have made?" with the question either being introduced by or concluded through a comparison to Pablo Picasso's Guernica. I've even been directly asked, "Guernica ended a war, what has your art done?" First of all, Guernica did no such thing, it documented a bombing after the fact. That's like saying the police stopped a murder when they showed up after someone had been shot. While the painting is undoubtedly a powerful expression of the terror of war, its primary role is one of affect; for many people it impactfully helps them feel anguish about the lives lost to military bombing. It is decidedly effective at that, but is it effective at mobilizing a social movement? In fact, the painting received decidedly mixed reviews when unveiled at the 1937 Paris International Exhibition, and it wasn't until extensive touring, much of it after the end of World War II, that it solidified its reputation as the antiwar painting. It was the mobilizing of hundreds of thousands of young people to fight fascism, largely through posters, pamphlets, murals, and other agitprop, never mind conscription—and certainly not paintings—that built the force necessary to stop the Nazis.

To clarify, I'm not trying to dog Picasso. I just think comparing Guernica to the posters of **Medu Arts Ensemble** or the graphic newspapers of **Jamaa Al-Yad** is like comparing cars and trains, they both get us somewhere, but to different places and in profoundly different ways. While often collapsed under the banner of "art," they are fundamentally different forms of expression, made in fundamentally different ways, for fundamentally different purposes. Intentional or not, the conflation of these things—whether by The Whitney, a well-intentioned artist, or an audience member at a public talk—does a certain violence to our understanding of the world. It makes it harder for us to see how actual political transformation occurs. By shifting the focus of social change from organizing people to mobilizing culture, we do a grave disservice to both our past and our possible future.

WHAT IS THIS BOOK?

This book is an assembly of edited transcripts from a set of conversations I held in 2021–2022 with ten social movement cultural producers. Rather than introduce them individually here, each conversation has its own opening comments. But I will say that I am extremely privileged that each of my interlocutors agreed to participate in this project, each has and continues to contribute greatly to movement culture and offer profound insights into it here. Originally framed as the Graphic Liberation discussion series, these exchanges evolved out of a visiting artist residency I held at Colgate University which was specifically shaped by the COVID-19 pandemic.

In 2019, I was contacted by DeWitt Godfrey on behalf of the faculty in the Art and Art History Department at Colgate. I had been selected for the Christian A. Johnson Endeavor Foundation Artist-in-Residence. As someone who largely works outside of both university and art institutional settings, it was an unexpected—if nice—surprise. Initial discussions around the form of the residency started in early 2020 but were quickly curtailed by COVID. The residency was initially pushed back, and eventually extended from Spring 2021 through the end of 2022.

In early 2021, Colgate students had moved to a hybrid model of being partially in class and partially virtual, and outside visits to campus were almost entirely shut down. Since I wasn't going to be able to start any project at the school or meet with students in-person, the Art and Art History faculty and I decided on constructing a series of online conversations (held over Zoom with a live audience, and later published to YouTube) which would both lay the groundwork for the residency but also double as a stand-in for an art department visiting lecture series. The title "Graphic Liberation" was hit upon through conversations with DeWitt, art historian and professor Brynn Hatton, and art and media studies professor Lynn Schwarzer. The conversation series provided voices and content to a largely closed campus, but also helped me build a conceptual structure around an interlocking set of ideas: how cultural producers work within social movements; how authorship—and therefore intellectual property and copyright—functions in these contexts; the centrality of collaboration and collectivity with other producers, audience, and both; and how imagery and ideas evolve and jump from one political context to another. Each of these concepts was further addressed in an exhibition, also titled *Graphic Liberation*, I assembled at Colgate's Clifford Gallery in the fall of 2021. Iterations of that exhibition then traveled to both George Mason University in Northern Virginia, the Cleveland Institute of Art (CIA), and Russell Sage College in Albany, NY in 2022. Both George Mason and CIA were kind enough to each facilitate one of these conversations, so eight were hosted by Colgate, while **Sandy Kaltenborn**'s was organized with George Mason and **Tings Chak**'s with CIA.

You'll notice there aren't many images in this book. For the live (online) discussions, I didn't want my conversants leaning on prepared presentations about their work, but instead focusing on being present in the moment. At the same time, I wanted the audience to have some grounding in their work, so I hit upon a compromise: each conversation would begin with 4 to 5 images of work, which each person could briefly describe. This created a scaffold for the following discussion to build on. This book is organized in the same manner, each chapter starting with a series of images and descriptions of them and their context, which then open out into a much more free-ranging back and forth. The chapters here are drawn from the live conversations, but are not beholden to them. The transcripts have been heavily edited—and

even sometimes added to—by myself, the conversants, and the editing team at Common Notions. The goal here was not to stay true to the live conversations, but to create free-standing discussions that are easy to read and highlight the insights and experiences revealed within them.

SOCIAL MOVEMENT CULTURE REVISITED

The conversations in this book are part of my process of feeling out the boundaries of "social movement culture" as a distinct, yet so far hazily defined field. Part of my goal with these discussions is to further the thinking and understanding of these ideas by talking to people who also sit in this third space, overlapping with art and design but not fitting neatly into either.

As previously mentioned, in 2008 Dara Greenwald and I curated an exhibition titled *Signs of Change: Social Movement Cultures, 1960s to Now*. The show contained over 2,000 objects—posters, placards, stickers, buttons, photographs, pamphlets, books, music, films, etc.—all produced in the service of creating social transformation. We used the term "social movement cultures" to describe this material not simply because it sounded good, but because through the process of researching this material (in archives, books, and conversations with artists, activists, and academics), we became increasingly dissatisfied with the overused and under defined terms "political art," "art activism," and "socially engaged design." These phrases, and others like them, center the formal quality (art or design) and modify it with the social quality (politics or activism). What we found in surveying the use of culture by people in struggle (be it in the streets, the factory, the home, etc.) was largely the opposite—the social quality of the movement, the needs and demands of its agents, drive the development of formal qualities far beyond the categorical bounds of art and design.

In Western societies, art largely functions as the realm of self-expression, while design functions as an articulation of commerce and statecraft. It's in the space in-between that we find social movement culture, which functions as the expression of the community, the collective, the voice of a group in motion. While a piece of movement culture may comment on politics, its primary concern is to enact politics. Rather than artist commentary on an issue, movement culture's role is as a self-conscious part of a larger social process to transform that issue. **Tomie Arai** speaks to this in our conversation:

> I've come to realize that the question isn't about making political art, it's not about producing political posters or making murals, it's about what you decide to do as a citizen, as a person living in this world, to enact change. It's about artists becoming organizers and artists becoming agents of change.

Such art is not "art as an end in itself." It is threaded with communities, organizations, and groups mobilizing for specific changes in society, or even the end of society as we know it. As **Emory Douglas** has put it, "the People are the backbone to the Artist and not the Artist to the People."[6]

The value of social movement culture is its use; not its "objectness" or commercial valorization. It is most often mass produced and/or reproducible. In fact, it is often built out of the pieces of existing culture, both movement culture and more popular and status-quo forms of expression. This form of graphic iteration can be seen no more clearly than in the 250-year history of the use of the raised fist as a marker of political engagement and intent. Its initial graphic canonization dates back to the French Revolution, but it is clearly still potentially potent today. A point **Daniel Drennan ElAwar** raises as he explains the very naming of his collective **Jamaa Al-Yad**:

> "Jamaa" comes from a root which gives us words that mean university or congregation, it's a reference to congregating for prayer, for example; assembly, coming together, literally. And "Yad" means hand, so "Jamaa Al-Yad" means "hand coming together." So denotatively, it means clenched fist, but it resonates with so much that exemplifies us in terms of hand-based craft, as well as kind of coming together to produce these works.

A fist is one of the most basic of resistance symbols, yet it can still carry so much depth and nuance.

With hundreds of thousands of fist graphics created over the past couple centuries—each a variation of the previous—what does authorship mean in this context? Again and again, within movement culture authorship is turned on its head. It can comfortably exist without a signature and is often produced collectively or anonymously. The members of **A3BC** are always engaging with this. Nia from the collective addressed this directly:

> And I think [what we do is] possible because we're amateurs in terms of our techniques. Somebody might have something they're good at, but there's no particular person that is always responsible for the same thing, so if they don't show up that won't stop it from getting done. It lifts the pressure off showing up, even though we do show up because we want to. Basically, if somebody really good doesn't come in it's gonna be a little bit shaky, but it will get done anyway, and there is no pressure.

This focus on collectivity doesn't end with production, but carries through the entire process of culture making, from conception to production to distribution. Movement culture is not complete when the creator sends it to print,

6. Emory Douglas, "Position Paper No. I: On Revolutionary Art" in <u>The Black Panther</u>, January 24th, 1970.

but when it is used and circulated by a community of people. This is something highlighted multiple times in the conversations in this book. Sandy Kaltenborn provides us with one example:

> When you do flyposting, the design doesn't really end at the edge of the poster—it doesn't even end with the artist or designer—but with the people who put up the posters in public space. They continue the shaping, the communication aspects, the content, and hence extend the poster design into the designing of public space.

Similar to authorship, copyright and ownership are also much less fixed. Social movement culture is often taken as open source, whether officially labeled as such or not. Because of this, the cumulative repository of movement culture—as it exists not only in archives but in communities and their ongoing projects—makes up an active cultural commons. This commons is both constantly drawn upon but also added to by each new movement that develops.

Articulating this field allows us to see its fundamental intersectionality. Graphics often expose a series of throughlines between otherwise disparate struggles as they travel, evolve, and iterate through time and space. Now this happens instantaneously via social media, but it appears to have always been true. As **Emory Douglas** recalled during our conversation:

> We used to get a lot of the posters from Cuba, they used to send us a lot of the posters they were doing in the mail. They had remixed four or five of my images, interpreting them into some amazing posters. It was coming through the mail! We would see it all the time because political posters were being exchanged from those parts of the world.

Here, Douglas' excitement about the mail illustrates that movement culture is as much a product of the tools and means used for distribution as of individual cultural creators. Again, the value of social movement culture is its social use, not its individual economic valorization. It comfortably exists without a signature, is often produced collectively or anonymously, and it is not complete when the creator sends it to print, but when it is used and distributed by a community of people. Movement culture is as much made by the movement as it is by its "author." As **Avram Finkelstein** says in our conversation:

> I believe that while we may have designed Silence=Death, the people who responded to its call actually *created* it. The relationship that images have with the people who deploy them—in particular if your work aims to open spaces for grassroots political organizing—is one where the image takes on a life of its own.

Interestingly, *Silence=Death* points to a much more appropriate Picasso work than *Guernica* to build comparisons with social movement culture. In the late 1940s, Picasso began making prints of doves. The initial ones were quite ornate and painterly lithographs, but by the early 1960s he had simplified them into line drawings of white doves, some with an olive branch in their beaks, others with flowers—or even broken weapons—in their clutches. While *Guernica* is far more singular and grand, the lowly doves have undoubtedly reached further—by being reproduced hundreds of millions of times as prints, shirts, ceramic plates, greeting cards, and postage stamps. And just as importantly, Picasso's doves are not unique, they resonate with the millions of other dove icons and illustrations created and used not just by individual artists, but by peace organizations and entire communities. While Picasso's unique hand is part of their appeal, what powers the doves under the hood is the fact they were an existing symbol of peace dating back thousands of years, predating even the Old Testament. The vast majority of the international peace movement's imagery in the post-World War II period have used dove motifs, and iterations of Picasso's doves specifically have been used by the World Peace Council and Communist Parties around the globe.

It is this piggy-backing on existing symbols that is one of social movement culture's most powerful tools. By copying and iterating material already familiar to masses of people, one can tap into people's existing knowledge and emotions, and more easily meet them where they are.

This repurposing of material with long traditions and a chain of meaning has been common practice in the world of political graphics. Its history is littered with examples of image production that not only spoke to its political moment, but was open-ended enough to allow others to build upon it, and rework it for use in other moments. This iterative process is a precedent for what we now call "meme culture."

As I've already implied, and you'll read more about in these conversations, social movements have complex relationships to authorship. Part of this is due to the inherently collaborative and collective nature of cultural production in the context of movements. It is no coincidence that all ten of the conversations here are with people who are or were actively part of larger communal projects; or—in the case of **Dignidad Rebelde** and **A3BC**—I was actually talking to multiple people. **Melanie Cervantes** and **Jesus Barraza** from Dignidad Rebelde spent a good portion of our conversation talking about community engagement and intersectionality. Melanie said something particularly poignant about how this comes not out of theory, but direct formative experiences:

I grew up in Southern California, and I think about looking at one of Malaquìas Montoya's posters critiquing the Vietnam War by emphasizing solidarity between Chicanos and the Vietnamese. I was in an ESL (English as

a Second Language) class coming into school and a lot of my classmates were refugees from the war in Vietnam. Understanding that you are my other me, that sense of interconnectedness, pointed out to me that struggles here are intrinsically linked to struggles elsewhere in the world.

In fact, there's concrete things we do that illustrate that. We were part of this group called Stop Urban Shield, organizing against this policing mechanism, a kind of trade show for repression, really, which brought police from Israel to Alameda county. They worked with Morton County sheriffs in North Dakota who arrested Standing Rock water protectors; they had training about how to use those tactics in Oakland. That's very concrete. There are many examples of how our fates are intertwined, and I think we have to have strategies for the graphic work we do that are just as complex and multifaceted.

For those of us that don't feel comfortable or safe in the communities we were raised in, or are not convinced that those are places that need or will nurture our work, it can be quite tricky figuring out how to work in places we are not from and with people that we don't share experiences or worldviews with. Within the discipline of design this is not a concern that is usually addressed because all communities are just potential consumers of your product, reaching them is simply about crafting the right marketing message. In arts discourse these concerns are swept under the rug of "identity politics," where women, trans, queer, and artists of color are rewarded for making work from their experience in ways that diversify arts institutions on a surface level, but economic class and conflicts over power are rarely if ever addressed. In our conversation, **Alison Alder** spoke to ways we can work around these problems in deeper and more profound ways, but also articulated the level of commitment necessary to do so:

> I had already worked for First Nations people in Indigenous organizations and I was interested in First Nations rights because it was and is such a huge issue in Australia. After a couple years I decided that I needed to know more, and that I needed to commit to understanding the issues from the ground up. I ended up working for Indigenous organizations directly for many, many years. Your life goes through all these twists and turns and learning about that side of Australian history was probably one of the more important pivots in mine.
>
> I wanted to learn how to put forward a perspective that was mine, built from knowledge, rather than talking for other people. I wanted to talk from my heart, rather than just present somebody else's idea. That was a really big leap for me, which I still aspire to now.
>
> I work at a university now, and quite a few students are interested in getting involved in campaigns, and I tell them they need to know everything

they can about that issue from a place of knowledge and commitment, not just a show pony position.

In fine art contexts, the role of the artist is primary and singular. And I don't just mean this in the sense that the artist is most often an individual subject, but also that their production—no matter how much it is the product of complex social and economic conditions—is seen as the self-expression of the individual subject. In a movement, the role of the artist—or cultural producer, or designer—is subsumed into the larger set of tactics, strategies, and goals of the social whole. And it is not simply the movement that benefits, the individual can also gain immensely from this process. In the discussions here, we find that various, and sometimes even overlapping, forms of collectivity abound. This insight is echoed directly by **Tings Chak**:

> Often people who do any kind of creative work tend to do it on an individual basis, and it's quite isolating. Working at Tricontinental in a collective setting with a small team changed my capacities and actually gave me some space to think.

While capitalism is dependent on our self-perception of individuation and uniqueness, opposition to capitalism is predicated on the opposite, the ability to organize people together to create a counterforce to the organization of capital. But how do we generate images that better express the complexity of our lives than capitalism does, but don't further a process of social division? What other elements of movement culture give it a shape and a way of being that make it meaningful to articulate it as a discrete field? **Judy Seidman** speaks of cultural production within movements as not a simple process of image creation, but a university in-and-of-itself, a place for artists and designers to learn, grow, and become new people—a core value of almost any revolutionary process:

> My understanding of what I was seeing and doing was often very different from that of the people I worked with. That didn't make my art less valid; it made it different. And for me, working in a collective was particularly important because I was learning about how other people were experiencing things that I didn't know about. Experimenting with how all these perspectives worked together, collectively, how someone else's experience spoke to mine, especially sharing experiences across racial lines. It was incredibly intense. Medu as university was an overwhelming education in many ways. . . .

The work of image creation and cultural production is not seen as more important than the labor of phone banking, fundraising, facilitating meetings, knocking on doors, feeding your people, or screaming through a bullhorn

at rallies. In fact, it is often valued less than many of these things. This may challenge ideas we have of culture's centrality, and having our assumptions challenged is also a core value of almost any revolutionary process.

DYNAMISM AND TRADITION

If I have something resembling a "practice," it's partly about bringing together multiple voices and experiences to engage with questions at the intersection of history, cultural production, and social movements. So, this residency at Colgate was a perfect opportunity to speak with others about their experiences generating images that better express the complexity of our lives than capitalism does, but don't further a process of social division and immiseration.

Each conversation captured in this book helped me further understand not only how culture has been mobilized for social transformation, but opened windows into ways to build on that foundation. A3BC's experience of making the entire process of image making collective and collaborative points us in one exciting direction. Tomie's work with the Chinatown Art Brigade and Sandy's subsuming of his design practice into tenant organizing are two others. Melanie and Jesus's conversion of their living space during the pandemic into a print studio, mobilizing new technologies towards political cultural production, highlights for me how even under the most isolating of conditions we can push forward. Both Avram's (and Gran Fury's) and Judy's (and Medu Arts Ensemble's) commitment to their legacy of movement work being held in the commons helps us chart a path away from individual ownership of culture. While everyone in this book spoke to an essential connection to larger communities, Emory and Alison—in different ways—highlighted how important that connection is not just for the artist but for the work itself, to gain traction and find life as an expression of larger social realities, not simply individual perspectives. Daniel spoke eloquently about how cultural production can help us make intergenerational struggle visible, and how communities are not simply constructed in space, but also in time. Finally, Tings's work connecting movement artists and designers across broad geographies and experiences points us towards the value of seeing both our similarities and differences. I very much look forward to the "Movement Culture International" that our conversation evokes!

And to be clear, there is also much contention and difference captured here as well. Emory, Judy, Tomie, A3BC, and Avram (really, everyone in this book!) would more than likely have a hearty and conflictual conversation amongst themselves about copyright, authorship, and the control of image usage. Meanwhile I suspect Tings and Sandy might hold some deep seated disagreements about the use of communist tropes in images intended for organizing. I don't believe there is a simple right and wrong on any of these

issues, our relationship to them will always be contingent on our context and what we are attempting to accomplish. Which brings us back to those epigraphs I began with. What do we do when the master's tools won't dismantle his house, but these same tools will always be the raw materials at our disposal to fashion our weapons? If anything, social movement culture is rooted in both its dynamism and its tradition. We must grasp both if we have any hope of culture playing a meaningful role in ending the world we know, and building a new one.

The live versions of these discussions were overall well attended and have had a second life as recordings on YouTube, yet it's still very exciting now to have them all collected under a single cover. This modest paperback that can be thrown into a backpack and taken on a train ride, assigned in a classroom, and hopefully found by other movement culture producers who never quite know how to describe what they do or where they fit in.

ACKNOWLEDGMENTS

This book, like any, took the labor of hundreds of people to complete. For the conversations themselves, they couldn't have happened without the 14 incredible people who agreed to discuss culture and politics with me. The entire Art and Art History Department at Colgate, from faculty to administration to all the amazing tech people that made the Zoom events go off smoothly, are at the heart of this project. The same can be said for George Mason University, in particular Jeffrey Kenney at the Gillespie Gallery, Don Russell at Provisions Library, Stephanie Grimm in Special Collections, and Christopher Kardambikas in the Print Department. At CIA, Nikki Woods and Amani Williams from the Reinberger Gallery pulled together the Zoom perfectly, and Maggie Denk-Leigh, Stevie Tanner, and Kat Burdine in the Print Department were essential.

On the transcription and editing side of things, Purnima Palawat did an incredible alchemical job of moving these discussions from rough computer translations into something a human can read. William Beaudoin did immense amount of heavy lifting on the editing, further turning the spoken word into the written one. He also helped me immensely with the introduction and as a sounding board for the framing of the book. Erika Biddle did her always impeccable job of copy editing, finding all those tricky bits that need fixing, and pointing out the places that need additional attention. Her work is the kind often thought of as thankless, so I want to thank her profusely! To Malav Kanuga and everyone else at Common Notions, thanks for your continued support in helping me make the books I want in the ways I want.

The thinking behind this project was done, as all thinking is, collaboratively. Dara Greenwald played an outstretched role, as did Alec Dunn and

all my comrades in Justseeds. Everyone at Interference Archive adds to our knowledge of movement culture with every hour they volunteer. Here in Brooklyn conversations with Chris Lee have been instrumental, and years of discussions with Eric Triantafillou have very much informed my thinking. West Coast compatriots Lincoln Cushing and Carol Wells are also bedrocks in this work.

Everything that I do is possible because of the support of my partner, Monica Johnson, and the patience (or just as likely impatience) of Asa Michigan. Thank you, always.

AVRAM FINKELSTEIN

THROUGHOUT MY LIFE AS A POLITICAL graphics producer, the Silence=Death poster has been a key visual and political reference point. Its economy of text and image, immediate visual impact, and ease of reproducibility have all been important influences. I have no memory of the poster from its initial life (I was fourteen and lived in a small town in Massachusetts), but my roommate during the first year of college was a core member of the local ACT UP chapter, and the poster hung prominently in our dorm room, as well as in t-shirt and button form on any number of bodies in motion across campus. At the time, I had no idea who had made the poster; it always felt like it was owned by the communities so actively using it.

I eventually learned about Gran Fury, and their broader design work with ACT UP, largely from books such as Douglas Crimp's AIDS Demo Graphics (Seattle: Bay Press, 1990), but wasn't aware of Avram specifically until 2008 when a friend sent along an interview he had done about Silence=Death which was published on the website Queerty.[1] I was so struck by his clear, direct, and frankly nonacademic way of discussing design that I knew I wanted to engage with him deeper. The first opportunity for this was in 2015 when I invited him to be on a panel at Interference Archive. The panel was organized around the theme "Solidarity, Distribution, Design: The Poster Today." Avram's participation was erudite and impressive; he touched on his work on Silence=Death and with Gran Fury, but also introduced his concept of the Flash Collective. This in particular resonated with me, and with a practice we had begun developing at Interference Archive, the "propaganda party," where we turned the archive inside out, from repository of movement culture to a space of production and distribution of that culture. Avram mentioned a book he was working on that he thought I might really connect with, and in 2018, After Silence: A History of AIDS through Its Images was published by University of California Press. He was correct; the book contains some of the best writing about political graphic production I have ever read, and I hold it up as an example of what I would love to see my writing accomplish. It was a great pleasure to have my conversation with Avram kick off the Graphic Liberation conversation series on February 17, 2021.

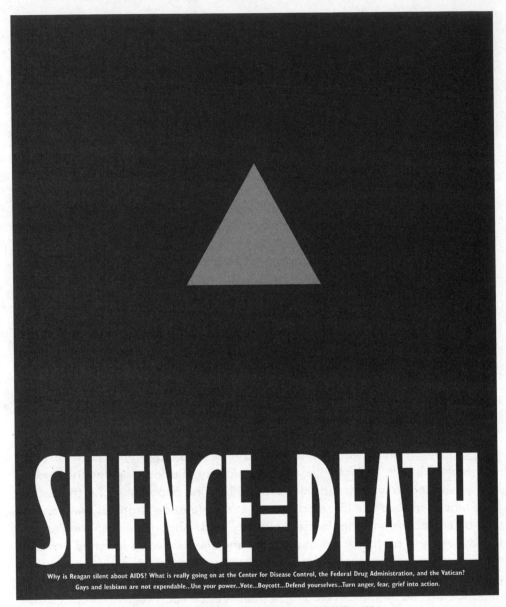

Silence=Death Project, <u>Silence=Death</u>, offset printed poster, 24" x 29", USA, 1986.

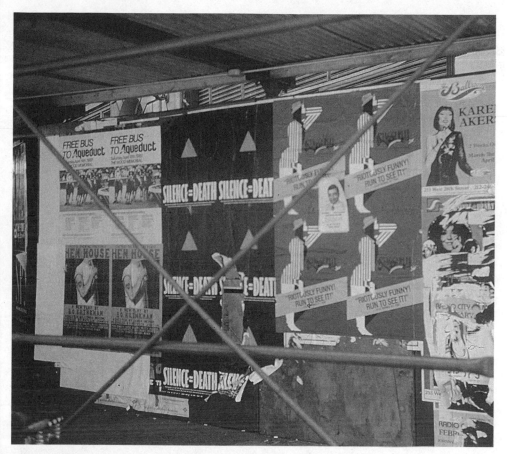

Silence=Death installed in Lower Manhattan, USA, 1987. Photo: Oliver Johnston.

← Avram Finkelstein: This is the *Silence=Death* poster as it appeared in the streets of New York City in 1987.[2] I think that it speaks for itself, but I'm hoping Josh will have a series of questions that relate it to his Graphic Liberation project. Since we all carry computers around in our pockets, I feel like there's a lot of information about this particular image already online.

Josh MacPhee: And here it is wheatpasted in Manhattan, correct?

Yeah, this is a photograph taken by Oliver Johnston, who was a member of the original Silence=Death collective, of the posters in situ. Oliver died in 1990 and gave some of his materials to another member of the collective, Charles Kreloff, who shared this with me. As far as I know, it's the only image of the original poster in situ.

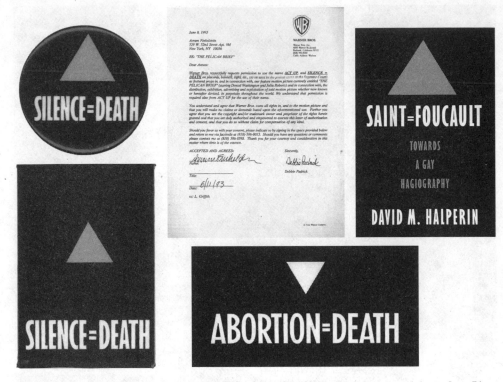

Various uses of Silence=Death, clockwise from top left: button, 1987; permission request, Warner Bros. Films, 1993; book jacket, Oxford University Press, 1995; sticker, Pro Life Alliance, 1996; kitchen magnet, Atta Boy, 1996.

↑Here are several iterations and uses of Silence=Death. I believe while we may have designed Silence=Death, the people who responded to its call actually *created* it. So, we can roll up our sleeves and talk about that a little more in depth, but these are a few iterations. One is a kitchen magnet, another is a Pro-life Alliance sticker, one is a book cover, one is a permission request from Warner Bros., for the opening sequence in the film *Pelican Brief*, with whom I had many conversations before we agreed to their use of it. Finally, we have the button. We can talk about any of these if they are of interest.

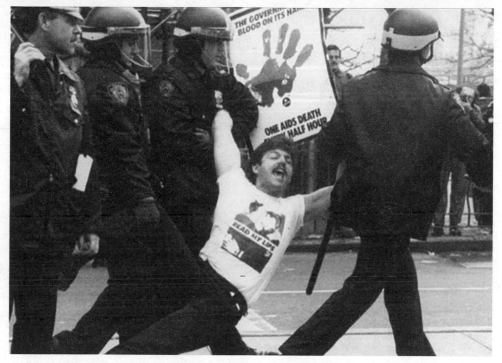

Activist in a <u>Read My Lips</u> shirt with a <u>Blood on Its Hands</u> placard being hauled away by the police, USA. Photographer unknown.

↑ The relationship that images have with the people who deploy them—especially if your work aims to open spaces for grassroots political organizing—is one where the image takes on a life of its own. In this particular case, someone is being dragged away in a t-shirt with a Gran Fury image and someone else is holding a placard with a Gran Fury image in the demonstration behind them. So, I think this is an example of the difference between how something activates social spaces at the moment in terms of political organizing, and how it holds up in an institutional setting. I feel like there is a huge difference between the two.

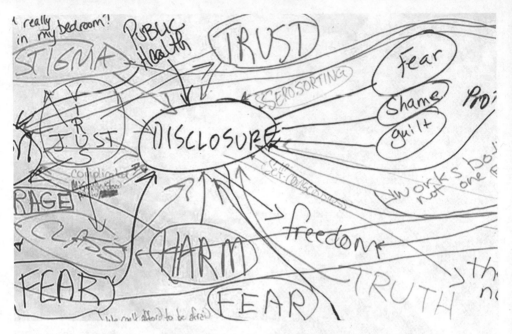

Mapping exercise for the <u>The HIV Is Not A Crime Conference</u> flash collective workshop conducted by Avram Finkelstein, organized by the Sero Project, Grinnell, Iowa, USA, 2014.

↑ At some point, after about a decade and a half of talking about my work, I came to realize that I wasn't going to be around forever and decided it would actually be more useful for me to pass on some of the skills that went into collective cultural production in the AIDS Coalition to Unleash Power (ACT UP). I came up with this pedagogy that I refer to as the Flash Collective, in which I assemble a group of strangers to create a political work in a limited duration of time, usually a day. Some have been done in two or three hours and there are some that have gone on for two days. At the beginning of each collaboration, I start with the mapping exercise in which everyone in the room is given a different color marker and responds to a prompt that I've written on a large scroll. It's a way of reading the room and getting a lot of ideas out without that go-around thing where everyone talks way longer than they think they're talking, which eats up a lot of time. It also forces the participants to collaborate on making something right away, which is the ultimate goal of the exercise.

So with that, and the idea that the power behind something like the Silence=Death project is in the process of making it as much as the object-ness of what comes out of it, let's talk about the <u>Silence=Death</u> image itself. I would argue it's one of the most enduring political graphics created in the second half of the twentieth century, probably in the last hundred years. It certainly has had an amazing life, as shown in microcosm with that array of images which included its deployment against itself as a pro-life symbol. Personally, one of the things that makes this image so powerful is how it— whether consciously or not—deploys a number of icons, concepts, and gestures that have been used by propagandists throughout history and combines them into a seamless whole which is so rapaciously effective that it burrows into you before you even realize you've read the poster. You talked before about the tentacles which reach out from this image—can you talk about some of these tentacles, some of the things that went into this image and some of the things that have come out of it?

You're hilarious in your understatement Josh. You've asked about ten different things that interest me greatly, so I will try to address some of them, and if I go down the rabbit hole pull me back. I do believe that there isn't any idea that can't be improved by multiple brains. The making of this poster, if you know something about it, was a six-person, consciousness-raising collective that was formed the year before ACT UP. It was based on feminist organizing principles and I started it with two other friends, Oliver Johnston, who I mentioned above and is deceased, and Jorge Sagra, who's currently living in Spain. The three of us had dinner, and we realized that there wasn't actually a space in which one could talk about AIDS in 1985 that didn't relate to care or support work but that related to larger questions. So, I suggested that we each invite one other person that the other two didn't know so there would be some tension, some consciousness raising within our collective, and we met every week and we had a potluck at someone else's house.

The object was to explore questions surrounding being a gay man in the age of AIDS, but every weekly conversation would break into a political conversation, and I quickly recognized that was what was missing from public conversations about HIV/AIDS. So, I suggested we do a poster and we did. We worked on that poster for nine months, which is part of the reason it's so packed. It's like we went through so many iterations and disagreements and critical arguments about how the poster should function, who the audiences might be, what the objectives of a poster should be. We didn't work on it for an entire weekly session every week for nine months, but it took us nine months to get it where it is and it's incredibly packed.

I think what you're noticing about it is very much a function of the collaborative thinking around this very complex issue which, up until that point, there wasn't street activism about. We realized that there was a tremendous

amount to talk about, and the only way to talk about certain things was to build these structures—all of which were intentional—into this poster. Which is partly what makes it open-ended enough for many, many different people, over long periods of time all over the world, to respond to it in different ways. That was also part of it, I think, a kind of consciousness raising. We tend to think of political organizing as this discrete thing, as everything is in capitalism, and it's a thing that you acquire or you own, whether it's knowledge or a physical object. I don't think political engagement is a thing, I think it's a series of gestures. It's ongoing. Consciousness raising means, from my perspective, that each person takes the next step for them, and there will be a wide spectrum of what that might mean. So, as a consequence, we didn't interfere with other people's use of it, even when we disagreed with it, because every iteration referred back to this original gesture and was a part of—"where did that come from?" "Who made that?" "What was it about?" "What did it mean?" That's consciousness raising.

I had a conversation the other day with two students at Colgate [University], Haley Ryan and Thomas Ayama, who are working on a project for class where they unearth some of these connections and histories embedded in that poster. I think because the pink triangle has been superseded by the rainbow as a universally understood representation of queerness, they initially interpreted the poster as connected to the Black Lives Matter movement, in part because of the deployment of the idea of silence, white silence, and "silence equals complicity."
They wanted to ask what you thought about these new and evolving interpretations of the image. Are they a positive thing? Are there drawbacks and what would those be? Can you unpack a little bit of your thinking around this?

Super-interesting series of questions. I remember shortly after the poster hit the streets and ACT UP became a thing, there was an art critic who wrote a book who decried the vagueness of the image and critiqued it as a result of that vagueness. Douglas Crimp and Lee Edelman got into a public debate about how clear it was and whether clarity was the point or not. I think the idea that this image, which was designed to be a consciousness-raising project, should be a particular thing is grounded in capital. The idea that our version was the only one that mattered and every subsequent use of it had no meaning was something I disagreed with. It's exactly the point of the project that people bring to it what they will.
During the Black Lives Matter demonstrations over the summer of 2020, I contacted every remaining member of the collective to talk about the question of Silence=Violence, which turned up in a lot of demonstrations, and whether or not it would be helpful for us to reach out to someone and see if there was some way we could be useful. We decided that we couldn't,

our voices did not need to exist in relation to that particular use of the slogan. Moreover, the beauty of the mass-produced, slick graphic nature of *Silence=Death*, which was basically an Abbie Hoffman/Yippie set of techniques to trick the public spaces of New York at that moment into thinking about this in a certain way, were no longer applicable.

In the Black Lives Matter protests, all of the signs, almost all of them, are handwritten on flaps of cardboard from boxes. That is exactly what was needed at that point, that set of gestures were so much more necessary than the idea of introducing some mass produced or preconceived idea of what would best represent the multifaceted voices that were coming to bear during those demonstrations. So, we decided against it. We were thinking of maybe doing a fundraising, limited-edition thing that related to and could support it, but decided that its existence was so brilliantly specific that any introduction of another element would destroy the point of that activism.

I think that's part of the way it baffled everyone's mind when we created this thing to exist in the public domain. It's so contrary to the way we think about credit and authorship and academic conversation and curatorial considerations. That's why I said there is a difference between the way these images exist in a white cube, where they are completely stripped of essence, versus on the street where it's a dialogue that's completely different and doesn't relate to the hegemonies of the Western European canon.

I want to come back to this idea of putting an image into the commons and the questions it raises around copyright because it's at the core of my thinking around the theme of graphic liberation.

I also want you to expand on this critique of the white cube. You've done a lot of writing that challenges the role of institutions, particularly art institutions, in not just representing, but literally re-presenting, political and social movements. I want to discuss what is lost in the violence of that process. As someone who's invested in an institution or counterinstitution engaged in these questions—Interference Archive here in Brooklyn—I want to know if you think there are better ways to present history or movement culture?

Now you've touched on five new tentacles that are something you and I had spoken about, so I know that this is an area of overlapping interest and concern. I should preface by saying that when I was a young activist in the 1960s, I had an unhealthy derision for the idea of history and historiography, and archives in particular. But of course, if it weren't for archivists and academics and historians, access to this material might have withered away. So, I've come to this realization later in life that there is a tremendous set of meanings attached to curatorial and historical, historiographic gestures. It's a different set of meanings and I think the scrim through which we view all of them has to do with valuation.

One of my primary critiques of the institutional uses of, let's just say the *Silence=Death* poster, is, *is it actually part of a system of valuation?* As a consequence, *Silence=Death*, that image we began our conversation by looking at, the idea that it should be juxtaposed in any way against Silence=Violence written in marker on the back of an Amazon box is a false division in a way. Both have meanings and the meanings lie within individual agency, which is one of the things that institutions are really bad at. As somebody who has done research and who has worked in archives, finding aids are incredibly impenetrable. It's just not possible for people to know everything there is to know about that image. How many members of Gran Fury knew members of the Silence=Death collective before ACT UP even happened? Did members of the Worcester Group (who did performances at that point in Lower Manhattan and whom both Gran Fury and the Silence=Death collective knew) date each other and have fights with each other? All of those tentacles are impossible to put in a finding aid. You would have to actually—I'm laughing because our friend Sarah Schulman sent me a galley of her 700-page book, *Let the Record Show*, and basically, it's the history of ACT UP and she has done this almost impossible thing, which is to connect things that other people have not seen. She did it based on the ACT UP Oral History Project which comprises interviews, each between two and four hours long, with hundreds of people. As a person who was a part of all of those interviews, I've been waiting for her to make some analysis of it, because you could read and study every individual account and spend your entire life's work studying ACT UP, and for example, still miss the fact that in the FBI files of ACT UP, the Tompkins Square Park Riot and ACT UP are connected. You would have to be a student of government and political surveillance in America to know that very thing.

Some of my best friends are curators and I love the Whitney, and I have a lot of pals who are academics and they're brilliant—they're smarter than I am for sure—but you can't, on a white wall, say all of that. Even in Sarah's 700 pages, you cannot make every connection and that is my question about the archives, not so much a critique. One more thing, before I go further down this rabbit hole: all archivists are deeply aware of this set of questions and spend a tremendous amount of time thinking about what the meaning of an archive is, could be, should be, as well as ways to improve it as an archivist themself. What's your response to my throw down about the deficiencies of individual objects and their archive?

I agree. Part of why we started Interference was we felt that existing institutions were not responsive or accountable to the movements that made this material. That said, there are a lot of movements that have done amazing things like, for instance, the Mothers of East Los Angeles (MELA) in the 1980s who first stopped the creation of a pipeline going through their neighborhood and then stopped the construction of a prison. There are literally no

popular images of that organization, it doesn't exist in our national conscious-ness, so if any more mainstream institution was going to put a flyer or a poster or a photograph from that back into public circulation, it seems like it would be an overall social good. Even if imperfect, the re-presentation of movements erased from public consciousness by capitalism and statecraft opens the pos-sibility of understanding that the struggle happened in the first place. I think that the tension between erasure and strategic, if limited, representation is a powerful place to think about. It's a question for people in both movements and institutions—how is this material going to have a life beyond the street?

Yeah, that is a separate question, but I agree with you. It also doesn't avoid the factor of social imagination, as it's constructed in capitalism. We're in a culture where images have spin-off meanings that don't necessarily relate historically to their original use or potential use.

For instance, the Black Panthers. There's a whole set of tropes about who the Panthers were and these don't in any way touch on—unless you're really a student of that movement—the free stores and the free breakfast for children program and the community organizing that the Panthers did and how it was a matrix for so much political thought and for so many other resis-tance movements. It was all obliterated in a series of gun battles, so now you have these tropes—

Literally and figuratively obliterated.

Literally and figuratively obliterated.

I think that being an observer of that moment and having Panther sympathizers and supporters in my own family was incredibly influential. And it's not an accident that when the Panthers began to actually set upon an alternative set of ideas about what social interaction and individual agency meant that they became such a threat and needed to be gunned down and imprisoned. There are many people who've done research and are much more knowledgeable about it, but I feel like that's an example of the way it func-tioned on the street at the time.

This is kind of a sidebar but somehow it illustrates what I'm trying to say. When Patty Hearst became a member of the Symbionese Liberation Army (SLA)—if you don't know about her, she was an heir to the Hearst family fortune, and theoretically, was kidnapped and kept by this left-wing organization; and she was seen in a video robbing a bank. It became this na-tional set of conversations that was so different for people who were young at that moment in America and saw what America was becoming. In a way, everyone assumed that she, just like we, had decided that the system was corrupt and, in fact, had her consciousness raised and was, in fact, robbing a bank and should be robbing a bank. Of course, when she left the SLA, the

lawsuits that were paid for by her family tried to establish all of these ideas as counternarratives.

That she'd been brainwashed.

That she was brainwashed. The reason I'm bringing up Patty Hearst is that Patty Hearst had a separate set of meanings if you were a young person doing resistance work at that point in time, that existed completely outside of the mainstream narrative about Patty Hearst. So, when I saw somebody did a *Silence=Death Star* poster and used an image from *Star Wars*, I thought it was hilarious and it related to a set of references and conditions that had a different set of meanings.

 To go back to some of your earlier questions about if I was handwringing about people using this image in ways that I did not intend, I would say the opposite is true. In order to really understand the meaning of images in an image culture, you have to be open to the mutability of images or text and image combinations and recombinations. They are not without meaning, they simply have different meanings.

In order to hold that position effectively, one needs to feel like they have agency over those images—that you get to play with them and rework them and put them back out into the world. That happens at a certain level on social media, but simultaneously there's an extension of capitalist enclosure with the clamp down on intellectual property. People with personal blogs getting cease-and-desist letters from rights agencies for example, because they supposedly pulled an image off the Internet and put it on a blog that literally three family members have looked at, and now they're getting bills for thousands of dollars.

 As people who are part of larger social movements that make graphics and images which we hope to be of use to those movements, how do we open up access to the entire commons of imagery when there's so much repression happening in that field? Both Silence=Death and Gran Fury put out their work as copyright-free or Creative Commons. At the same time, there are people of your generation and my generation who are very, very actively holding the rights to their material and trying to sell it off in order to survive. Which is hard to fault them for under capitalism. How do we negotiate these complexities?

That's a super-fraught set of questions. I realize everything I'm saying today is considered from a position of privilege, but I have a different relationship to those questions. That body of work is not my work, that's not what I do for money. So, as a consequence, it's probably easier for me to have a cleaner relationship to capital, because I have commercial clients. I don't feel conflicted

about doing the work because it's understood that that work is not owned by me, it becomes the intellectual property of the person who pays me. That's very different from political grassroots organizing and whenever I use the word propaganda in relation to work I had a hand in, or if members of either the Gran Fury or Silence=Death collective use the word propaganda, people get very flipped out about the idea of it because propaganda is a means for social control and is never thought of as the simple power of an image.

Every image is propaganda in an image culture, everything has meaning, everything's up for grabs. I have a different relationship to ownership, I think, and it's probably because I was a "red-diaper baby" and I was a teenager in the 1960s and I just have a different relationship to those questions. Don't get me wrong, even though Gran Fury's work is in the public domain, there has been more than one instance in which members of the collective had great misgivings about that over time. But you can't be in the public domain and control it; you're either in the public domain or you're not.

There have been very fierce disagreements about t-shirts that have been made using these images. We gave them to ACT UP to use as fundraisers for ACT UP, but for some members of the collective, it's become a problem. One example is when Opening Ceremony did a series of reissues of them that were, in fact, ACT UP fundraisers. Of course, Opening Ceremony is a fashion brand and wholesaled these shirts, and they ended up in Barney's in LA, and there were members of the collective who had a meltdown over it. But the fact was, ACT UP made more money from the sale of that t-shirt than they ever made from the sale of t-shirts that they produced themselves. The proportion that went to ACT UP exceeded any amount of money ACT UP was comfortable handling.

So, what in fact does it mean to have something be in the public domain, but want to control it? These are the built-in terrors of capitalism that Marx predicted. As a system that could not be dismantled, this is just a part of the way it functions. You're either playing on that field or you're not playing on that field, those are really the choices, and if you're playing on the field, then it's not our field, we don't own that field.

Everything that we make becomes a commodity. I guess then the question is, how much control do we have over that commodity? And what other valences can it have, commodity or not?

I know, in my own work, I have found that the less intense the claim to authorship, the more useful and effective the work can be in the world. We've now reached a point at which a lot of communities and political organizations have realized that it's to their benefit to pay the people who do their cultural work. So, if I'm getting paid to make something, then part of my condition, usually, for making it is that it's also put out for people to use for free. And I found that there is always the odd situation in which something gets used in a

way that makes you extremely uncomfortable but, for me at least, that's always been balanced by one hundred other examples of it being used in ways that I never imagined and that are really interesting.

I completely agree with you. I feel as though one of the primary reasons why, as in your words, *Silence=Death* has had this long and very vast set of meanings has to do with the fact that we didn't own it. It could never be that *thing* that you're referring to if we had consciously attempted to do that. In fact, we only copyrighted it because a First Amendment lawyer in ACT UP advised us that if we didn't copyright it, someone else could copyright it and prevent ACT UP from using it or prevent us from using it. Which is exactly what happened with the smiley face. In the collective we struggled with, well, do we want to copyright it in order to give it away? Which is what we did, and nobody understood it [laughs]. I mean we might as well have set a bomb off in the middle of the meeting when we said that to the membership within ACT UP. It's a very difficult thing to understand. In the collective we used to jokingly refer to it as the smiley face of the eighties. Our feeble gesture of control was to copyright it so that nobody else could, which is a completely different relationship to the idea of ownership.

Audience: Why do you think a pro-life organization was interested in using iconography from the <u>Silence=Death</u> poster? Do you have any insight on that?

Super interesting. So, if you don't know much about the rise of the religious right in America or didn't live where Operation Rescue was, it was a right-wing project in the US that intentionally studied the protest movements of the sixties to see how they could apply it to the anti-abortion movement. It was ten years in the making before they started blocking people at the entrances of reproductive clinics. So, it seemed to come out of nowhere, but it actually didn't. The right has this hierarchical, subterranean way of organizing their politics. Using the iconography falls into that set of gestures because the AIDS movement was becoming so popular and this particular image was in some level of common use. I believed it was only recognizable to people within certain bubbles, but it was a big enough bubble that Operation Rescue decided they would piggyback off of us. *Abortion=Death* has one set of meanings but they left the triangle on it.

When I saw it, I was like, well, okay so if I were in Operation Rescue and I saw the sticker my first question would be, "What does that even mean?" So, an Operation Rescue member would have to learn about ACT UP, learn what the triangle meant during the Holocaust, which was consciousness raising, in my opinion. We couldn't prevent them from using it, but it actually had a benefit, which was it created a world in which somebody who would never follow AIDS activism became aware of it.

Josh MacPhee: I wonder if they kept the triangle because it connected the idea of abortion to the Holocaust.

Possibly, but at that point in time, you had to have been very versed in Holocaust studies.

As an aside, I will say that in the past six years or so I've noticed a spike in interest in academia in the question of the triangle, the pink triangle, and its relationship to the Holocaust. There are numerous books being written on it and I've been interviewed about it with increasing frequency. So, I feel like you might be right about that, but I think that back then it was not common knowledge. It was a densely coded gesture that we chose, the pink triangle, because we realized the original poster was going to be in response to William F. Buckley's call for tattooing people who are HIV-positive. As we began to consider that as the subject of the poster, we realized well, whose body is that tattoo on, what gender is that body, and what color is that body? We realized we couldn't have it function the way we needed it to function with that set of questions about representation, and then made this hotly debated final decision to use the pink triangle.

I have had similar experiences with appropriation by the right. I put out a book in 2004 called Stencil Pirates, which was a history of the street stencil as a tactic. I was disturbed to find out a couple years later that a white supremacist website was selling the book with a tagline that all Nazis should read this book to learn how to do propaganda.

Wow. Well, I might draw the line there, Josh [laughs].

I mean, this is the thing about when it becomes a commodity. I don't know where they got the books. It was completely out of my control.

I had this fight with my father when he was still alive. When I went away to college, he asked me if I wanted an American Express card, and I said no, because you can't put your toe into capitalism and decide if you like the temperature of the water. If your toe is in, you're up to here [gestures to forehead]. It's not only a matter of the ability to control, but the way in which you utilize the commons that's an ongoing battle if you're an activist. Politicization isn't an endpoint, it's a gesture and an ongoing project.

Audience (Catherine): Regarding the idea of people putting up posters in the streets, you described it as "tricking the spaces of New York City," could you expand on that a little bit?

I'm not sure what you're asking. Are you asking about the use of the street by nonprofessional entities and to think about public spaces in that way?

Audience: Yeah. In New York City there are these professional wheatpasters who are advertising products or events, but within that you're using a similar format and method to paste up <u>Silence=Death</u> posters. I think it was described as a sort of tricking or appropriation.

I think that so much of the Silence=Death collective's practice and my individual practice, way before the Silence=Death collective formed, the idea of appropriation was a critique. It means using the language of authority against itself. At that point in time, it was Reagan's America. We had many conversations about a manifesto. One of the members of the collective, Charles Kreloff, said, "no one is going to read a manifesto; this isn't the sixties anymore, it has to be hidden within the language of capitalism." So, we actually paid for those spaces, because it guarantees that they will not be papered over and we decided to do that as an intentional intrusion into otherwise commercial spaces. Which is very different from wheatpasting a flyer on the street. Having said that, other collectives like fierce pussy tiled individual photocopied images broken into sections and made billboards on the side of a cube truck and drove it around the city one Pride weekend. It's possible to not participate in capitalism and still participate in its tropes and means and strategies.

Brynn Hatton: Thank you so much Avram and Josh for this conversation. It's been enlightening and wonderful to hear more about work that I've loved and followed for so long and teach every year, so thank you so much. I have a simple question; it may have complex answers but I want to ask it anyway. It could be with respect to specifically the pink triangle or any of the other work that you've done.

Do you have any lessons learned about what an image really needs as far as components to do the kind of work that you want it to do? We've been talking a lot about the necessary tension between flexibility and co-optation. For instance, there's tremendous power but it's a precarious kind of power to have an image on a truck. Or the kind of influence something like the pink triangle has, and how it can be put towards political projects that are not necessarily part of the original ethical intent. Often the transferences are good, like the triangle in <u>Silence=Death</u> being a natural atmospheric match with Black Lives Matter, but that is not the case with the pro-life movement. I'm just wondering, in this negotiation of how the image works and how it travels, what components in an image itself, in your time and in your work, have you learned are good to have in order for the image to do the kind of work that you would like it to do, not just that it will somehow "inevitably" do?

Oh my God, such a good set of questions, Brynn. I'll say a couple of things about that, one is that Silence=Death casts a mighty shadow. If you feel like you have to have a poster to identify your individual or collective agency as an activist organization, you can easily fall into the trap of thinking that without such a thing your work won't have meaning. But, as I said in the beginning of this conversation, I actually think it's the meaning that thousands of activists all over the world infuse that poster with that gave it that meaning. I think it's a trap to think of the image first. I also think it's true of capitalism, because branding is so essential to the way in which ideas and goods are sold, that we tend to think in this monolithic way about political agency. I don't think of it that way at all. I feel like for as many successes as Gran Fury had, we had miserable failures. And the truth of it is, it's the try-shit-and-fail part of it, aka the ability to be comfortable with one's own frailty in terms of longevity and meaning and iconography, that is so key.

If you are comfortable with failing, you will never fail when it comes to articulating your agency as a political person in the commons. So, my primary advice is try shit and if it doesn't work try something else. They count on us giving up, they count on that. I'm Jewish, my people have been chased all over the globe for centuries and have been practically obliterated from the face of the Earth and I'm content with the idea that I will just have to always sleep with one eye open. It's just part of being a Jew in the world. I think that the idea that you should be able to define what it is you want to say in one image is a trap. You should think of every image, every gesture, every thought, every participation, every demonstration you go to, everything that you try as having meaning. Just because we don't all see it, it doesn't necessarily mean that it didn't have meaning. It could mean that the one person who saw it, twenty years after you're dead, will have an idea based on that one thing you did and that will change the world. Why isn't that enough?

Josh MacPhee: Just wanted to say thanks again to everyone and to encourage all of you who have not read Avram's book, <u>After Silence,</u> to do so. It's one of the best pieces of writing about the making of culture within the context of a social movement. There may not be a lot of competition for that title, but regardless, it is fabulous. It's really useful for anyone that wants to go deeper into their own thought process about culture-making in the context of political advocacy. It's really useful in regard to setting some guideposts for ways of thinking about collectivity, image production, distribution, and context. It's chock-full of useful knowledge and it's definitely well worth everyone's time and energy.

You're very kind to say that. The intention of the book was to open up possibilities for other cultural producers to think about critical questions. I critique my own work in this book and that's intentional. A lack of preciousness is a thing that, as activists, we need to embrace. Thank you, that's all very kind of you.

Josh MacPhee: The thorny representational issues that you've raised here and talk about in the book, they've only gotten thornier since the eighties. As image makers, we need to be prepared to make mistakes and to learn from them and to move forward and do better. And to just recognize it always is a process, there is no perfection from the outset.

NOTES

1. Andrew Belonsky, "Avram Finkelstein's Words Resonate," Queerty, February 25, 2008, https://www.queerty.com/avram-finkelsteins-words-resonate-20080225.
2. The poster was only on the streets from the end of February through early April 1987.
3. There have been many lawsuits involving the humble smiley face, involving its use by everything and everyone from Walmart to Nirvana.
4. Avram Finkelstein, After Silence: A History of AIDS through Its Images (Oakland: University of California Press, 2020).

TOMIE ARAI

I FIRST MET TOMIE ARAI in 2013, in the lead-up to the Interference Archive exhibition <u>Serve the People: The Asian American Movement in New York</u>. The show, organized by Ryan Wong, brought together a powerful slice of the cultural production of New York City's Chinatown in the 1970s and eighties. I was blown away when he brought in a wide selection of political posters from that time, none of which I had ever seen before. Many had been screen printed at Basement Workshop, and of those, most had been designed by Tomie Arai. Largely using a red, yellow, and black palette, these early posters of Asian people in struggle were some of the first images of what was then a nascent concept: Asian America.

Tomie was at the center of the construction of this new identity, initially working at Basement Workshop, the first Asian American arts organization in New York, and one of the first in the country. She then went on to work at Cityarts Workshop, a mural organization rooted in Lower Manhattan. She then helped found the Asian American arts collective Godzilla in 1990. Over the past thirty years she has crafted an exceptional career as a public artist working closely with the communities where her work is installed. Soon after I met Tomie, she helped found the Chinatown Art Brigade, a collective of artists and media makers that work closely with community organizations to address issues facing their neighborhood, specifically gentrification and displacement.

Tomie's life and work—which charters a path that intersects with print and poster making, murals and public art, collectives and group work, and activism and community organizing—is if not singular, very close to it. It was great to be able to talk to her about these connections (and disconnections) on November 3, 2021.

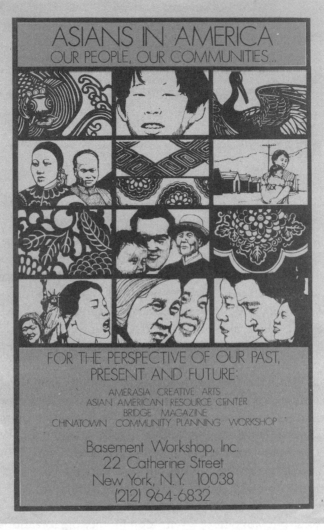

Tomie Arai, <u>Asians in America</u>, offset poster for Basement Workshop, USA, c. 1972.

↑&↗Tomie Arai: So, this was quite a challenge. Josh asked me to land on five images to talk about and I decided to share some work that I had done in collaboration with organizations that I both loved and respected, and in some small part, had a role in helping to build, because that's the work that I find I always like to talk about and seem to value the most.

I'm beginning with two posters that were based on images that I created for Basement Workshop. The first image is a poster I designed almost fifty years ago at Basement, which was at that time just a loose collective of individuals, but eventually developed into the first Asian American cultural center in New York. It was an incubator and hub for hundreds of Asian American artists and writers and poets, dancers, and performers over the sixteen years

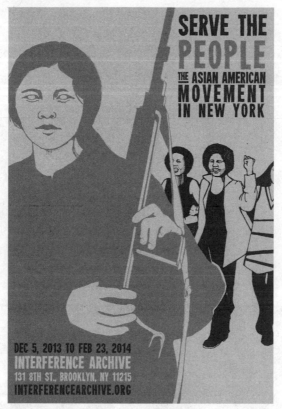

Interference Archive, <u>Serve the People: The Asian American Movement in New York</u>, screen-printed exhibition poster, USA, 2013. This poster design by Josh MacPhee is based on artwork created by Tomie Arai for *Yellow Pearl*, an anthology of art and poetry published in 1972.

that it was in existence. It was more than a cultural center. In the first image, I listed the four programs that Basement had developed, and these images actually came out of a number of different poster and graphics projects I'd done with Basement over the years.

I had the chance to listen to the conversation with Emory Douglas that Josh conducted,[1] and it was interesting—and I would love to talk a little bit more about this later, because Emory and I had been in conversation in 2019 right before the pandemic. We both came out of a graphics background and had each worked for magazines and newspapers before we became involved with organizations, so the high-contrast, black-and-white drawing sensibility is something I felt I shared with Emory when I first saw his work.

The second image is a poster for the exhibition *Serve the People* that was curated by Ryan Wong for Interference Archive in 2013. The show was a way to chart the Asian American movement through art and culture and I was very pleased that Ryan went as far back as Basement to find this image, which was about self-determination and the women's movement, and use it as the face of the exhibition.

Tomie Arai, <u>Laundryman's Daughter</u>, screen print on BFK Rives, 30 x 22 inches, USA, 1988.

←*Laundryman's Daughter* was the first silkscreen print that I had ever done. I'd made a lot of silkscreen posters, but I hadn't really ever done an edition of prints before. It was for an oral history project that I conducted in 1989 for the Museum of Chinese in America. I was the first artist in residence at the museum and I don't think they knew what to do with me, but they opened their archives, and they had a really beautiful collection of oral histories and historic photographs and donations of artifacts in the community, and I was able to sort of walk my way through them.

One of the things that I was really taken with was the oral histories. This was my first print based on an oral history and it's been a practice that I've used ever since. For forty years, I've based so much of my work on the collected stories that I've been honored to receive from different people and communities that I've worked with across the country. It was also my first introduction to what I now understand is a dialogic process of collecting experiences and histories, that really distinguished the Chinatown History Project—which is now the Museum of Chinese in America—from all the other museums in the city. Jack Tchen, who was the Museum's cofounder, introduced me to the idea of co-authoring and co-curating stories with people who had actually experienced these histories. That was the beginning of really relying on historical accounts, archives, photographs, and the shared experiences of people that I met through my work.

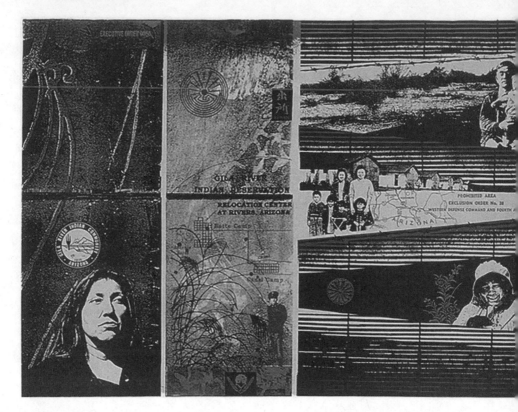

Tomie Arai, <u>Return</u>, screen-print diptych, 22 x 62 inches, USA, 1998. Commissioned by the Arizona Humanities Council to commemorate the 50th Anniversary of the end of WWII and the closing of the Japanese American concentration camps built on Indian reservations in Arizona. The print was given to the Gila River and Colorado River Indians as a gift from the Japanese American community and is hanging in their tribal offices.

↑ I also wanted to share this silkscreen print, called *Return*, that was commissioned by the Arizona Historical Society in 1997 to be given as a gift to the Native American tribes from the Japanese American community living in Arizona. The occasion was the fiftieth anniversary of the ending of World War II and the closing of the Japanese American internment camps. During the war, the government built ten Japanese internment or concentration camps across the Western states and two were built on Indian reservations in Arizona without their consent. One was called Gila River Relocation Center and the other Poston. Fifty years later, the Japanese American community and the Native American community gathered together to talk about that experience. During the war, it was illegal for Native Americans and Japanese to even speak to each other, so clearly there were a lot of issues that were left unresolved. It wasn't until this conference, which was called *Transforming Barbed Wire*, that people came forward and really exchanged experiences from both sides of the barbed wire.

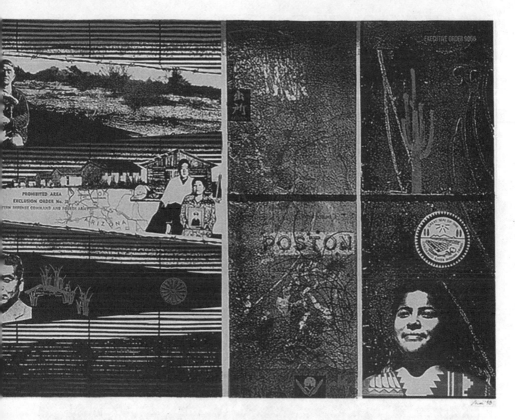

My grandparents were incarcerated at Tulelake and later at Topaz, but the experiences of the Japanese in Gila River and Poston were very similar. I think that, as somebody who is part of a cultural collective that is fighting against gentrification in New York City's Chinatown, we're just beginning to understand what it means to be settlers on this ancestral land of the *Lenapehoking* and how we need to acknowledge that as immigrants, we are part of the settler colonialism that has disrupted and destroyed so much of Native culture in our country. I'm only beginning to become aware of the overlapping histories of Asians in America and Indigenous people. My grandparents on both sides came from Japan to work on the sugar plantations in Hawai'i, which were responsible for displacing and destroying so much Indigenous culture on the islands. This was a story I wanted to share as part of the work that I'm doing and continuing to learn more about.

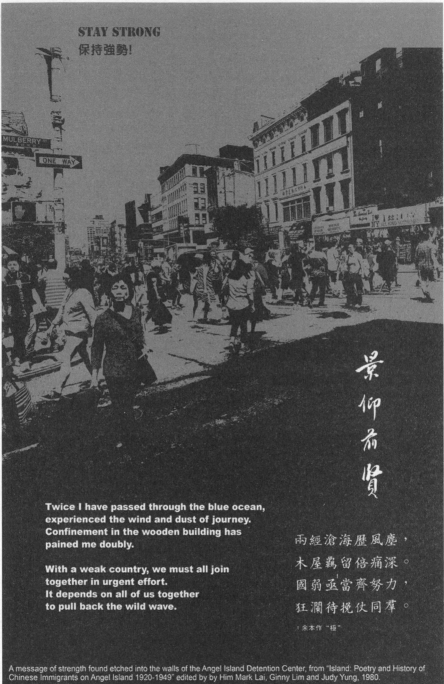

STAY STRONG
保持強勢!

Twice I have passed through the blue ocean,
experienced the wind and dust of journey.
Confinement in the wooden building has
pained me doubly.

With a weak country, we must all join
together in urgent effort.
It depends on all of us together
to pull back the wild wave.

景仰前賢

兩經滄海歷風塵，
木屋羈留倍痛深。
國弱丞當齊努力，
狂瀾待挽仗同羣。

余本作 "極"

A message of strength found etched into the walls of the Angel Island Detention Center, from "Island: Poetry and History of Chinese Immigrants on Angel Island 1920-1949" edited by by Him Mark Lai, Ginny Lim and Judy Yung, 1980.

Tomie Arai, <u>Stay Strong</u>, poster design, 11 x 17 inches, Love Letters to Chinatown Project, USA, 2020. Letters, poems, and posters were collected through an open call and posted around Chinatown by volunteers from the Wing on Wo Project to uplift the community during the pandemic. This poster design was based on poetry that was written by Chinese immigrants and etched into the walls of the Angel Island Immigration Station in the early 1900s.

←This last piece is a poster that I created during COVID for an organization called the W.O.W. Project. For those of you who don't live in New York City, Wing on Wo is a store in Chinatown, it's one of the oldest porcelain stores in the US, and it's now the home of a cultural center. In fact, these small mom-and-pop stores, in communities like Chinatown, have always been considered cultural centers and places where people congregate for social reasons. Wing on Wo is now a very dynamic and vibrant women, trans, and queer-led, community-based initiative in Chinatown.

So many businesses were severely impacted by the pandemic. Almost immediately, many people stopped going to Chinatown because they were afraid of getting the "China Virus" and now, so many local businesses are facing foreclosures and evictions because of the economic precarity brought on by the COVID lockdowns. Wing on Wo decided to create a project called Love Letters to Chinatown, and they invited people to write messages of hope to the community and had volunteers take these messages and paste them around the neighborhood.

I based this poster on a poem that was etched into the walls of the Angel Island Immigration Station in San Francisco almost one hundred years ago. The poetry that they discovered on the walls was really what saved the detention center from destruction. I was struck by this poem because it seemed so relevant, even though it was written on the walls of a detention cell by a Chinese immigrant who had just arrived in America. I'll just read the last four lines, which are translated from Chinese: *With a weak country, we must all join / together in urgent effort. / It depends on all of us together / to pull back the wild wave.*

Josh MacPhee: It's so profoundly clear, just looking at that handful of images, that the heart of your work is about different forms of storytelling. So, I want to set a marker to talk about that, but first, I want to go back to the beginning. You went to art school, correct?

I did go to art school. I didn't finish art school.

I'm interested in this, especially because so many of the people who are tuned in are art students. How did you make that leap from art school to embedding yourself in a community organization that was rooted in cultural production but was also clearly a political center as well? Basement Workshop was at the crossroads of a lot of different campaigns and social justice issues and work around healthcare and tenants' rights and all these other issues in Chinatown in the early 1970s.

Well, I find that question a little ironic because I actually wasn't able to finish school. I was a single parent and really had to find a way to make a living. In hindsight, I look back at the rather stupid choices I've made in my life and

how sometimes, without knowing it, those choices determine everything you do from that moment on. Someone once said, "we are all at this moment, every choice that we've made, we are exactly where we should be." But not having been able to finish college and having to work and then also finding myself in sort of desperate situations where I didn't really know what my future was going to be, really made me think a lot about what it means to survive, what people in my situation need to do in order to survive. I think I've always had empathy for people who are disenfranchised. Being without an education, it's absolutely true that you are an underclass and you're devalued.

I had to find my way through that and one of the books that I've recently been so thrilled about is by Saidiya Hartman called *Wayward Lives, Beautiful Experiments*.[2] It's stories from the radical archives and one of the things she talks about are these women who were so marginalized, so powerless, and yet they found a way through by guessing at the world, and I just love that phrase, "guessing at the world" and seizing chance, I feel like that really was my story.

I was very fortunate to find myself in places where people, especially artists, were so generous. I learned everything about art from other artists and from working on the spot, learning as I was going. I remember I just always wanted to be an artist, but nobody in my family was an artist, so I really didn't know how to be one. I'd go to the museum, I wouldn't see anybody like me—I'm sure that's a familiar story—I just always felt like I was among those people who had to figure it out and build the places you wanted to be in.

My first paid job as an artist was painting murals. I learned how to paint a mural by going up on the scaffolding, standing next to somebody who showed me how to do it. Secretly, it was always something I wanted to do. From the beginning, I always wanted to make people's art. I was able to go to the High School of Music & Art, which now is LaGuardia Arts, and from a very early age, I knew I wanted to be an artist, I just had to figure out a way to be that person. To answer your question, the 1960s and '70s are really responsible for shaping my worldview. I can't say that it was just one thing, but a combination of world events and making choices about where I felt I fit in, the antiwar movement, the women's movement, all the militant models that were out there in different communities trying to build new and powerful institutions for those areas. Those are things that really influenced me and made me want to follow in those footsteps.

What was so impactful about the Serve the People exhibition, for me, was that so many people that are my generation and younger take for granted the Asian American identity, as if it's a fixed thing that has always existed. The show really opened that up and illustrated how no one thought about or used that term until the early 1970s, and that it came out of the political work that people like yourself were doing. As you said, it was the middle of a US war of aggression against Vietnam, the Cultural Revolution had just happened in China. You

were drawing from the visual landscape of some of these places and struggles because they were the only images that you saw of people that look like you. Can you speak about what it felt like to be at that moment of realization, and of creating some of the initial visual representations of Asian America?

I know there was recently an article in *The New York Times* by Jay Kang, questioning the term Asian American. I think that's part of the conversation now, whether or not a term like that is useful when our communities are really so diverse and it doesn't accurately describe all the different trajectories that brought people from Asia to here. I think that the term was so universally accepted because it was a way to subvert this notion that we were all the same and that Asians were a monolithic race. Most Americans couldn't tell the difference between Vietnamese, Japanese, Chinese, or Korean people, so rather than talk about our differences, we embraced our common experiences, and it was a way to proclaim that we were proud of who we were and all our shared experiences and histories. It was a way to turn what seemed like a negative stereotype into something much more powerful if we understood the power in numbers.

Back in those days, we talked extensively about whether or not there was an Asian American culture and what that looked like, and we always looked at the Black community and said, well, you know, they have jazz, do we have anything like that in our culture and our common experiences here in America that defines us? I don't think that question has ever been resolved. I know, for me, I think that everything changed after 9/11. I realized that America was not the center of the universe. We had chosen to define ourselves by our American experiences, but there was a whole world out there that we were not acknowledging as part of that experience. Back in the 1970s, the war in Vietnam and the relentless media coverage of all the atrocities were very impactful. The recognition of the national liberation struggles of other countries—including Vietnam, Cuba, Nicaragua, and Chile—were something to aspire to, and that's where many of us got our inspiration.

Let's use that to jump back into this idea that you always wanted to do people's art. You worked for Cityarts, which at the time was one of the really big, innovative mural programs in the country. Can you talk a little bit about Cityarts and your role doing murals and the lessons learned?

To be perfectly honest, the reason I was so excited about murals and this notion of what it means to make people's art was because I was looking at the world through a Marxist lens. I was very excited about the kinds of social experiments that I was seeing around the world and how people were coming together to build a people's culture. Seeing the posters, for example, from Cuba and the Organization of Solidarity of the Peoples of Africa, Asian, and Latin America (OSPAAAL), the murals coming out of Nicaragua, it looked so exciting.

There is a mural movement in the US that many people say has its roots in Chicago with Bill Walker and the Organization for Black American Culture, his mural *Wall of Respect*, and the Chicano mural movement in Los Angeles. We kept hearing about all these different public art projects and the first mural I think I ever worked on was a mural that I saw as I was walking down the street in Chinatown. There was someone on the scaffolding who called down to me, and I don't know how they recognized who I was, but they asked me to come up and they gave me a brush. That was actually the way that those projects were structured, to grab participants off the street, and I was just completely sold at that point. I thought it was a great idea.

Cityarts at that time had a slogan, which was "out of the gallery and into the streets." Taking art out of the gallery meant working with local artists and community residents to create art together, and not just transfer the designs of professional artists onto walls, but from beginning to end, from planning to design to painting, create works of art for—and with—the neighborhood. Back then, a neighborhood was a city block, and a neighborhood could change from block to block. If you were someone who lived in Chinatown, that was your neighborhood, you didn't go to Little Italy. The Lower East Side was a neighborhood that was different from a neighborhood in Brooklyn. It was so important then to live and work in the spaces that you made art in. The way we define community now is so much broader and there are so many communities of affinity; it's no longer your geographic community that defines you. Even so, one of the lessons that I've learned is that you have to spend time in a place to really build the kind of trust that you need to go out and make art with people.

With both poster making and with murals, we've seen in the last thirty years—not that it wasn't happening before too—a massive transformation in the way that we engage with shared space, public space; this idea of what one's neighborhood is has evolved and changed for a lot of people. Also, these cultural forms have rapidly been picked up by advertisers and become dominant ways that things are sold back to us at this point. Do you think that there's still a lot of potential in these forms or do we need to come up with new ways of engaging with communities and "placekeeping" (a term I've seen you use in the Chinatown Art Brigade)?

You know, I heard that you could get an MFA in Community Art now [laughs]. So yes, it's certainly institutionalized. Art is a business, and of course, all art eventually gets commodified. That's how they keep the art world going, so I feel like I'm deeply cynical about the ways in which some of our radical movements have been branded and began to serve other purposes. But I'm really very encouraged by technology, by the way that the Internet can reach so many people and impact so many people. At the same time, I do feel like we need to reimagine what public spaces in our cities and across the country can

look like. It's not surprising to me that during the pandemic and during the Black Lives Matter global protests, monuments became a target for so many people, as symbols of power that need to be replaced and removed.

I was fortunate to be a fellow at Monument Lab in Philadelphia during 2020, so the symbolism of monuments and the question of what will replace these memorials to white supremacy is something that we talked about as a cohort during that time. Just replacing statues of Confederate soldiers with other statues is really not the answer. I think we have to look at the way that history has been portrayed, how so many of our histories have been suppressed or forgotten, and think about these public spaces in a more expansive way as sites of learning. We should create memorials that aren't necessarily conceived of as permanent monumental works of art, or art at all, for that matter.

I feel like people everywhere are looking for ways to create new models for producing work, communicating, bringing people together through art and culture. Every time I turn around, somebody is doing something really interesting and exciting and that's very uplifting.

You've been at the forefront of some of this public work that doesn't tell a monumental story but is actually polyvocal and weaves back and forth in conversation with people in the place where the work exists. You've brought in the screen printing and done these larger works; can you talk a little bit about the process of that, what you're trying to accomplish, and the directions that you would like to continue to take the work?

Yeah, I so appreciate these questions about making things because I never get to talk about that. I only get asked about the subject matter or the content. It was really easy for me to make a transition from doing murals, which are large-scale works of art that actually have to be done collectively, because there's no way that one person can paint a whole mural unless you have tons of time, and the results are always very different.

The collective process of working and thinking collaboratively asks us to question who the work is for, how it gets made, who gets to take the credit for it, what is the power dynamic within a group, all of the things that happen in the course of doing something with other people. The transition from murals to making prints seems like going from a public to a personal space. And, in many ways, printmaking is a studio practice. It's certainly taught that way, but one of the things that drew me to printmaking was that it was democratic, that I could create multiples of an image and share them, I could give them away. I didn't see the preciousness of a one-off piece; I could take this image and I could show people how to make art that could be shared. Printmaking was always a public, or a social practice for me and there was reciprocity in it. I could work with somebody, and sometimes you know, in a shop, printmaking is a communal or collective space and in the course of working we could give

each other our work, or we could think about how we could share skills, or we could come together to create multiple stories.

I've participated in portfolio projects, which I love, where every artist that participates gets a set of the prints and then the rest of the portfolios get distributed to libraries. I've discovered that it's the process that has always engaged me; it's that point where you're always leading with a question and then somehow you come together with someone else to answer it.

There's so much oral history going on now too. One of the things I helped develop during the pandemic was an archive of oral histories and artifacts we called A/P/A Voices: A Covid-19 Public Memory Project. We were not just interested in documenting the impact of the pandemic but we wanted to know how Asian Pacific Americans were surviving the lock-down, their thoughts about the Black Lives Matter global protests, and how they were responding to anti-Asian violence. All of us have tried to sort out what happened and for some of us, it was a terrible, terrible few years. There were lots of people collecting stories of trauma, essentially, and so the idea of taking these stories and extracting some meaning from them is, really, an ethical question. What would the point of doing that be? And how can we archive this moment with as much respect and care as we can, in a non-extractive process?

That is another way of looking at process too. How can we change the ways that artists, for example, can work with people and build more care into things, so that moving forward we're actually building different models for making work. I don't know if I answered your question because I can't remember it [laughs].

[Laughs.] You answered a good chunk of it. Let's jump into questions—if anyone has any out there?

Audience: What is your process for turning these archives or historical resources that you have access to into your artwork?

Well, you know, I am a printmaker and I'll share this with you and tell me if it makes any sense at all. Very early on I got tired of doing editions. Professional printmaking is not painting, it's very processed, labor intensive, and craft based. There are no surprises; it's all pre-production and the goal is to make the same image over and over again, exactly as you had conceived it. So, I decided that first of all, I didn't think I was a very good printmaker. I didn't want to get hung up on the registration of the different colors or thinking about selling the work, which was not really that interesting to me. I just wanted to tell a story, so I decided to use silkscreen as a drawing tool. A lot of the public projects that I've done lately, which include banners and murals, have to do with taking the screen and moving it across the surface randomly so that the images overlap, because I wanted to be able to tell stories in a different way, not

in the way that you would read something from left to right, for example, but in the way that an archaeologist would find information by digging from front to back or from back to front.

I started collecting a lot of images and that's something that I do now, with every different community that I work with—whether it's historical imagery which tells me something about the actual place that I'm in, or images that are shared with me by people I speak to, or just photographs that I take of a location. I try to create narratives from these images that don't necessarily have a beginning, middle and end as a story, but just are interconnected.

I'm aiming to create some kind of vocabulary with these images that are a language that I can use. For instance, if I go to Chinatown and I'm asked to do a print about Chinatown, I might start with research—a lot of it is just talking to people, meeting people, going to places that people recommend I seek out, or if there is a cultural center, I go there. What's really important is partnering with an organization that's in the community that can help connect me to other people. I sort of build a set of images and a narrative that can emerge from that experience. Does that answer your question at all?

Audience: Did you and your cofounders create the Chinatown Art Brigade with one specific goal in mind and, if so, what was that goal, and if not, where do you see the collective going in the future?

Thanks for that question. The Brigade is an example of something that starts as a project and then over time becomes an organization, almost without our knowing it. We began when we were invited to do a mural with the Committee Against Anti-Asian Violence (CAAAV), a grassroots organization on the Lower East Side. They have a program called the Chinatown Tenants Union that fights for affordable housing in the area and they wanted us to do a mural with their tenants about gentrification. We actually didn't want to do a mural because I knew the bureaucracy of getting a space to do a mural in New York City was not worth the time and effort.

One of the members thought that doing a light projection would be a lot more fun and would also be a way that we could involve the tenants in creating messages that could be shared around the community. We partnered with The Illuminator,[3] who provided the projector and technical expertise and personnel, and we began to do light projections in Chinatown. It evolved and spanned several months, and we are now in the seventh year of different projects with the Chinatown Tenants Union, and we are still building the kind of trust we need between the tenants and ourselves to really get them to believe that arts and culture are one way that they can advance their campaign for housing rights.

Very early on we realized that as artists we were complicit in the displacement and gentrification that we saw in the neighborhood because there were already over one hundred galleries in Chinatown, each gallery displacing a

small business that might have served the community. I think because we were artists, and because we understood this as a situation we could talk to other artists about, we took that on as a focus. Displacement and gentrification are never stand-alone issues, and when you talk about displacement you're also talking about the environmental impact of displacement and the climate change that occurs, the health issues that come from terrible housing, the unemployment that is responsible for so many people losing their homes, and on and on.

It was something we could talk about concretely that really seemed to resonate with that area, because developers have been trying to make Chinatown the next arts district in New York. When the Whitney Museum moved to Chelsea in 2015, it displaced dozens of galleries and they all gravitated to Chinatown for the cheap real estate. At that time, it really did feel like an issue we could connect to larger forces transforming the neighborhood, it was not just the artists and galleries, it was the developers and the ways in which they were using art and culture to make places more attractive or desirable for people to invest in. This is what we were pushing back against.

We're just one of many Asian American collectives that are in formation now, which is really encouraging to see. We're trying to work in coalition with as many groups as possible. I personally don't think that organizations have to live forever. They serve a need and sometimes that moment is over and people move on. But we're still hanging on. We've been partnering with Decolonize This Place over a number of issues that hold cultural institutions in New York accountable and expose the way museums and their Boards have leveraged their power to art wash the bad money that supports them.

As one of the senior [laughs] members of the Brigade—I have to assure you that everybody else is a whole lot younger than me—I've come to realize that the question isn't about making political art, it's not about producing political posters or making murals, it's about what you decide to do as a citizen, as a person living in this world, to enact change. It's about artists becoming organizers and artists becoming agents of change. I don't necessarily think that art can change the world, but I think that we need people to imagine what the world could be, and artists are so good at that.

There is a role for artists in the movement, but you don't always have to think about it through what kind of art you make or do. You could be the most political person and do still life; frankly, I think that there's room for all kinds of art in the world. It's really how you see yourself in the world that makes the difference.

NOTES

1. Josh's conversation with Emory Douglas follows this conversation in this book, pages 57–77.

2. Saidiya Hartman, Wayward Lives, Beautiful Experiments: Intimate Histories of Social Upheaval (New York: W.W. Norton, 2019).

3. The Illuminator is a collective of artists and activists which formed during Occupy Wall Street in New York City in 2011. They provide a mobile, high-powered image projector system for use during political demonstrations and actions. See http://theilluminator.org/.

EMORY DOUGLAS

THE BLACK PANTHER PARTY FOR Self Defense is one of the most well-known of the militant organizations that emerged globally in the late 1960s. A large part of the reason for this is the art and design work Emory Douglas did for the Party as the Minister of Culture, producing hundreds of eye-catching illustrations for their newspaper, The Black Panther. These newspapers were scarce in the early 1990s when I was becoming politicized, so I was introduced to Emory's work via sloppily photocopied political pamphlets collecting key Panther texts, often with a cover illustration borrowed from Emory's vast body of work. These covers were not only black-and-white copies of images that originally contained color, but they were copies of copies of copies, with the contrast blown out and the images obscured by visual artifacts of the copying process. Even so, I was enamored by the work, and wondered who this "Emory" was that had signed all these images of Black revolutionaries toting rifles and wearing "Power to the People" buttons.

In the early 2000s I had the privilege of seeing Emory give a talk about his work while I was in San Francisco, and all the pieces fell together. Interference Archive holds almost one hundred different issues of The Black Panther, and I regularly dig through them, always finding new images and interesting visual intersections I hadn't caught before. Emory's ability to play with line and pattern, and layer images within images, messages within messages, have kept his work fresh fifty years on. It is still regularly being riffed off of, if not straight ripped off, which to me speaks to how much he was able to embed in it the spirt of a people in struggle. We got to talk about this and so much more on March 17, 2021, and I'm very proud to have Emory as part of this project.

WHAT IS A PIG?

"A low natured beast that has no regard for law, justice, or the rights of people; a creature that bites the hand that feeds it; a foul depraved traducer, usually found masquerading as the victim of an unprovoked attack."

Emory Douglas, <u>What Is A Pig?</u>, illustration, USA, 1967.

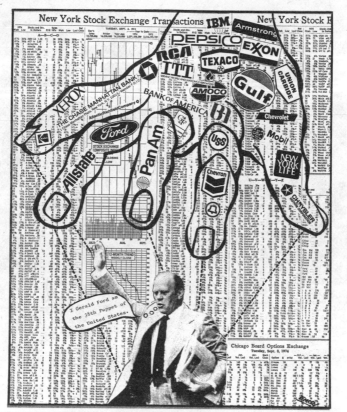

Emory Douglas, <u>38th President of the United States</u>, illustration and collage for <u>The Black Panther</u>, 1974.

←Emory Douglas: I know you suggested five images, so I just randomly picked five, two are historical references, three are retrospective works I've done recently. This one here was the starting point of the iconic image, called *The Pig*, that transcended the Black Panther Party (BPP), and became a national and international symbol defining those who were misusing their power against the people. It was defined as "a low natured beast that has no regard for law, justice, or the rights of people; a creature that bites the hand that feeds it; a foul depraved traducer, usually found masquerading as the victim of an unprovoked attack." It came out of the BPP and it started around point number seven [of the BPP's Ten-Point Program]: "We want an immediate end to police brutality and murder of Black people, other people of color, all oppressed people inside the United States."

↑Number two of the historical ones, this one is just showing that here we are, sixty years later, with the same corporate structure of control. It says, "I, Gerald Ford, am the 38th Puppet of the United States." We understand it, because of the mass destruction and wars and stuff going around for natural resources and minerals and people, through all the parts of the world.

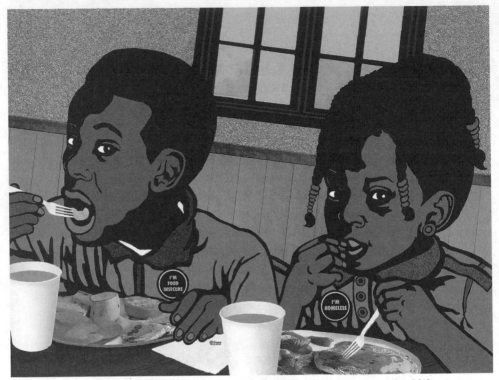

Emory Douglas, <u>ATTENTION!!! I'm Food Insecure, I'm Homeless</u>, digital illustration, USA, 2018.

↑ This is a local and more recent one I've done. The buttons say "I'm food insecure" and "I'm homeless," and we're talking about it in the context of COVID, we're talking about it in the context of global warming, phenomena that are calling for the increase of homelessness in this country and around the world.

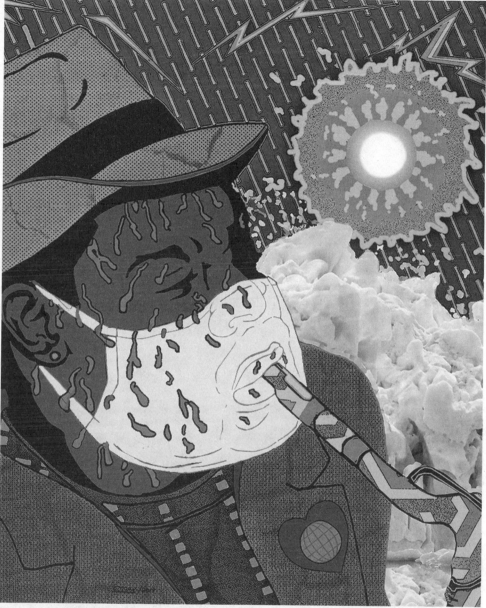

Emory Douglas, <u>SOS Global Warming!!!</u>, digital illustration, USA, 2020.

↑ Here's one I had done about global warming recently. I had done it without the mask and I felt I should put the mask on it as well. It's dealing with the issue of global warming, glaciers melting—you know, we're getting close to the doomsday clock point of no return, or what have you.

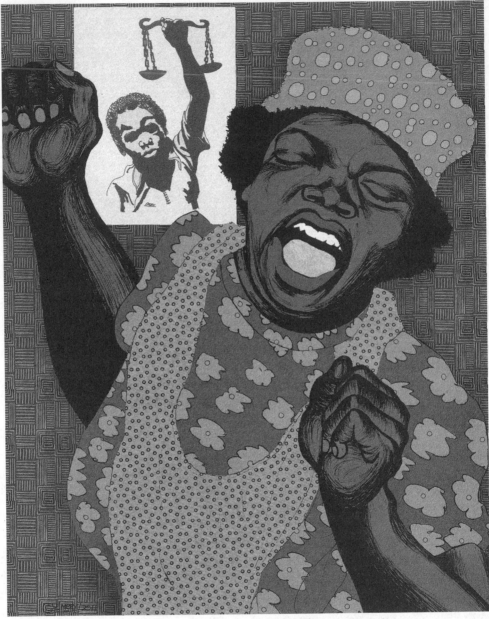

Emory Douglas, <u>FREEDOM / JUSTICE</u>, digital illustration, USA, 2019.

↑ This is the last one, talking about justice, in relationship to *justice*, period. This is in the context of police abuse and murders; you've got Panthers who have been incarcerated for over fifty or sixty years, while you have pedophiles who have gotten out in less than twenty or thirty years and what have you.

Josh MacPhee: These are great. I'm going to jump in and talk about the third image, the one about houselessness. You've talked in the past about how your work—particularly with The Black Panther paper—was reflecting the ideas that were in the community. There's a lot of young people, a lot of young artists, who really want to figure out how to move from self-expression to experimenting with some form of collective expression, to try to speak with and not just about, their larger community. Do you have any tips for how you did that when you were in the Party, and now today? What did it mean to be expressing the desires and the needs and the wants of the people?

Well, I mean it was a reflection of the guiding principles of the BPP, and that's the Ten-Point Platform and Program. We want power to our poor and oppressed communities who are dealing with quality-of-life issues like unemployment, inferior education, being exempt from military service, decent housing fit for the shelter of human beings. All those things were part of that Ten-Point Platform and Program, so the artwork reflected that in sometimes a very provocative way and other times in a less provocative way. It was meant to be either way, depending on how you felt about it.

Were you in regular conversation with rank-and-file Panthers and people in the community to try to get the vibe on the street, so to speak, and illustrate things that reflected peoples' experiences?

Well, you're growing up in that environment and coming into the BPP. That was already within myself because I grew up in that context. And I could contribute the graphic design skills I learned at [San Francisco] City College. When you start to do the work itself, you get feedback from the community on how they identify with the images. Particularly when they are caricature drawings or what have you, they could sometimes say they remind them of their uncle or father or brother or someone. Now they're becoming the heroes in your art, they're becoming performers and they see themselves on the stage, and if they like the styles and the artwork, it becomes something that they look forward to seeing each week and become informed and enlightened by it as well.

One of the things my partner Monica does is make comics, and part of why she likes making them is because she says that when you stylize figures, a lot of different people can see themselves in them. When I look at your work, each poster, in a way, looks like it's one panel from a larger story. Have you ever worked in comics? Were you influenced by them, by editorial cartoons? What's the history of the development of that style that's so strong, the black outline around the figures?

Well, the style itself, I used to like woodcuts, but they took so long to do! Therefore, I began to mimic that style, usually playing with shadows and highlights with markers and pens that get that woodcut feel and look to the artwork itself. So that's how the bold style came about. The newspaper had to be out on a weekly basis, therefore you had to really turn around the work. And it was not only doing the artwork but also doing the production, pre-press preparation of putting the paper together. It was also a part of the collective contract, it was a responsibility that took time, consumed time, so woodcuts would not have been an option.

Did you have a crew of people working with you, or were you the one who did most of the paste-up?[1]

Initially it was myself, and when they first recruited Eldridge Cleaver to become the Minister of Information for the newspaper we worked out of his studio apartment. We just had regular tables, markers, pens, we made up our own layout sheets, used regular light from the window and lamps. We had very minimal supplies, we had a portable operation, we could pick it up to take it from point A to point B. It evolved into a seven-day-a-week, twenty-four-hour, 365-days-a-year operation, when we would have to work in shifts—beyond just the production of the newspaper: doing community work, working with different health clinics, schools, we did publications and production work for all that as well.

I've always wondered—there's a lot written about the schools and educational projects of the Panthers, but was there any art education within the program? Were you teaching young people to do art, were you training people in layout?

I'll tell you a story. Early on, in 1967, we were invited to Cuba. Huey Newton wanted me to go to Cuba, but Bobby Seale lobbied against my going; he said, "Well, Emory can't go because we don't have nobody to work on the newspaper!" So, I wasn't able to go at that time. After the Party began to evolve and grow you had people who came in with different skills, and they were assigned to work in different areas. Some artists came in to work in production on the newspaper, and it was my responsibility to teach the Panthers who maybe had the artistic skills but didn't have the production or the pre-press skills to put things together. We called that "each one, teach one." It meant I taught them what I knew, which then meant I could travel when it was necessary. If something happened, at least everybody in your cadre had a basic understanding of how to put the publication together. Other artists did a considerable amount of graphic work, you know, even though I may have done say 85 percent of it, they still did a huge volume themselves.

As the party grew, and as the circulation of the paper grew, I've read that at its peak maybe it was like 300,000 being printed—

It was about 100,000 printed, and we had 400,000 readers.

That's a pretty big operation. What were the rest of the parties and chapters and their relationship to the art, were they free to cut it out and reuse it, put it on flyers?

That was a given, yeah absolutely. When you look at some of these documentaries that have been done, and you go to different chapters, you'll see the artwork sometimes in the back on the walls, or even in some of the fiction films because that's the way it was. Everywhere we had chapters and branches, you would always see the artwork as an intricate part of the area.

Was the thought that the community owned the work in a way?

You realized that what you were doing and how they responded to it was bigger than yourself. It was something that they looked forward to. When we first started on the paper, Huey and Bobby had a vision for it. I remember they were trying to recruit Eldridge Cleaver as the Minister of Information. They used to come to a place called The Black House where he lived upstairs, it was a Victorian house in San Francisco. A lot of cultural things were going on downstairs and he lived upstairs. I went in one Saturday, and there was nothing happening. Bobby was working on the first paper, which was a legal-sized sheet of paper done on a typewriter, and he had done the border with a marker. I told him how I could help him improve that because I still had materials from City College, and he said "okay," so I went home, came back, and he said, "well, we finished with that, but you seem to be committed, you've been hanging around and what have you. We are going to start the paper and I want you to, first, be a revolutionary artist, and then you'll become the Minister of Culture. The paper will be to tell our story from our perspective." We wanted to have a lot of photographs because part of the community wasn't a reading community but learned through observation and participation. So, if they saw the photographs and the headlines and the captions of the art, they would get the gist of the story. They wanted to have artwork in the paper, a lot of photographs, so they had this whole vision.

When I began to work on this first tabloid issue, I began to apply the design training I had at City College. You try to get the feel of the design elements on the front, middle, and on the back. The pig drawings ran throughout, but by about the third or fourth paper, I began to do caricature drawings of people in the community on the back of the cover. Those images became a staple in the paper as well.

We have a pretty good collection of the papers at Interference Archive in Brooklyn and I've sort of scoured them, looking for things that you've written about art, and in one of the papers, there was a talk that you gave that was reprinted. You said something that to me was really interesting and impactful. You said, "the People are the backbone to the Artist and not the Artist to the People."[2] Particularly when you go to an art school or in the context of the art world, artists see themselves as the sort of hero or the struggle, and it's really nice to see that quote in which you very succinctly flip the script. Can you talk a little bit about what that means to you?

It means the art came out of a movement and was inspired by the desires and needs of the community. So, in that context, the people are the backbone because you're listening, you're observing, you're feeling what they're feeling, and you're interpreting those feelings through the art that you do. If you're not in contact and connected with that, then you're totally divorced.

I remember when I did a thing at the New Museum of Contemporary Art in New York, I had a dinner one evening and one of the Panthers from a Harlem branch was there. He would say how some people in the community bought a paper because they wanted to see the artwork each week. So, what he starts doing is turning the paper over and he would sell the paper by showing the artwork. The back connected people to the vision.

That echoes the experience of so many revolutionary contexts. That's what the Soviets did during the revolution in Russia, they made these giant, illustrated posters to talk about what was going on; it's what happened in Nicaragua, with the Sandinistas, with stenciling and big murals communicating with the education program, which is exactly what the Panthers were doing.

We used to get a lot of the posters from Cuba; they used to send us a lot of the posters they were doing in the mail. They had remixed four or five of my images, interpreting them into some amazing posters.

Yeah, those are beautiful. I noticed in your book there's also an image you made that's a remix of a Chinese Cultural Revolution poster, but the figures are drawn in your style.

Yeah yeah yeah.

So you were looking at that stuff?

Oh, absolutely, it was coming through the mail! We would see it all the time because political posters were being exchanged from those parts of the world.

There might not be a real answer to this, but it's something I've always wanted to ask. As the Minister of Culture, you were doing all the graphic arts, but there's all the other aspects of culture, right—there's music and theater and poetry. Were the Panthers moving towards having a broader cultural program in which there would be a music wing and there'd be a theater group and—

We had all that, but it was evolving as we grew and developed. We had a singing group with Elaine Brown, she had a record out.

You did the cover![3]

Yes, and then we had the Lumpen,[4] which was a singing group who also performed. We had Aminata Moseka—Abbey Lincoln—who came and did things at the school with the kids for a couple of weeks.

Oh wow, I didn't know she worked with you.

Oh yeah, Oscar Brown Jr. came out and stayed for a couple weeks, you had John Lee Hooker, you had Sheila E. We had all these interconnections. Santana, before he was famous, had come and did things with us. Maya Angelou used to come and talk with the kids at school. So, there were all these cultural links. Many of the jazz musicians back east, like Archie Shepp, used to do programs and performances in solidarity with the Party back in the day.

Were you looking to organize that at all, or just letting it evolve as it grew?

It was organized in the sense that you're there with people who say, we met so-and-so, and we're gonna talk to them and see if they'll do a fundraiser for us. They would agree to do it, then we set the time and what have you. Those kinds of things we did. I remember when Tower of Power, and also the Grateful Dead, did programs for us. That was because we asked them to contribute. And they were very happy to do so.

You've talked about commercial art being a great enemy of the people, for example the amount of advertising that gets thrown at the Black community and—

Like that Gerald Ford image I showed. [Laughs.] Yeah.

It's interesting because a lot of people—I'm not asking this because I'm trying to trip you up, I'm interested in what you think about this—a lot of people quote Audre Lorde, "the master's tools will never dismantle the master's house."[5] It seems like you were well on your way in an attempt to dismantle

the master's house with the tools of branding and advertising. What do you think about that tension?

If you use it to educate and enlighten and to inform, it's one thing. It's another thing if you do it to duplicate what the master's doing.

So, it's like turning it into a different tool.

Yes, in a way. Showing how you can use that framework and structure for something constructive, something enlightening, something informing and educating. That's the same thing with the music with the Lumpen, who were singing revolutionary songs. They took regular, standard rhythm and blues or rock and roll but they added revolutionary content to the music, because that was the mainstream culture that the masses identified with.

In your work, you took Zip-A-Tone patterns, and you took all these things from commercial art, and you used them to create depth of field and texture within your images. . . . One thing I've always been struck by is the layering of the messages in your work. You have a central figure in the front and that's where your eye first goes to but then you realize that they have a button on, and there's another message on that; and then behind them there's someone that's holding a sign and then behind that there's a building that has another sign on it. There's three, four, five layers of messaging. How did that evolve, because it's genius, but it's very rarely done and certainly very rarely done well.

It's again observing, feeling it integrate into the work you do. Comrade Panthers wearing buttons, community members wearing buttons—we can integrate them into the artwork. Again, that's putting them on the stage, empowering them by seeing themselves in the attire as revolutionary, conscious actors and performers. It just came out of instinct and observation, feeling that it was something relevant to do, yeah.

I wasn't born yet for a lot of that [laughs], but just looking at it, it rings true. It rings like it's representing what people were feeling.

I used to read a lot of books from the civil rights movement, picking up different slogans, and then we had our own slogans, we had people talking all the time—you began to maybe plagiarize a little bit. After a while I began to get a feel from the artwork of what language I wanted it to speak. I became more creative in the text I added to the image itself, to reflect that image in a more meaningful, in-depth way.

And the Zip-A-Tones, that was a material that gave more depth instead of just having black-and-white ink drawings. They were using it in cartoons and animations—cartoons particularly—and I wanted to apply it. We couldn't afford the time to do the stippling and shading with markers and pens so applying those different patterns to the material gave more depth to the artwork as well. Plus, we only had black plus one color we could afford each week! Using those textures, using spot ink, and moving the tones of the ink gave a feeling of full color.

Yeah the art of duotone, it's been lost. There's this quote—that you said in your essay on revolutionary art—that I really love: "To conceive any type of visual interpretations of the struggle, the Revolutionary Artist must constantly be agitating the people, but before one agitates the people, as the struggle progresses, one must make strong roots among the masses of the people. Then and only then can a Revolutionary Artist renew the visual interpretation of Revolutionary Art indefinitely until liberation."[6] So basically artists have to renew the visual interpretation of revolutionary art until liberation. Artists have to continually be reinventing what revolutionary art is until we're free, that's how I interpreted it.

Absolutely, it has to be relevant in the context of the time, of the moment.

How does that affect you now, what do you think about when you ask yourself how you're going to make revolutionary art for 2021?

I went to a thing at UCLA a couple years back and I did a presentation; there was a lady in there who knew my work from the 1960s, and she'd seen the more recent stuff I'd been doing, and she said, "you're doing the same thing, just in a different way!' Well, that's being able to interpret how I should be doing it now based on how people's point of view, context, and all those things come into play. What I did fifty years ago may be okay for an image here, an image there, but it's not going to work the same today. The whole dynamic is different, more compounding than it was in many ways, more special interests now than then. So, you got a whole lot of new dynamics you got to include into the context of the art that you do.

I remember when I was in New Zealand, and I was traveling on a train and kept seeing all this amazing graffiti art. I had seen the same thing in Portugal, it was powerful, big. I'd look at it, but I couldn't decode it. But I was looking at it! That inspired me to interpret brighter colors in the artwork I do now, because I see how powerful those colors are. You can do it on the computer and get rich colors just from your printer. Whereas before you couldn't do that, you had to go through the whole process, it cost you a fortune, you had to know how to do the color separations.

So, you had the privilege—and the power—when you were a young artist to get involved in the Panthers, and have what you were doing become part and parcel of a broad revolutionary program that was highly organized. What would your advice he to young artists for whom such organizations aren't as available? I think people have a hard time knowing what to get involved in, or how to get involved, because there isn't that same kind of party structure, there aren't the same kind of organizations that there were fifty years ago.

You can certainly learn from the past, but you can't duplicate the past. You can be inspired by it and be in spirit with it, but you have to do it in the context of now. So, in that mindset, make sure you stay in the moment. You can be inspired, but you also have to have a basic knowledge of what's going on in the world if you want to be able to interpret those things in your artwork. Because, you know, you may be challenged on it, and if you just do it for the fun of it, and for the blind emotion—which you can do for a limited period of time—if you're not informed how are you going to express what you've done, how are you going to stand up, if it's provocative?

I always say my work means something provocative. Not a distorted interpretation, but a provocative interpretation, you see. That means that people sometimes take it out of context, so if they challenge you on that you gotta be able to respond in an informing, enlightening, and educating way. That's very important. And if you want to do it, don't just do it for the fun of it, know that this is not a fun thing, it may be fun while you're doing it, but don't do it for the sake of the fun. Don't do it now and just forget about it, you want to make a commitment. Of course, I understand some young artists go to school because they want to get a job and make a living. But they still can make contributions.

You got a lot who are committed and want to be committed, but they have to figure out how to do it in a collective way. We came out of a collective, I always explain that. The whole dynamics of what I did came out of a collective. We came to the point where we lived together in collectives. We had political education classes in the collectives, we had responsibilities in those collectives. So our whole thing was social justice and politics, not just internally but working with external community organizations as well. All that is part of mental growth: critiquing, evaluating oneself and what you're doing. All those things play into how we move forward as a collective.

That dynamic may not be available to a lot of young people today. So, they have to look and figure out what group they want to contribute to with the work that they do. And the thing is, then people might be critical of it! "What's this?" "What's this stand for?" What you think is great may not be visually great to those who see it. So, you have to be ready to make adjustments to the work that you do. To make it clear, those kinds of things. You might think you're doing a great thing—took you hours, days, and what have

you—but it don't come across, so you have to go back and be willing to rework it, redo it.

Once the BPP had seen I understood the politics, though, I was given the green light to create whatever I chose to. So, it was only about a handful of times that I was asked to do something specifically, graphic-wise. Other than that, I had the green light to create however I chose to, whatever it was.

Were there times when other members of the Party said, "can you change this?" Was there a feedback loop?

It was carte blanche—there have been times when somebody's asked me, "well, what does this stand for?" It's just that then for me, hearing that, I said, "okay, I gotta figure out how to make it clearer next time."

And there was stuff that just didn't come off, period. All the way from back in the production layout process, not visualizing what it's gonna look like when we're finally printing. So the quality of it may not have been there as well. So, everything wasn't peaches and cream. But we got to that point, being more consistent than not.

I really want to underline what you've just been talking about, because our culture presents self-expression as the core idea of art and culture. I think you're articulating an alternate idea of collaborative expression, or collective expression, and saying that if we really want to change things, maybe that's a more powerful tool.

It can be a self-expression in the context of a collective expression. Not separate from.

Right, they have to be in conversation.

It was not a "me are," but "we are."

I want to ask one more question and then we'll go to the Q and A because it looks like a bunch of people have put questions up. I'm asking variations of this with everyone that I'm talking to because a theme in this series is my claim that within political communities and culture, graphics become almost like a language or an alphabet in that people use and reuse pieces and parts—like when someone picks up a Posada image from the Mexican Revolution and reuses it in a new context, or repurposes elements of a Cultural Revolution poster from China.

When you were making your work and you were putting it in a paper that had 100,000 copies getting out in the world, it was a moment that felt revolutionary. People were cutting stuff up and reusing it and repurposing

it. We're now in a very different time. You were making work to be used by
your community and now, especially with the Internet, all art is out there for
anyone to grab. How do you balance this tension between making work that's
supposedly for everyone, when maybe there's actually some people you don't
want using it, maybe you don't want Nike to put it on a t-shirt? How do you
navigate that?

You have to work through organizations that can assist you with those kinds
of issues, because they do come up. Fact is, everything is on electronic media.
I share my work over electronic media for people to look at. Not necessarily
for them to take it and run with it, but to share and see what's being done. You
have to have ownership today in some kind of way. I mean ownership in the
context of it being exploited and abused by something that you don't want
to be exploited or abused by. So that means you have to work with organiza-
tions that can make sure you have legal representation. You have to have legal
representation, sometimes. If you can't, then that's another context—a lot of
folks can't afford that. Don't get frustrated then go confront some legal advi-
sor that wants tons of money to even deal with it. You have to work through
organizations that will represent you fairly. That is the reality that exists.
And with this new thing they have now, the NFTs or whatever it is, they can
electronically copy your work and make thousands and millions of dollars off
of it and it's virtual work.

What about a small mutual aid group in Bed-Stuy that puts an image of yours
on a t-shirt to try to raise money to get food to folks, how do you feel about
that?

Well, if they consult me, I work with that. I work with all that, all the time,
community-based things. But I let them know they can't just come in, that's
just like me coming into your house and taking your furniture and not asking.
If you call yourself progressive, then you have to be mindful. That's one of
the things we always talked about from Mao's *Red Book*, which says, "do not
take a single needle or piece of thread from the masses. . . . Return everything
you borrow."[7] Those are principles that you have to be guided by if you call
yourself a genuine revolutionary working for the interest of people. I mean, of
course, this is a learned behavior from life's journey that we have to overcome
going forward. If you ask, I'll say, "Why're you asking?"

Audience: Can you describe your collaborative work with the Panthers in
a little more detail? You said that once they were confident in your politics,
they let you make the images you wanted to make, but I'm just wondering if
there was more back and forth, or what that collaboration was actually like?

Always back and forth, because you're in a collective. When working on the paper, I'm doing the production aspect, Eldridge is there, he's doing the reporting and writing. Before we even had a stationary location, when we were working out of Eldridge Cleaver's studio apartment, Huey Newton and Bobby Seale would be coming over, and they would always be talking politics! About what was going on and what they did that day, when they had a confrontation with the police out in the neighborhood or what have you. Or talking about the possibilities of some axis in conjunction with other organizations.

In that context, you grow as you're listening, hanging out, going around the neighborhoods, and our political education classes. Everything was interconnected and the artwork was a reflection of that interconnection. You get the response back from the party members, how they identify with the work as well, and that reinforces that what you were doing was relevant.

Audience: Did you have any mentors who inspired you at school or in life that helped you form this powerful basis to create your images?

Well, it came out of the upbringing, growing up in situations that inform you, that you become more aware of as you become involved in social politics in the movement. I think it was just life's journey, in one sense, and being able to get into an organization that was relevant in the context of the times and connecting with other organizations, having solidarity. All that played into it. For example, we had Panthers who were part of the antiwar movement, who supported draft resisters, who went to Scandinavia. Bobby Seale spoke at that forum in Canada about the war in Vietnam;[8] we had Panthers who went to North Korea, to Vietnam, to Cuba, to show our solidarity, all those kinds of things. That was reflected in the international section of the newspaper on a weekly basis as well. We were also informing and enlightening the community who—maybe not because they identified with us or what we're about—but who began to just read or look at the paper and get a whole 'nother perspective than they were getting from the mainstream paper.

Audience: What about the technology, or the lack of it, when you first started the newspaper and how that might have affected the style. You spoke a little bit about the time pressure to create work but was there any direct influence on the sort of visual style that you developed?

The visuals, as I mentioned, were the woodcuts. I liked woodcuts then. But it took so long to do woodcuts, so I began to mimic them and began to use prefabricated materials from Format. We used Letraset from time to time, Zip-A-Tone, a couple more brands, whatever was the cheapest. You'd get a whole sheet for one-dollar-fifty or one dollar, other ones may cost you two-fifty or three-fifty. But Format was even better, because it had adhesive backing, you

could cut it out and place it and save the rest of it. Sometimes the others might scratch up because they were so delicate.

So playing with that was also a part of the visual expression in the artwork. Use them how you felt they could be used. When you buy one of those books most of the time they show the elements as bricks on the wall, or borders for certificates, not as textures for clothing, not as textures for skin, you see? So, when you break the mold and use them how you choose, you come up with a whole new visual expression.

Audience: Do you think the pig is still a convincing symbol for posters in the twenty-first century, as an object or symbol for the current state of racial politics in this country?

It can be—depends on how you interpret it and how people respond to it. I went to the border for a week with Favianna Rodriguez, and some artists called CultureStrike, and we visited both sides of the border and what have you—this was about four, five years ago. And I came back and did images using the pig in that context.

Josh MacPhee: At the time you were using the image of the pig, students in Mexico City who were rising up used the gorilla to represent the cops! It's different animals in different contexts.

I know, yeah. Somebody early on came by and showed us a book, I think from the 1800s, that used the pig drawing.

Audience: I noticed a lot of the underground press of the 1960s and '70s were borrowing your artwork and aesthetic. Denise Oliver and the Young Lords, the Malcolm X United Liberation Front, Seize the Time, or Rising Up Angry.[9] How did you manage those visual shares?

Some of them had their own visual style which they incorporated my art or style into, you see what I'm saying? They had their own way. Maybe they were inspired by what we were doing and they began to develop their own from that. But then it wasn't a problem, because we were comrades, we were working collectively. We knew what it was going to be for, so it was no problem.

DeWitt Godfrey: I was reading some material earlier about your interest in and affiliation with the Black Arts Movement and we have a related question here: can you say anything about the relationship of your work to the work of Charles White? You've mentioned him in the past as an artist you were aware of through his calendars. Was there any direct influence from his work on the way you depicted Black people?

Well, I guess trying to make them look Black, in the images! As far as the style, no. I remember my auntie had the calendars when I was a kid and I used to stay at her house quite a bit, I was about nine or ten. Each year she would get this calendar with this Black art on it from this insurance company. And I was awed by the artwork. It was only later on that I became aware, through historical context, who Charles White was in the Black Arts movement.

Audience: How does the collectivism of the Black Panther Party influence your solo work today, even after the disbanding of the Panthers in the 1980s?

I'll be seventy-eight in a couple of months, so I don't do mural paintings anymore—I don't want to get up on that scaffolding, you know what I mean! But I have been traveling. I did work with aboriginal artists in Australia, four or five times with Richard Bell; been to New Zealand four or five times, did some collaborative work there; Portugal; various places.

I show something to some friends and say, what do you think about this? Just to see what they say. Get their feel or response from it. And when I do prints I observe what they like, what they don't like, what they think about it, what they have to say about it. I'm always aware and conscious of the feedback cause I'm also always trying to see how I can make sure the message is clear. I think Amilcar Cabral, the revolutionary from Guinea-Bissau, had once said you have to be able to speak in such a way that even a child can understand. I began to contemplate how you can make art in a way a child can understand, at least get some meaning from it. And I speak to third graders! I had a third-grade group two or three days ago. They're much sharper now than we were. [Laughs.]

Josh MacPhee: My five-year-old is one of my greatest critics.

DeWitt Godfrey: The sense of being open to the opinions of others, seeking that out . . . even printmaking itself is a very collaborative discipline, right? When you're working at a press, you're surrounded by many people helping you execute the work. So, I can see that connection very clearly, thank you.

Thomas: I read that you had a large picture library essential to the making of your works. How did you build up this photographic archive? Were you using the services of Liberation News Service[10] to obtain photos and how did you negotiate copyright?

Several photographers were around. Pirkle Jones, the well-known photographer, his family used to take pictures; any pictures they took we had access to and right to use in the paper. Stephen Shames, same thing, he was around

back then.[11] There was a photographer from LA—I can't think of his name—he took a lot of pictures. We had local photographers like that, and then we also built up our own photography department and had our own photographers. So, we had that all to pull from.

Josh MacPhee: So, you had a relationship with those photographers—they were like, "you can use whatever you want . . ."

Anybody could take pictures. They would be their pictures, but they had to give us the right to use them in the context of our newspaper, PR, politics, whatever.

DeWitt Godfrey: It's another form of the research you mentioned earlier, what's required to understand and contribute to an issue.

Audience: Considering white ignorance, complicity, and bystanderism, especially on social media, how can I as an artist address and represent injustice while emphasizing solidarity? It's kind of a big question.

Well, the question is you have to begin to visualize it in your artwork. You can have discussions about it with folks but you're going to have to apply it, as a visual artist, to see how your interpretation and relationship comes out visually! You can have the greatest theory and thoughts in the world—until you begin to put it on paper and work through the process!

DeWitt Godfrey: My students always ask me if things are gonna work and I say: until we see it, I don't know.

Once you've said it you can critique it! And take it to another level, another scope. From the shallows to the deep end.

NOTES

1. A paste-up is a method of laying out a publication by hand, physically cutting and pasting elements from the typesetter to determine their layout on the page.
2. Emory Douglas, "Position Paper No. 1: On Revolutionary Art" in The Black Panther, January 24th, 1970.
3. Elaine Brown, the only female "Chairman" of the BPP, released two albums, Seize the Time (Vault Records, 1969) which Douglas designed the cover for, and the self-titled Elaine Brown (Black Forum, 1973).
4. The Lumpen was the "house band" of the Oakland branch of the BPP. They released one 7-inch single in 1970 on the short-lived BPP record label, Seize the Time. For the story of the Lumpen, see Rickey Vincent, Party Music: The Inside Story of the Black Panthers' Band and How Black Power Transformed Soul Music (Chicago: Lawrence Hill Books, 2013).
5. Audre Lorde, "The Master's Tools Will Never Dismantle the Master's House," in Sister Outsider, ed. Nancy K. Bereano (Berkeley: The Crossing Press, 1984), 110–113.
6. Emory Douglas, "Position Paper No. 1: On Revolutionary Art" in The Black Panther, January 24th, 1970.
7. In Chapter 26 ("Discipline"), Mao states: "The Three Main Rules of Discipline are as follows: (1) Obey orders in all your actions; (2) Do not take a single needle piece of thread from the masses; (3) Turn in

everything captured." Mao Zedong, <u>Quotations from Chairman Mao Tse-Tung</u> (colloquially called his <u>Red Book</u>), see https://www.marxists.org/reference/archive/mao/works/red-book/.

8. The "Hemispheric Conference to End the Vietnam War" was held November 29–December 2, 1968 in Montreal, Canada.

9. The Young Lords Party were a Puerto Rican parallel to the BPP, their newspaper was titled <u>¡Palente!</u>, and Denise Oliver (who had also been a member of the BPP) worked as an editor, writer, and artist for the paper. The Malcolm X United Liberation Front was a Tallahassee, FL-based splinter from the BPP, which produced a publication under the title <u>The Front</u>. <u>Seize the Time</u> was a newspaper produced by the Seize the Time organization, which grew out of the early 1970s split in the BPP. Seize the Time supported the Black Liberation Army and the portion of the BPP that went underground. <u>Rising Up Angry</u> was the newspaper of a Chicago-based group of the same name. Largely rooted in the white working class, the group and paper were modeled on the Black Panthers, mixing organized politics with counterculture.

10. Liberation News Service (LNS) was a press service for underground newspapers. Similar to how newswires like Reuters or Associated Press work, subscribers to LNS would receive a packet of printed articles, artwork, and photographs regularly (weekly at its peak). These would then be integrated into newspapers and other publications.

11. Both Pirkle Jones and Stephen Shames were photographers who were sympathetic to the BPP. Jones and his wife Ruth-Marion Baruch's photos of the group were published in <u>Black Panthers 1968</u> (Greybull Press, 2002). Shames' photos of the BPP have been collected in multiple volumes, including <u>Comrade Sisters: Women of the Black Panther Party</u> (ACC Art Books, 2022, co-authored with former BPP leader Ericka Huggins), <u>Power to the People: The World of the Black Panthers</u> (Abrams, 2016, co-authored with former BPP leader Bobby Seale), and <u>The Black Panthers</u> (Aperture, 2006).

DANIEL DRENNAN ELAWAR/JAMAA AL-YAD

I'VE BEEN RACKING MY BRAIN, but I can't recall exactly when Daniel Drennan ElAwar and I first met. I do know our friendship solidified when I got to travel to Beirut in 2015, and Daniel and I spent hours walking the city, talking about politics and culture, and sharing with me his personal history. Born in Lebanon, but raised in New Jersey via adoption, Daniel worked for years in publishing in New York City until he could no longer handle the fickle nature of the industry, nor fight the pull of returning to Lebanon and trying to make sense of the initial ruptures that had structured his life. Teaching at the American University of Beirut, his growing political engagements, no-nonsense appreciation for the design styles and calligraphy indigenous to Lebanon, and his support for Palestine endeared him to his students while making him persona non grata to the administration.

I find Daniel's commitments ever impressive. From his willingness to build a community and the Jamaa Al-Yad project with his students to his dogged research into his personal past, and his diving into the work of Palestinian solidarity in the refugee camps on the edge of the city, he undertook it all in a place he was both from but also an outsider. He has since left Beirut, temporarily settling in Vancouver to teach illustration, and always looking for places where his skills and desires are not only valued but can be a contribution to building something new. I have always appreciated his directness, candor, and empathy, and all of these are on display in this discussion we held on September 29, 2021. While all these conversations were influenced by the COVID-19 pandemic, this one was also held in the shadow of the August 4th, 2020 port explosion in Beirut where over 200 people were killed, over 7,000 injured, and upwards of a half a million had their homes destroyed or otherwise had their lives uprooted.

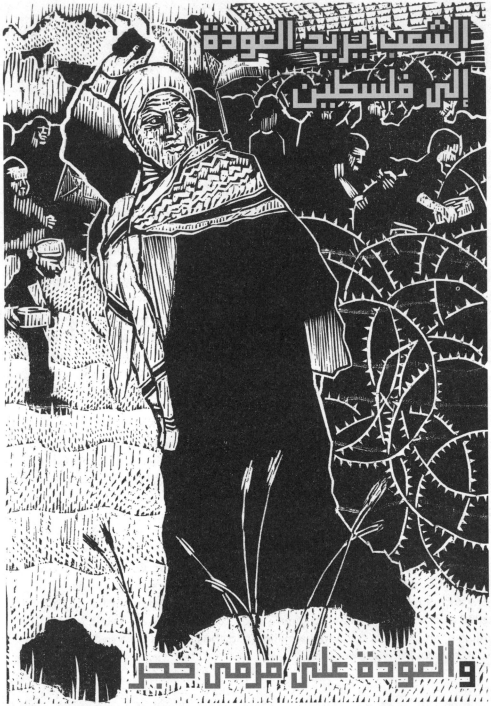

Jamaa Al-Yad, <u>Return is But a Stone's Throw Away</u>, woodblock print, Greater Syria, 2011. Poster memorializing the martyrs from the March of Return to Palestine.

←Daniel Drennan ElAwar: Well first thank you for having me and thanks to Colgate University. I'm coming to you from what we know now as Vancouver, the occupied lands of the Coast Salish peoples and their resistance here is, every day, an inspiration to me.

This poster is in response to the Day of Return in 2011, where all of the nation-states, as we know them today, surrounding Palestine, organized marches to the border in order to protest for return and liberation of the land. There were seventy thousand Palestinians and their supporters from the refugee camps in Lebanon, who went down to the border by bus. There was a series of posters developed for that.

The day started out quite, I want to say joyous, almost euphoric. People who had possibly never left their camps now being within visual distance of their homeland was quite phenomenal. The only issue was that it was a little bit too much. A lot of people, but especially the young people, started making their way down to the border fence. At a certain point we noticed that there was a smoke screen going up on the other side and it quickly became clear that snipers were coming into position. Twelve young men lost their lives, killed while protesting on the Lebanese side of the border.

The march obviously needed to end at that point and we made our way back to Beirut. But as a follow up we produced this poster, rather quickly. It was carved into a curved piece of butcher block that I happened to have that was not useful anymore in the kitchen, and it was based on a photo of a woman who was taking the symbolic action of throwing a stone across the border. What you see in the background are young men literally moving tank mines and barbed wire, in order to get close to the border. And the poster reads, in Arabic, "The people demand their return to Palestine" and "Return is but a stone's throw away."

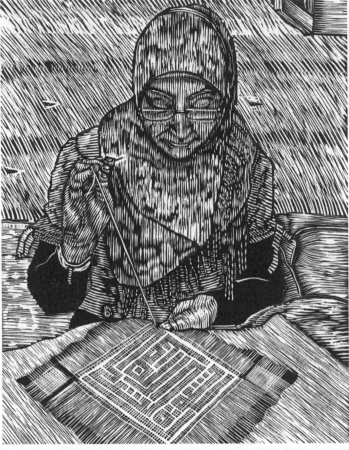

Jamaa Al-Yad, <u>Revolution Until Victory</u>, woodblock print, Greater Syria, 2019. Commissioned by l'Institut du Monde Arabe, Poster showing collaboration with Greater Syrian embroiderers working on themes of revolution.

↑ This is a quite recent project we did. We were asked by L'institut du Monde Arabe [The Institute of the Arab World] in Paris to contribute something to a book they were working on with the rather annoying title of *Does the Arab World Still Exist?* We wanted to respond quite definitively that yes, the reality today goes on, no matter how it's mediated in the upper levels, or in other nation states. We were working with some embroiderers from Greater Syria, so women from Syria located in Lebanon, Palestinians also located in Lebanon, as well as Lebanese embroiderers.[1] And it was a collaborative project in which we took the square-kufic Arabic for "Revolution Until Victory" and we asked them to embellish it with their own designs. It was supposed to turn into a long-term collaboration but also help them with their cottage industry, if you will, and getting word out about their work and turning it into a small productive force. But COVID interrupted and that needed to end. This is the image that we worked on, one of the women working in her house.

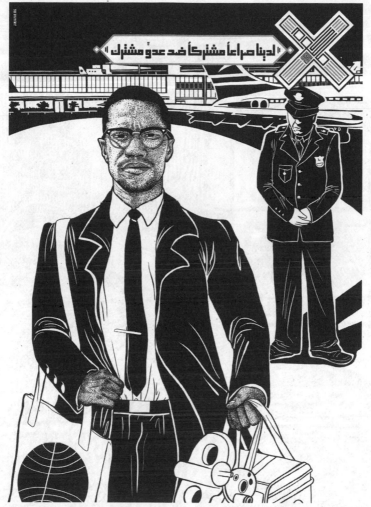

Jamaa Al-Yad, <u>We have a fight that is common to all of us against an enemy that is common to all of us</u>, pen and ink/digital, Greater Syria, 2015. Poster produced for the theater play <u>Malcolm X Returns</u>.

↑ This is from a series of posters that we did in 2015. My colleague and dear friend Tariq Mehmood in Beirut was writing a play about the return of Malcolm X to the region after he had been there decades earlier, but also commemorating the anniversary of his assassination. We did a series of posters, a lot of research, we designed a logo, we took some of his statements and quotations, translating them into Arabic. There was a theater play as well as a lecture. So, a whole series of events, including interviewing the woman who was responsible for getting him onto the campus of the American University in Beirut, where he was initially banned from speaking. The five posters that were produced give an overview of him during this journey and give us different aspects of his life as a form of commemoration.

Jamaa Al-Yad, <u>The Resilient Original</u>, woodblock print, Greater Syria, 2015. Poster in support of the last remaining kufiyyeh factory in Al-Khalil, Palestine.

←This was a collaboration, working with the lone-existing kufiyyeh facto-
ry in Al-Khalil, Palestine. Much of the production of kufiyyehs as we know
them is now done overseas, not in Palestine. The premise for the project was
twofold. We were asked by an organization in Norway, a Lebanese woman
actually, a friend of the collective, who wanted to make sure that people there
were aware of the difference between an original kufiyyeh and a counterfeit,
for lack of a better term. She was also making sure it is clear that if something
is labeled as being manufactured in Israel, in fact it very well might have been
made in the occupied West Bank or Gaza, that it is produced by Palestinian
labor. The project was going to target Beiruti storefronts and shops, where
fake kufiyyeh are sold to tourists and that kind of thing. The project involved
calligraphy, the woodcut that you see, photography, one of our members video
documenting and interviewing the owner of the factory and members of the
Hirbawi family, who are still working this factory—a lot of back and forth. We
produced this poster in four languages. It is still possible to buy these original
kufiyyehs and the factory is going strong.

Josh MacPhee: We jumped right in, so maybe we should take one step back
because my guess is that the majority of people who are watching don't speak
Arabic. So maybe you could tell us what Jamaa Al-Yad means and where the
name comes from.

Sure. So maybe taking a *further* step back: I was born in Lebanon, from the
age of five I grew up in New Jersey in the States, Lenni-Lenape and Delaware
territories. In 2004, I had a desire to go back, and I taught at the American
University in Beirut, and at the same time started researching the history
and trajectory of artists' collectives and cooperatives in the Global South—
what brought them together, what kept them together, but also what un-
did them. The idea was, through the research, to reestablish links to what
was to me a quite valid culture, but which in a colonial institution like the
American University gets set aside for the idea that we need to appeal to the
West somehow.

In 2007, we started working on forming a collective. We went to some
lawyers, because it had to be officially done and registered with the govern-
ment. We were presented with templates for bylaws and charters that were in
French, if I remember correctly. Obviously, NGOs predominate in the coun-
try, and so the legal aspect of things focused on an NGO model, so it included
everything we didn't want to include—50 percent plus one voting, quorum,
non-consensus-based way of working, election of officers, all of these things.
When I said I don't want this, we are nonhierarchical, we are open, we want
to work based on a consensus model, we were informed that we would have
to write our own bylaws and charter. That was a process that took about two
years. Our approval came through in record time—normally that can take a

year or two, but we were approved in a couple of months, I think because of our focus on local culture.

So, *Jamaa Al-Yad*: '*Jamaa*' comes from a root which gives us words that mean university or congregation, it's a reference to congregating for prayer, for example; or assembly, coming together, literally. And '*Yad*' means hand, so "Jamaa Al-Yad" means "hand coming together." So denotatively, it means "clenched fist," but it resonates with so much that exemplifies us in terms of hand-based craft, as well as kind of coming together to produce these works.

Such a beautiful way of articulating the idea of the clenched fist as a gathering of the hand.

It's funny in a way, because you know, Arabic resonates linguistically in ways that are harder to feel in English. When I explain it in English it's like I've taken the clockworks apart and it doesn't mean anything anymore, but you get the idea of it.

So, you are in Vancouver now, and I know a number of other members are in North America; the group has become diasporic in a lot of ways. But simultaneously Lebanon, and Beirut in particular, have been the center of some pretty significant events of global impact. How are you now relating to the collective work, the sense of place, the focus on the local? I'm really interested in how we're going to talk about collectivity across borders and time zones. So how are you negotiating and navigating that?

Yeah, it's a really great question and it's a difficult one to answer, if only because the events of recent times have just been so completely overwhelming in so many ways. It's interesting, I was conversing with a former colleague and dear friend of mine, kind of reminiscing as I was preparing for this, pulling together some stuff just from my own memory. I shot him an email and he said, "yeah, remember the good old days when resistance was organic and not reactive?" In the sense that now—especially with the port explosion and the ongoing strikes that have been taking place in the country, the bombing again of Gaza, the war in Syria, everything.... Then on top of everything, COVID. How I often frame it is that there are no words, there's nothing to say now. I know in my heart that, as the Palestinians say, "existence is resistance," and you move forward. It's heartbreaking in a lot of ways when friends and family say to me, "keep your memories and don't come back." It's really hard to hear that kind of thing. The emigrating impulse of the Lebanese, which is historically part of that region, is just kicking into high gear.

I can remember when I was teaching, there was a year or two where students stopped planning to leave the country. The desire was to stay and to build and to work and all of that kind of thing. Now we find ourselves spread

out all over. The old idea of having a space to work in and share, that type of *taller* [Spanish word for studio], studio, or atelier, however you want to call it, serving as a locus of action has kind of been undone. It's harder now to speak in the generic, meaning, when an email goes out to the group and we're talking about a project in the face of what's going on in the country now—where medicine is running out, gasoline is running out, one crisis leading to the other, the already feeble infrastructure of the country just coming completely undone—everything becomes quite specific.

A friend of mine just returned from Gaza, he wanted to visit family he hadn't seen in ten years. When the bombing started again, and I'd send him emails, the old things you would say previously, all the words you would use in terms of perseverance and steadfastness and patience in the face of adversity, they don't mean anything. I would say to him, I don't have words for you. I actually started resorting to quotations from Palestinian poets, those who had previously gone through similar situations and pulling from them a kind of strength. Those are turning into projects now, illustrated posters using the words of particular poets, for example. I don't know if I'm answering your question. I think in diaspora-mode; there are two levels to it, one is dealing with the day to day of where you are, which is often a place—xenophobic, racist, Islamophobic, whatever the case may be—and then also of pining for a life that you had but knowing that life has gone. So, trying to balance those in a way that allows for activism to keep moving forward.

I remember in 2010, the Socialism Conference in Oakland was right after the Oscar Grant trial.[2] A member of the Black Panther Party was there, and I said to him, "How do you keep doing this? Brothers and sisters arrested or assassinated, exiled, etc.?" He looked at me and he said, "I may not see the revolution in my lifetime, but I need to carry the flag forward to those who are coming up after me." That has stuck with me, and there's similar resonances there with phrasings and words from the Palestinians, so that's what I try to keep in my heart.

If we take that anecdote, your conversation with the former Panther, and then we jump back to 2010 when you did your first big action, which was this newspaper supplement. . . . This supplement was put in a major Beirut newspaper to promote generative discussion around Israeli Apartheid Week. That project created this moment, or maybe better phrasing: a space, in which younger people were having conversations with their parents about the activism and organizing and agitprop that they had done during the Lebanese Civil War thirty years earlier. Can you tie this very intense moment we're having back into that intergenerational conversation? Work that allows for the possibility of looking backward in order to move forward?

So, for the posters which made up the supplement, just to give a little bit of context, we included a recipe for wheatpaste, and there were eight posters,

none of them was backed with another poster, they were each a free page in the newspaper. These went out with the left-wing newspaper *Al Akhbar* and the idea was people would activate them on the street, cook up some wheatpaste, and put them up. Some of the students reported that their parents, who had been trying to protect them from politics and shelter them from what they had experienced, were all of a sudden coming forward with these stories of what they had done during the Civil War. So, there was this generational bonding, if you will. At first, we lamented that we didn't see any of the posters out, but it turned out that people were hoarding them. The tradition of the poster is so strong and the resonance of that supplement hit so many spots that nobody wanted to get rid of them. And so, they held onto them, which is fine!

My friend Rami has described something he calls "the organic days of resistance." I take it to mean that alternative infrastructure still existed, there were still printers and pressmen working with metal type, there were still small presses. Like on the Lower West Side, the printing district of Manhattan, you used to be able to go to a small press and say, "can we swap out our plates at the end of your press run and use up the rest of the paper and ink?" The printer is amenable to that because the cleanup is a little easier with less ink on the press. I happily recall those days of the local printer and the print shop as a site of activism and community mindedness and all of that kind of thing. I expected to get maybe 500 copies of our supplement that way. And so, when the counteroffer came from *Al Akhbar* to print up one for every newspaper, which numbered about 12,000 in terms of circulation, I was blown away.

I would end by saying whether that would be possible today, I'm not so sure. That alternative infrastructure in Beirut has been lost a little bit. So many of our projects when I was still there manifested in a way that included people just coming out of the network, out of the woodwork, coming together in no official way and no formalized way, but all of those networks were just latent to the way the culture worked. So, when you have these overwhelming crises, if you will, then the networks need to be used for other things, and people are less inclined to divert from that and so that's where I see things right now. I'm trying to maintain a sense of moving forward and continuing our projects, but I think they will likely take on a different tenor and a different manifestation. Perhaps they need to do the job now of recreating those networks or going back and making sure that they're still intact. This is what I've started working on as a kind of side project now.

But to your point, when you take a look at our projects on the website, each one is framed historically, politically, culturally. A lot of our emphasis is on the historical. Instead of a unique incident or moment in time that needs a response, we see a continuum of moments that need a response and a continuum of activism. Then it's less overwhelming in a way, you're part of a bigger project. It's no accident that, especially within academia, the popular idea is that the new is always better and we're always moving forward and active

engagement with history needs to be done away with. Whether we call it post-modernism or otherwise it becomes problematic.

This dovetails into something that has been running through all these <u>Graphic Liberation</u> conversations, and this may seem oblique at first, but trust me and it'll come back around. I'm really interested in how political movements nego-tiate intellectual property, and a tradition of political graphics that on the one hand is communal but which gets enclosed in different ways, by things like claims of authorship—whether from individual artists or corporate or state en-tities. This idea of the print shop as a locus of resistance makes me think of a story—a little less than a decade ago I worked with a local chapter of Al-Awda in Chicago helping to organize a march and cultural celebration for the Right of Return. I designed a graphic for them, for t-shirts and flyers. We brought the graphic to the printer, maybe two weeks before the event, and then unbe-knownst to us, the printer, who is a printer in the Palestinian community in Chicago, backchanneled the graphic to friends on the West Coast. Between sending the design to the printer and that demonstration, I happened to go to DC for a big antiwar march—this is like 2002, right after September 11th—and I see a guy marching down the street with my t-shirt design, but in different col-ors! I asked him, "Where did that come from?" And he said, "I got it in the Bay Area." I got back to Chicago and friends explained that this is just what hap-pens within old-school Arab culture, there isn't the same sense of copyright. The graphic is useful so it gets sent to people who can make use of it and it wouldn't have even crossed that printer's mind that they should ask first.

 I took it as a point of pride, I was in no way offended by it. I'm interested in how this reframes the loss of infrastructure. If the mindset is still the same, then maybe there's still a space for this kind of back-channel liberation work. How do we, and how do you personally and how does the collective, negotiate these questions around intellectual property, communal, visual, identity, etc.?

Yeah, it's a great question. I remember discussing this with you at one point, perhaps when you were visiting us there or visiting Beirut, but it came up as a discussion, and we were looking at the poster tradition of OSPAAAL in Cuba and how the temptation of fame in North America would often cause artists to break away, or to insist that their work be signed or that kind of thing and kind of leave the group, and so that's a part of it. We also discussed if we should give credit or place our names anywhere on our work, and the collective was like, "well no, absolutely not, this is collective work." On some level, it makes sense because in some especially high-energy moments of working, one per-son would do a drawing, someone else would carve it, someone else is doing the calligraphy or the square-kufic lettering and someone's doing the graphic design, and so it just became all hands on deck. But all of our work has always been placed on the website free for people to use.

Like you're saying, whether it's a poster that shows up in some remote town in Mexico that I hear back about or whether you know, during the March of Return, the images we put up were showing up as station identification on TV, as coverage of the event, or us seeing huge banners and billboards as we were bussing down where I was like, "that's not how we had made them"—people were adding color—so like you're saying, these things are interesting. We got down there, and people had made signs with them and everything like that, and that's just part of how that works, the idea of that dissemination and the need for getting the message out precluding even the glimmer of any idea of, "hey, wait a minute."

If we look at copyright and intellectual property as being functional to ideas of property and ownership and usually corporations, who are manifesting for what they can squeeze out of use, and that kind of thing, it was never a question that we needed to make it known that this was our work. But it's interesting too, there are certain things we haven't seen; like, I haven't seen t-shirts, other than the ones we've created, for example, so maybe there's a bar of understanding there as to what is doable. I mean if it's part of the action, I don't know. It's a really great question and to me it's interesting to see, through the statistics for the website, where things are going on, based on who's hitting our pages and from where, and what's being downloaded, that's a whole other side of it. I've often wanted to put, on all of the things we put up, a request, "please document and send us back footage or photographs," or whatever the case may be, but I'm just happy that at any given time, some aspect of our work is being downloaded and reproduced and disseminated.

This question around intellectual property, who owns visual language, is really embedded in the larger project that I'm doing as part of this Colgate residency which is exploring the idea that, over the past 200 years that collectively, we, humanity, in a way, has created a shared left iconography that exists in a way like a language, that has almost letter forms that can get combined and recombined in different ways and I wanted to get your thoughts on this, also in the context of thinking about the importance of the local to your work, but at the same time, if you look at the collective's output, you see fists and doves and prison bars and slingshots and these icons that make up almost letter forms of a kind of visual language of liberation. How do you feel about the potential internationalism of this language but also maybe the limits and how things maybe mean different things in different local contexts, or if we reached a point in which there's a certain universality that we can use as a shorthand, that this is almost like a left folk idiom.

Yeah, really great question. Well, first, I would say so much of what we do historically ties back to the days of rural decolonization and liberation movements that were cross-purpose and bridging with each other and sharing

information in a time when that was no easy feat, and the iconographic imagery that came out of that era was one of not ownership, but sharing.

If I look at something like *Lotus Magazine* that came out of the Afro-Asian Writers' Association[3] and those ideas of, "we're not going to translate the language, we are speaking to a particular audience," and then having a printer in Beirut or Cairo adding embellishments and illustrations to that and that not being a problem, and so it's a form of a universal notion of common struggle tied at certain points with mostly local references and like any language references, it can be learned. In our local context, if I think of Greater Syria, symbolism takes on huge import—like it does everywhere—but in the sense that, if you look at the tradition of the Palestinian poster, the tropes and idioms and representative symbols just become this amazing constant referencing that obviates the need to explain or to add a lot of text.

Arabic as a language is brilliant in how it is able to resonate along symbolic and poetic lines; like the series of posters that we did where we took Lebanese proverbs and tied them to illustrations of everyday Palestinian life in a way that played with the proverb. Proverbs are still part of the living language, these are things that are said all the time, so those references, tied in a new context, became quite compelling.

The other thing to note, especially for us, was that we were working in a place which proudly, sadly, claims that it is trilingual—when in fact it's not—so most design is translated into French, English, and Arabic. We made a decision very early on to focus on Arabic, and if we need to be talking over the heads of those who don't understand the language, we're going to do that. I think that's one of the things that has worked to our advantage. We don't mind producing, say, a series of posters that are in different languages, but we don't want to translate. To translate is to water down and to move away from something that has huge meaning. We see our audience as mostly local, and so my work here continues along those lines. For example, I see in my students often a desire to speak to the local audience, and my question is always, "what's your acculturation, whom do you want to speak to?" That audience may be elsewhere. You're not obliged to pantomime or act out or translate—again going back to that analogy of a clock that you've taken apart, you get a sense of how it works, but it's not working anymore. I feel like the aspects of our work that speak to the most local are also working with those tropes that have the deepest resonance. It's no accident to me that particular places—whether Andalucía or Al-Andalus in Spain, or places in South America—all of a sudden become interested in our work and get in contact and there's a back and forth. Places of resistance, places of revolution, understand that language and speak it readily. I don't know if I'm answering your question, Josh.

It's more of a terrain than a question. I'm really interested in the way that you and the collective have attempted to reinvigorate this idea of the square-kufic

lettering, which can be a pictorial Arabic form. This almost allows you to get away from this tension between image and language by actually integrating them. What are some of the ideas behind that?

The square kufic traditionally comes from architecture and so it's a square tile that needs to be put into use to represent Arabic form. It is a school, if you will, of how to approach Arabic that is rectilinear. It's used extensively, mostly in marketing and advertising. It's bold and graphic, so companies will turn to it for logos and that kind of thing. But it also has those resonances of faith and the ability to just play with the language in a really amazing way.

On a personal note, I was coming back to Lebanon, and was learning Arabic. To learn calligraphy, you're talking years of apprenticeship for all the different forms, but Beirut doesn't have any active schools for calligraphy anymore. So, this ended up allowing me to get away from certain trends within the graphic design realm in Lebanon, which were things like somebody taking Frutiger or Baskerville typefaces and making the Arabic version of it, which to me, [laughter] I don't know what to say to that, it's so problematic on so many levels.

The square kufic, which you can see in our work and our first attempts, many of them mine, were kind of stumbling and clumsy. It's organic and you make up your own rules as to how you want to portray letter forms, and it takes on a life of its own. But it can sit there in the background, often needing help or input for understanding what it communicates, especially when it starts turning on itself. But I like that idea of something a little bit more subliminal, or something that carries through, that speaks to those who know and doesn't say anything to those who don't, to me it's quite powerful.

We asked some friends of the collective who work as calligraphers to do the "Water is Life" calligraphy that we used for the Commonwealth project.[4] It was a colleague of the collective who did that piece for us, but again, not asking for attribution or signing it in any way, it just became the work of the collective.

You can call it clumsy, but I regularly wear the t-shirt that you produced that features Malcolm X's name written in a kufic X form, and every single time I wear it, someone stops me and asks me about it. It is profoundly arresting.

You know what this is like, working as a graphic designer and finding that moment when something just clicks and you're like, "okay, this can't be anything else, and this is just perfect the way it is." That was one of those moments. I think the most heartening aspect of it is the fact that those shirts sell out in Beirut as well as Dearborn as well as other parts of the Detroit area with not just large Arab populations, but also large Black populations. It is so heartening to me that the symbolism bridges communities and allows for a back and

forth and a resonance that is really quite powerful. That image in particular, I don't say this too often, but I'm really proud of it. Every once in a while, one of the members will circulate an image—usually from Detroit or Dearborn—of somebody working in the community wearing that t-shirt, and there's no higher honor.

Edward Jiang: It seems to me that a lot of the collective's work is overtly political with purpose. My question, though, is a little bit meta. Do you believe that all art is political in nature, or that the artists choose to make something political or apolitical?

Really great question, thank you Edward. I go through this as an instructor. I'm teaching here at Emily Carr University, a professor of illustration, but often dealing with students majoring in painting, printmaking, and other fields. The Pacific Northwest school of painting is a formalist tradition, mark making, really getting into the medium, and the political gets pushed to the side. I'm of the opinion that something that doesn't resist the dominant cultural mode is part of the dominant cultural mode, and I'd argue that is equally political. I think we're in a time now where we no longer have the ability to remove ourselves from the fray and to speak to a rarefied audience only interested in form. These more rarefied, conceptual explorations don't meet the current crises that are taking place globally. So, on that level, to ignore what's going on in the world and produce artwork only about art, to me is a political decision. You've made a choice where you fit in terms of your economic, political embodiment, however you want to frame it.

Audience: So, if I understand this correctly, Jamaa Al-Yad is a movement that aims to resist the things harming the people in the Middle East, specifically Syria, Lebanon, and Palestine, and is concerned about bringing attention to these issues and giving people hope to keep going. What is the effect of your work on your target audience, and in the broader world, how is your work received?

Thank you, it's a really good question. Like I was saying before, we are always tying ourselves into precursive movements, into the continuum of art and activism, as opposed to seeing what we do as something separate or new. It is the embodiment or manifestation of what's going on—on the ground. We don't see ourselves as a group that is observing what's taking place so we can comment on it, it's stuff that's lived, gets communicated, and activated directly. When you look back at the tradition of the movements for decolonization and liberation of the sixties and seventies, there's so much rich material that we don't see ourselves separate from, we see a continuing of a tradition, and it's not just local to the region, it's really worldwide. For

example, Vijay Prashad has resuscitated—in no small way—the idea of the Tricontinental and each newsletter comes with a collection of artists working in different parts of the world along liberatory and emancipatory lines.[5] It's phenomenal, and knowing that work is out there creates a sustaining feedback link.

Audience: This is a question about reception and critical evaluation: what are your criteria for success or impact?

This is an amazing question. I remember when we were working on the *March of Return* poster series in my office at the American University—some people doing scratch boards, some people carving linoleum, some people doing the graphic design, all of this under deadline pressure—and someone looked up and said, "What if nobody sees this? What if nobody responds to it?" And I said, "If there are twelve thousand copies of this newspaper and they all get ignored, but one poster ends up in the room of one young Palestinian and inspires them, it will have been worth it."

That came back to me when MoMA did a small exhibition based on the Occupy movement, and the poster we did for the *Occupied Wall Street Journal* showed up on the first floor of the museum and all of my former students who are in New York started taking selfies with the poster. They were texting me, saying, "You've made it, we've made it!" and I was like, "ehh, that's going to be gone in two months, no one's going to remember it," and yet the posters we did over a decade ago are still up on the walls of the refugee camps in Lebanon.

So, when you asked me how we view our success, to me, if there's a resonance with somebody and feeling of elevation or carrying forward, that's all we need. We've been in gallery spaces in Europe and other things like that, but that is much more ephemeral than the long-term existence of our posters in people's lives.

Audience: Can you talk more about subliminal communication?

Yeah, subliminal probably wasn't the right word to use. The way I frame it for myself, growing up in the States and then going back to Lebanon, and then coming back again and now being in Canada, the kind of code-switching that needs to take place—what I'm allowed to say, what I need to be quiet about, ugh. The Jersey boy inside wants to scream half the time but that's not allowed; it ends up being problematic.

Who is your audience? If you're in a room of people looking at your work, are you obliged to talk to them? If I'm working on a project, I go back to Malcolm X. Whenever you look at his interviews, he's always talking above the head of the interviewer. I mean, sometimes literally, there's amazing footage of him talking above the heads of the first row in the auditorium filled by

the American Nazi Party, sitting there with their arms crossed in full regalia and swastikas and everything.

So, I'm speaking in the presence of someone, but I'm communicating above their head to somebody behind them. How does that change my work, how does that change how I feel about my work? I think about the ideas of minstrelsy and the early days of vaudeville, when Black actors—replacing the white actors who used to wear blackface—were obliged to wear blackface themselves and also speak in the pidgin dialect that had been created for them, because that's what the audience was expecting. And this I find heartbreaking and infuriating at the same time, and so, how do I avoid that, how am I true to myself and to my work and to my audience, and if somebody wants to understand, then the onus is on them, as opposed to the artist who's creating it.

Josh MacPhee: I think that whether we want to use the word subliminal or not, it is important that we all acknowledge that we're awash in visual language and are poorly equipped to be able to interpret it. We learn how to read and write, but we don't really learn how to read images, and images carry immense amounts of resonances with them, and so we read things that we don't even realize we're reading. Advertisers are the real master manipulators of this, but I think that there's lots of great examples we can draw from that illustrate how this has been used in liberation movements. For example, if a graphic has a person in it with an afro, we'll associate that with the Black Power movement, and then that reference gets drawn into the interpretation of the image without us even realizing that we're doing it. There's literally thousands of ways that happens in our heads every day. I think that it's overdue that people making agitprop for social movements today get better at using that to our advantage.

I think it's a great point and I would only add that it's important to understand how our work has been co-opted—that the facade of activism is often used in imagery that contains nothing in the way of valid activation, and the flip side is true, too. You know, it's stunning to see—and I'm saying this as someone born in Lebanon and adopted to the United States—images of US soldiers in Afghanistan holding babies. There is a trope of "the baby lift" and the saving of children after a war, whether it be the Vietnam War or the Korean War, as we call them, wars of aggression against nation-states in East Asia and other places. Tropes like this, we need to be able to unpack and understand them, the weight they carry and the effortlessness with which the dominant culture just pushes them on us, assuming that no one is out here to be critical or to challenge them.

Audience: It sounded like you were not <u>against</u> translation, so to speak, but were arguing for maintaining an original linguistic form. I'm wondering how you

plan to reach farther audiences that don't understand the language, or if your only goal is to inspire those that can?

I think it's a starting point. If you take a look at our website and projects, many of the posters have been translated, so the starting point is Arabic, but there's a sense, a need, in the Lebanese context, to translate into the two other predominant colonial languages—English and French—and then beyond that we often translate into Spanish. Ideally, that can continue, it's purely a function of time and ability.

 In many ways, the desire to not translate came from not wanting to follow what was expected of us by the Lebanese graphic design context: always three languages in one poster and all are given an equal balance, even though the majority of the country speaks Arabic. It is the national language, after all, even though a lot of education takes place in English and French. Taking into account the fact that many of us acculturated in other languages and have a mother tongue that perhaps isn't Arabic, starting in Arabic expresses a desire to recapture it and go back to that. It's interesting, many of my students, whether from immigrant contexts or Indigenous students or others, are looking to recapture language—my suggestion to them is always to throw yourself into it and then don't do the translation, see that as a way of empowering oneself.

Josh MacPhee: It's important to acknowledge that translation is not a neutral activity. I think it is fair to say that many in the Anglophone world perceive translation as a problem for others: "how come you aren't translating what you're doing so that we can understand it?" More books are published in English than any other language by far, yet English is the language the least number of books are translated into. There's just a lack of interest for the most part in other languages, translation is used in a passive, yet imperialist, fashion to move ideas from the Anglophone world into other parts of the globe, rather than the other way around.

It's a really good point and I would only follow up and say that with that weight or expectation that it be translated into English is a sense that if I don't understand it, it doesn't exist; or even, if I don't understand it then it's not worthy of existence. So, it can be important to take a stand and say, "for you to understand this requires effort on your part, not our part."

NOTES

I. Drennan ElAwar uses "Greater Syria" to refer to precolonial conceptions of the region over contemporary nation-states.

2. The Socialism Conference is a long-running, annual US-based convening that brings together socialists and other left-wing theorists and activists. It was originally organized by the now-defunct International Socialist Organization and is now put together by the publisher Haymarket Books.

3. Lotus was a quarterly magazine published by the Afro-Asian Writers' Association from 1968–1991. Printed in three languages—Arabic, English, and French—over the course of its run, the Arabic edition was edited and published out of Cairo, Beirut, and Tunis, with the English and French editions printed in either the Soviet Union or the GDR. The magazine arose out of the Bandung Conference and the nonalignment movement and held an anticolonial editorial line with a (nonexclusive) focus on liberation movements in North Africa and the Arab world.

4. Commonwealth was a 2017 exhibition at the Queens Museum in New York City organized by Josh MacPhee. It connected the climate justice-oriented print work of the Justseeds Artists' Cooperative with contemporary movement artists who created work as part of anti-pipeline and other water struggles, particularly the then-recent fight over the Dakota Access Pipeline. A portfolio of risograph prints was produced as part of the project, in which Jamaa Al-Yad contributed a print.

5. For a lot more on this, see the interview with Tings Chak in this volume, pages 163–183.

SANDY KALTENBORN

I KNEW I LOVED SANDY KALTENBORN within five minutes of meeting him. In 2007, when Alec Dunn and I unrolled a selection of screen-printed political posters we had made and brought with us to Berlin and Sandy's studio, his immediate response was, "These are nice, but don't you think screen printing is a little quaint? If you want to have a political impact, don't you have to print at least 1,000 copies?" His blunt directness has been a compass for me ever since. I had made my way to his studio because he had been designing some of the most dynamic posters for the European counter-globalization movement, and I wanted to include some of them in Signs of Change.¹ Those posters were included, but more importantly, Sandy and I became friends.

Sandy's ability to look at design (and political) problems from unique and oblique angles has always impressed me, and I've been an unofficial student of his ever since that first meeting—always asking myself questions about my work that I learned from him: is this a social image? How does this make the audience think about the subject in new and interesting ways? Meanwhile, by 2012, Sandy had merged his design practice with grassroots community organizing, setting up the tenant organization Kotti & Co with his neighbors, primarily immigrant families. While communication strategy was key to their work, it was grassroots organizing that did the heavy lifting and ulti-mately forced the city of Berlin to remove a number of buildings from private developers' hands and convert them into social housing. It is this tendency to see the finding of solutions to his (and society's) problems as his practice, rather than the other way around, that fits him squarely in the company of the other cultural producers included here.

On February 16, 2022, we got to capture part of our ongoing conversa-tions as a contribution to the Graphic Liberation series.

Top: Cover of exhibition catalog from Sandy Kaltenborn and Holger Bedurke, <u>Politisch/Soziales Engagement & Grafik Design</u> (Berlin: nGbK, 2000). Bottom: Exhibition collective preparing the show, Berlin, Germany, 2000.

←Sandy Kaltenborn: Well, first of all, it was a real challenge to only send you four images and, as you can see, already on the first slide I tried to trick you.

This first cluster of images are all from the project *Politisch/Soziales Engagement & Grafik Design* [Political/Social Engagement & Graphic Design]. The book cover is of the catalog for this exhibition that I curated with some friends here in Berlin at the nGbK (*neue Geselleschaft für bildende Kunst* [New Society for Fine Arts]), a very basic democratic gallery, collectively run. It was exploring the French graphic tradition, mainly that which came out of the '68 student revolt in Paris. This is my lineage, what was important for me within my graphic design education and in my activism. I was very much influenced by this movement, and by this group Grapus, which is at the center of that tradition. The exhibition showed a lot of collective works which emerged from this group. Maybe we can talk about this more in detail later.

To talk about the image on the book cover, some of you probably have recognized this hand. It's a cut out from a work by German antifascist designer and artist John Heartfield; it's actually an election poster. The original text, which I overlaid with this blue box at the bottom, said: "The Hand has 5 Fingers! With These 5 Grab the Enemy!" and then something about voting for the Communists.

And the second reference is the broom which covers the cut-out eye in the center of the hand. In the 1990s, when I moved to Berlin, flyposting was—and still is—a big thing.[2] I was really into it. Putting up posters and signs and symbols and graffiti. So the broom is about flyposting, but at the same time cleaning the eye or brushing the eye. This is another visual reference, this time to Polish/French designer Roman Cieślewicz. Cieślewicz very much influenced the French tradition I mentioned earlier. There was a quote of his we placed in the beginning of the book which goes: "In times where we are flooded with images which smear and close the eyes it's the responsibility of artists and designers to make images which clean the eye."[3]

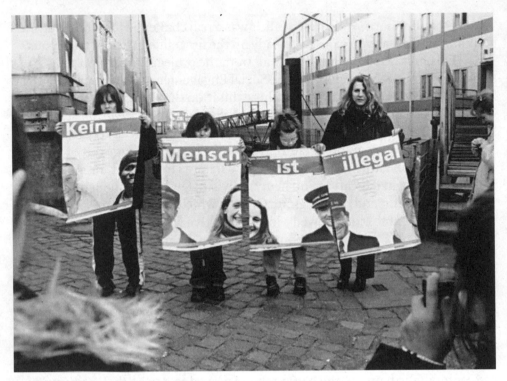

Workshop with refugee children in the Hamburg harbor (refuguees were housed in the container ships seen in background). The kids are holding a poster series for the Kein Mensch ist Illegal campaign, Germany, 1998.

←This is a poster series I also designed in the late nineties as part of a workshop with refugee children in the harbor of Hamburg. It's one of the first posters I designed on a computer. I had a very hard time cutting the portraits out digitally! The series is about people without legal papers, *sans papiers*, so-called illegals. It creates, over the four posters, the slogan "No One is Illegal," which was a big campaign in Germany at the time, initiated at the art exhibition Documenta. You have to understand that back then we didn't have a situation like we have today, with a lot of immigration and diversity becoming part of the mainstream. The mainstream was completely white-dominated, and so placing these "un-normal" people on posters was, if not radical, interesting at least.

What's a bit difficult to see is that underneath the main letters, there's some small text, and this relates to different situations that people without papers are confronted with in daily life. For instance, one reads, "I'm going crazy sitting around in a room alone all day. I just want to go to school and learn like the other kids. Just learn. But no school would take me." Another poster reads, "My friends knew that I no longer had a visa. They should have called an ambulance for me. But how would I get the necessary papers, under what name could I be admitted? It was really difficult, impossible to solve." One talked about public space and racial profiling, and the text read something like, "I was just hanging around and suddenly they were in front of me and one wanted to see my ID. They didn't wait for my answer, threw me to the ground, and put me in a chokehold."

So basically, what you see is friendly portraits of four people, they're smiling at you, and then you start reading the text and it's describing violent situations. So, there's this interference or irritation between the smiling portraits and the text, which also triggers images. This was the concept of the series, and it was widely distributed throughout Germany; it was a very big print run, actually. I picked this poster to describe here mainly because of that technique, what I would call its communication strategy, which I find worth talking about.

Image-Shift, <u>Krises,</u> offset printed poster series, Germany, 2009. A poster series as a city Scrabble game where the people who flyposter become part of the design process.

←As I mentioned earlier, I was always very interested in flypostering. When you do flyposting, the design doesn't really end at the edge of the poster—it doesn't even end with the artist or designer—but with the people who put up the posters in public space. They continue the shaping, the communication aspects, the content, and hence, extend the poster design into the designing of public space.

This poster series is actually quite boring in terms of the graphic design within the edges of the page. The posters read, "*KRISE?*" ["CRISIS?"]. Each letter has a specific meaning, I think the first one says "*kapitalismus*" ["capitalism"], the second one says "*rettungspaket*," which are rescue packages for banks, so they save the banks but they don't save the people. The third reads "international," the fourth "*solidarität*" ["solidarity"], and the fifth "*emanzipation*" ["emancipation"], and the question mark says "*wie weiter!*" ["how to continue!"]. We made these in the late '00s, when the financial crisis was hitting the planet. This very big activist group had the urge to bring the crisis into the streets and tell the public there was a problem at a time when Germany didn't feel like there was one.

This was also a citywide Scrabble game; the people who did the flyposting actually expanded the ideas in the posters by using the letters to create more slogans and actually design the city. So, we wanted to see how creative they could be with these five letters and a question mark. This is just a small sample of what they wrote. "Kiss" or "cookie" or "cake" or "ice cream," these are all little words. What was very interesting was that they started on their own—even though we didn't facilitate this—they started their own communication about it. They created a challenge or battle, who could make the weirdest and funniest Scrabble words with these six posters.

Top: Demonstration of Kotti & Co, Berlin, Germany, 2012. Middle left: Sandy Kaltenborn, Infographic on the social housing funding system. Middle right: Conference held within the Berlin city parliament, Germany, 2012. Bottom: Demonstration for children in front of the Kotti & Co gecekondu.

←Whoa, okay. These are images from my engagement in the last ten years. I picked these four images because to some extent they're about design, but much more on the question of how can different forms of design shape society? One such form is a tenant initiative I started with my neighbors a decade ago called Kotti & Co. Kotti is the nickname of the big intersection where I live, where I'm at right now, right here. It's called Kottbusser Tor and it's in Berlin in Kreuzberg, a very diverse, countercultural, progressive, green-governed neighborhood, strongly hit by gentrification in the last ten years. Kotti & Co has been and is fairly successful. The way we managed this is that we built what I would call multilayer protest. But it's not about protest, it's way beyond protest.

So, these four images; the first one on the top left shows a demonstration. In the very beginning we started with small demonstrations. Then we squatted something, and you can see this in the top right picture, on the left-hand side, something like a wooden building. We actually erected a building here in the street and occupied it, and it is still standing now, for ten years. In that photo is a demonstration I organized with children of the primary school, and this was the end of the demonstration, when we came to our little wooden protest hut. We have an association beside our activist group, called Kotti Co-op Association, and we do community work, so we do exhibitions in public space and we try to do a lot.

The image on the bottom left is an infographic—not the best I've made in my life—that explains that this struggle started in social housing. I wouldn't like to dig too deep into social housing, but social housing in Berlin is something very different than in the US. It's not sustainable, it's not forever, and a big chunk of it is in private hands. So, the whole financing system, how it works, it's a mess. It basically means that we, the taxpayers, pay a lot and at the end of this whole process of erecting and renting and maintaining the buildings after thirty or forty years, all the money has gone to the private investors and the rents are exploding. That's exactly what's happened to us.

The infographic was part of a publication for a conference we organized—you can see the picture on the bottom right—which explained to the government a sustainable funding model for social housing, a revolving fund. It's not something we invented but we traveled to Austria, to Salzburg, and other places where they are erecting very cheap, very good-quality social housing, without any credits from the bank, so we tried to bring this into the public discourse and to the politicians, into Parliament.

One of our first demands was this conference on social housing because we understood that the problem is much more complex than just changing the law. The title of the conference is a provocation, and it's also about design. We called it *Nichts Lauft Hier Richtig*, which kind of translates to Everything is Wrong. The building shown in the slide is actually the building I'm sitting in, it's located here at Kottbusser Tor.

The people sitting at the end are the State Secretary, a sociologist, and next to him, a homeless person who showed up at our protest camp, who we just brought along all the way, because he's a great guy. His name is Tunji. Next to him is my co-organizer Ulli, and the one who's moving his chair is me. On the far right, you can see people from the housing administration, who were kind of forced by politicians to attend. At the very front of this photo you see three women, and there were many more women. These are working class women, they're all my neighbors, and so we brought them into Parliament.

Their presence was not only about expertise and discussion; it was also about confrontation so the people who are in charge of this fucked-up system are sitting on the other side of the table from those actually threatened by rising rents, those who have a hard life because of these programs that don't work.

Josh MacPhee: This is great. You basically gave us the whirlwind tour of your last thirty years of work, and embedded in that is your thinking about design and what it can do, what it should do, and what it does well. And maybe what it doesn't do so well.

As a launching-off point from this, could you talk about your transition from being focused on designing within the four corners of a page to designing with the realization that ideas have to come off that page, and that the page has a specific location in the world? So, thinking about what it means to take the ideas you've learned practicing design and enact them in different fields in the world.

I remember the last time we had a really long chat you were telling me that you were at the verge of dissolving your studio because you were so deeply embedded in the work with Kotti & Co. Can you talk a little bit about moving from <u>the page</u> to <u>off the page</u> to <u>screw the page, there's more import-ant things to focus on</u>?

Yes. Where to start? Well, let's start here. Every design is social. Every image, every product shapes us every day. A mug does. And a poster does. And an image does, and what we just saw with Jeffrey and his kid also does, and if we talk about the social and political aspects of design, we actually couldn't have had a better introduction as Jeff and his kid just gave us.[4] It's never just about his introduction, it's always about much more. When I say every image is social, and when we take this seriously, then we have to understand that the social is something which is between at least two people, it's more of a dialogue and less of a monologue.

I was always interested in—I want to say political posters, but every poster's actually political, advertising is political, so it's a weird distinction, but let's try to work with it. When we think of political posters, we have im-ages now in our head and these images are probably fists and struggles and

fights and stuff. Most of the time they're illustrating a struggle, they're complaining, they're criticizing certain sets of circumstances. So, they're kind of like a piece of writing trying to be put into an image, but not really challenging what lies behind the eye.

What I find interesting is what happens after the audience, the recipient, read or see the image. That's actually much more interesting than a great artist putting out their message and saying, "hey folks, that's what I want to tell you, and I'm on the right side in this struggle." That's why, when I started doing design in the context of social movements, posters, I was always interested in what the media can do, beyond just carrying information. When I design a book, for instance, it is a lot about the layout, typography, and the pages, but it's also about the paper and what happens when you open the book and how expensive the book is. All these things are very interesting for designers who care about larger questions, I feel.

I'm making a big jump now. You talked about how I was thinking about dissolving the studio, that I felt for a period of time the studio was dissolving because other things were more important. When you're talking about political struggle and fights and battles—at least in the social movements—activists, they raise these questions about design but are not entering the field to a certain extent. They stay in their subcultural, countercultural movements, self-fulfilling, very identified context and scenes. What's interesting to me is where does social change really happen? It happens when some people change their opinion, and changing your opinion means you have to confront and interact with other people and other realities and that's what culture is about. I mean culture in general is a form of solidarity, where society negotiates certain matters.

What I like to say is, if you want to answer certain questions or engage in certain questions, you have to enter the fields. You have to irritate yourself, you have to be curious and open to change, and when you enter these struggles, you will see very quickly that your understanding of design is questioned on a very productive level. To give you a simple example, when I started this tenant initiative with my neighbors, I wanted to design the first flyer. First of all, who is it for? And what kind of aesthetics do I use? Because the neighborhood is super diverse: we have a lot of Turkish immigrants here, we have a lot of very conservative people, we have working-class people, we have counterculture people, leftists, activists. For Berlin, it's quite diverse, it's one of the most diverse places in Berlin, so what aesthetic? I made the first design where my answer was: don't use color, because if it's in the mailboxes people think it's advertising. I made a great design, which was right in your face, but my neighbors explained to me, "No, if it's like this on an A4 leaflet,[5] people would put it in the bin right away," because they don't have this translation where they read it as something which addresses them on a different level than advertising.

I'm very grateful for the work I did for decades, because I never was forced to do any stuff I wouldn't like and I never did anything I didn't see the sense of. I can make my living, I don't get rich but I'm happy, so it's a great privilege. But even though I was involved in movements and actions, most of the design work was this work-for-hire, it was about telling the world, or communicating content.

What happened with this tenant initiative, to me, it really questioned my work on another level. This was not about *saying* the rent is too high, it was about actually lowering the rent! The buildings which surround me here were all privatized in the early 2000s. This is a very poor neighborhood and most of the buildings used to be owned—until recently—by a real estate company, a stock company called Deutsche Wohnen, which is quite ugly, and it was Cerberus[6]—you probably know Cerberus, they also owned homes for a while—who sold it. This was not about discourse. This was really about, "We're not starting this to protest, we're starting this to win, to simply win."

We started with the "I Love Kotti" sticker. You probably know what this is, Milton Glaser's *I Love New York*, so what's the design work in this? I copied Milton Glaser. Many other cities in the world did so before, "I Love Amsterdam," "I Love Nepal," whatever. But here was the difference: this was a neighborhood which was mainly talked *about*—it didn't have any voice, because we are very poor people, marginalized people living here, working-class people, homeless people, unemployed people with no voice. This neighborhood has always been talked about as a dangerous and problematic place. So suddenly here was this initiative which said, well this might be the case, this is a difficult place, but we like our home.

The second thing we designed was a postcard, and it reads: "Greetings from Kottbusser Tor" in the center, surrounded by photographs of the neighborhood. One of the photos features a banner that says, "We Love Kotti" and "We Hate Rent." It doesn't show a fist, it doesn't say, "Oh, we're all suffering, the rent is rising, help us." It says on a small line on the back, "Stop the rising rents at Kottbusser Tor—Tenant Initiative Kotti & Co." And it says the same on the "I Love Kotti" sticker design. There's no fist or something. To make a very long story short, I find it interesting to think about the connection of such a simple sticker and a postcard. Ten years of organizing later, the city bought these buildings—containing 3,500 flats—back from the private owners for about three billion euros. We've managed in the last decade to shift billions into our poor neighborhoods. And it's not only here, some other neighborhoods too.

I believe that there's a connection between visual communication, communication design, and political strategies. Maybe from there, you understand why I felt, at some times—well to be honest, being a designer always bored me, I find professions actually very boring. I find it interesting when design professionals interact with other fields, and when they get their identity

as a designer challenged. And the most interesting is actually when we collaborate. The most interesting projects are when you collaborate with sociologists, with artists, with working-class people, with homeless people and then it's not about me being a designer, it's about what we accomplished together with our very different experiences and knowledge. I also don't like to call my studio a graphic design studio, I call it a communication design studio.

You talked about this with your first project, that you are steeped in the history of communication design and have a deep toolbox, for lack of a better term, of the visual and other mechanisms that are used to convey ideas.

One of the things about a lot of the work you've done, like the sticker you showed, is that it references this history in the development of how ideas are communicated. How do you navigate that space between design that's self-referential versus design that's attempting to communicate to people who aren't steeped in that history of design? You know, when you're deploying Heartfield—

It's super difficult to design without distinction, without exclusion. I don't know if this goes in the direction of your question.

Yes, absolutely. With the Kotti & Co project, you've created a platform that has used an immense amount of design. I mean everything does; but it self-consciously used design to push on levers for social transformation and was really successful. Part of that is the ability to reach out of a countercultural milieu, or out of the internal dynamics within a specific neighborhood, to address issues around rent and tenants' rights on a citywide or even a national level. There's not a lot of examples in the US of that happening recently. Usually the design, even if it's very effective in a certain field, doesn't necessarily transcend the kind of space or the people that are just focused on that zone. But you've broken out to the point where if you live in Berlin, you have to negotiate and deal with the dynamics that you've helped build through your tenants' initiative. What were some of the communication tools for helping to make that happen?

Making yourself, as a designer, productively dependent. I'm not this initiative, this initiative was diverse from the very beginning. As I mentioned, we had working-class people; very religious, conservative people; more Turkish AKP/ Erdogan fans; radical leftists; atheists; people who wear glasses, people who are small, people who are big; kids and senior citizens.

Starting up my computer or sketchbook, it was always in my mind: how would they see it and how would this work? I had the great luxury of being able to test things. I'd like to give you one example—coming back to the conference I showed images of in the beginning, I already said we had the

politicians, we had the administration, we had the people from the neighbor-hood, and we had an audience. So how does the brochure with information and the program have to look so it can reach and convince experts? We have to design infographics which they can read and understand and take seriously, but they shouldn't be so complicated that other people feel excluded by them. So, in this brochure, we had images from our neighborhood. For instance, we had a portrait of a woman, too complicated to explain, but it was on the back side, and she was showing her passport. It's about racism and segregation and so on, and she was standing in front of the city development administration here in Berlin and showing her passport, saying: "What happened to me in this neighborhood was racist."

As I said in the very beginning, it's nearly impossible to not exclude someone when using aesthetics, but my aim was to develop a visual culture, or language, which is simple to access but not superficial. For instance, I made a poster which reads, "Rent Eats the Soul," and everybody understands that rent eats the soul, you know. You have a poster behind you, "Cancel Rent" with hearts, which is interesting, with the hearts. Everybody understands that high rent is a pain in the ass if you have little money. But Rent Eats the Soul is a reference to a film by Rainer Werner Fassbinder, *Angst essen Seele auf* [*Fear Eats the Soul*], so there was another layer of this poster for another audience, which is maybe more into film and the academic. There's this double refer-ence, or rather these two layers, so it was not superficial. It was very straight-forward, but at the same time, had many layers beneath. The first response from my Turkish working-class neighbors who don't know the movie—and the movie's interestingly about the relationship between two working-class people, one white woman and a person of color, and about the possibility of love in a racist Germany in the 1970s—was that this is not very good German, there's some words missing on this poster.

I don't know if this goes in the direction of your question. I would say, we should take every image very, very seriously, but we also shouldn't take them too seriously, at the same time. The recipient is always free to read what-ever they want to read. You can go tomorrow, or maybe later this afternoon as it's still midday at your place right now, walk through the streets and try to counter-read advertising and make jokes about advertising within your mind, read the images the other way around, and it's funny. It's very entertaining. But communication . . .

Part of what you just said connects back to your original image of the clean-ing of the eye—which I think is prophetic, given that most of us now spend upwards of five or six hours a day on a little tiny screen in our hand looking at images scroll by endlessly. It seems pretty clear to me that for the most part they're gunking our eyes up, and at the end of the day there's far less clari-ty than there was at the beginning. Has your thinking around this changed,

because the demand for eye cleaning certainly over the last twenty years has exploded. It's so much more intense at this moment than it was, it feels exponentially more intense every day.

Yes, as it did when Gutenberg invented print, right?

Come on, there was more time to adjust.

Yeah. I understand what you're saying, and I would go with this, but at the same time I would reject it. There's a tendency of cultural pessimism, that things get worse and people can't read images anymore, can't read books, because they're stuck to their iPhones. I have the feeling the field is expanding, therefore it's very important, or at least important to me, to think about distribution and context of reception. I like to think about how it feels to take a book in the hand wherever this person is sitting at the moment, think about how the medium does something to them. Or like the image behind me, for instance, or the images of your kid behind you: in a white cube exhibition the reception will be fairly different.

I'm not as pessimistic, I still believe in the social capacities of images. But I'm more interested in the images and design and media ingrained within larger processes and contexts, and understand them as one part within a wider stream of communication or transformation or change.

For instance, here in Germany, I've made a lot of antiracist posters in the past and I was involved in a lot of antiracist struggles, and probably will continue to be. Germany is not a very diverse country, still very white, but I have to admit that with social media in the last years, other stories, other aesthetics, other bodies have emerged into new spaces and into the mainstream. When I look through Instagram I see a lot of aesthetics, which carry stories, perspectives, identities. They're a flood and they are a great flood though I'm also swiping through and I'm just like, woah, way too much, you know. I still believe in visual communication, let's put it this way. I think what's happening is interesting, and I welcome these new possibilities, but at the same time I feel a bit old, like why can't we just have one poster and talk about this one poster and this poster will change the world. That's not going to happen. But of course, there's social movements and battles where one image is very strong, very powerful, and it can change the world too. So, I think it's still happening at the same time and it's great, it's interesting.

You mentioned the word flood, which gets into questions about control and about collaboration. So, for instance with Kotti & Co, did you do all the design work or were you dissolving your identity as designer into being an organizer? Were there organizers who were dissolving their identities into being designers or cultural workers? How did you negotiate the slippages between

these kinds of labor? I know that you feel strongly about certain images being the ones that should get used.

It's a very challenging question. Let's enter this answer in a bit of an authoritarian way. I believe I'm a good designer and I have a lot of experience, and I want the best for my initiative, so I can be very critical. The same goes for language and for texts. I've written most of the text of Kotti & Co with a few others, and there's a certain poetry and kindness to the language which we developed. So that's difficult. I'm still a professional. I'm always happy to explain and to argue.

There's a standard in most of the social movements in the leftist activist world in Germany, where everybody should be able to do everything. I don't necessarily believe in this. I don't have the skills of my neighbors. I don't have social networks, real networks, like my neighbors—well now I do, but I didn't have them ten years ago. I don't speak Turkish and many other things. I'm no good at Turkish cooking, for instance; some Afghan food, maybe, not really ... it's kind of like all in the mix—not as good as my mother.

It's a challenging question because I'm not totally dissolving away from my profession but, at the edges, I'm doing much more than just designing and operating as a designer. My identity is not being a designer or an activist. I don't like the term activist in the first place because it implies some people are active and some people are not active—in the context of a right to the city, everybody is fucking active in the city, so even the homeless people are activists in this sense.

What was beautiful is that some of the designs were taken up by others. For instance, people would draw their own banners and little cardboard shields at demonstrations and they would take the "I Love Kotti" and merge it and change it. We have a lot of other initiatives in Berlin who copied this Milton Glaser idea from New York which I had introduced for tenant initiatives. So, it's floating, which is great.

There was one person who had been with us for a while who was an illustrator, and he was a great illustrator but image-politics-wise I had some issues, because his illustrations were very much about the neighborhood gathering, very diverse, and they're raising fists and flags. That's an iconography which we know from the twenties—more than a hundred years ago—and I find it fairly boring, because these kinds of images only fulfill some kind of reassurance that we're on the right side. It just speaks to a little world and it's not reaching out. You know if you see a fist or slogan, you can say, I like it, I identify, I agree or I don't, end of story. Or I like it so much I'll put it up in my living room or in my bathroom, great, end of story. Though that's still important, we all need cultural products to reproduce our being, our identities, that's for sure. I also have things around me which I don't have the high expectations for that I have with my own work.

I would maybe defend the lowly fist, at least argue that it has other uses as well, but I also agree, I understand your point. I do think that part of their power is their instant recognizability, and that people across language and geography and time can recognize and see each other and build solidarities out of that.

I agree. I've become more tolerant over the years. I believe twenty years ago, you remember our argument around these questions . . . but I still like to raise the question: if we use these icons of political design from more than a hundred years ago, which still function, how do they translate to today and can we take it further from there?

I think I would maybe ask the question from the other angle and say, okay, if we're gonna drop these images and these graphics, what can take their place that can not only do the work on a local level to help to organize or build solidarity in a community, but also connect that struggle with the struggle that's happening somewhere else? It's easy to build newer internal communication strategies that create a sort of in-crowd within a small group to feel that they're part of or connected to something. It's harder to build those in ways that are not only open to people who aren't in your geographical area or speak your language, but also people that aren't already engaged. If we tear down the old, what are our new images and symbols?

I agree, I agree. But I would like to add that the fist image reduces struggle to strength and battle, and I believe that the left is strong when we manage to ingrain daily life and difficulties within our visual culture, and not only overused and impoverished images of struggle. This is not a contradiction to what you just pointed out, it's just basically what I believe. I've made images with the fist actually, I don't have it with me, a huge fist and with a huge flag.

I'll give you an example of the red flag, this was also in the nineties. In Berlin we have this traditional radical left First of May demonstration, 20,000 or 40,000 in the highest times, radical leftists on the street. It's very strong and there's always riots at the end and it's quite an institution. I was active in a leftist video group called AK Kraak and we had a screening on May 2nd, so I thought, okay, May Day is a revolution and on May 2nd we all go back to work. So I made this poster with a huge red flag and it says "Revolutionary Second of May." We were out flypostering and saw the other radical leftists, also flypostering their real red flags and the fists and so on, and they were starting to tear down our posters because they felt challenged, saying, "how can you be so disrespectful to a revolutionary struggle?" It polarized and caused a lot of friction and irritation, but the irritation was productive. A lot of people loved the poster, some people hated the poster.

If anything, these arguably tired—if still powerful—symbols provide a platform for iteration and manipulation and critique and they seem very fertile for this kind of engagement, for trying to turn them inside out and see what comes of it.

I wanted to show you, I forgot to put this up. [He holds up a sign which says "imagine a bookshelf . . . so i look smarter . . . or a design studio so i look more creative."]

For your background.

Yeah, for my background, the bookshelf is a bit further away. I have a lot of books too, so.

I don't think anyone was worried about your lack of reading.

Yeah.

So just to end maybe, I've been rereading a transcript of a conversation that we had over a decade ago, in which you talked about this idea of workplace blindness. Or, you call them, "inner-circle logics." Now I seem to be stumping you with your own phrase, but I think, basically, you described how when you sit at the same desk every day, and you look at the same screen, that you develop patterns and how important it is to break out of those patterns. I clocked that but didn't think much about it a decade ago. But now, after two years of a pandemic, it's taken on an entirely different meaning—our lives are so much more circumscribed in terms of what our physical bodies are doing.

It's one thing to be a designer and sit in front of the screen with the knowledge that the work you do is going out in the world and you'll get to engage with it. It's another thing to sit in front of a screen all day and not have those outputs where you actually get to see the embodiment of the work you do. Maybe your reality in Germany is different than it is here, in terms of the relationship to the pandemic, but I feel like I have a lot of workplace blindness.

I was wondering how you're relating to that, particularly in working with other organizations. How has not physically meeting with any of the people that you work with transformed the work, made it more challenging?

Well, the pandemic and the social isolation or reduction is definitely a challenge and it's not good for us human beings and for creativity in general. But I don't know if I can really relate to your question. I mean, for instance, the eyes behind me in my virtual background are all photos of the eyes of kids from the neighborhood. This photo of them was taken in my studio, but they aren't there anymore, they are now at the subway station and there's hundreds of them, and when I look out of my window, I see the children going to school

and know it's their eyes and they are very proud that their eyes are in public space. I go down to the Kotti & Co structure we talked about before, and we just had a bunch of exhibitions out there, even though there's the pandemic. We work with kids and we produce political images on cushions and pillows with a woman in the neighborhood.

Even if there's no pandemic, it's good when you go to art school to take a different subway line or bus some days, or maybe you change the side of the street you walk down. This doesn't just apply to the pandemic, it applies to "normal" life. It's good to change your perspective, especially when you're a creative worker. Change your perspective, change your technique, change your computer, change your thinking. It's a big challenge.

We're a communication design studio, so we're not artists. We have clients and each client is different and we don't reduce the clients to their project, we try to interact on a human level. When we ask "how are you doing" or share stories, it really has a meaning. And that's exactly what I tried to point out with Jeffrey and his toddler in the beginning. That's exactly what cultural production is about for me. We are privileged because we have a lot of different clients, small ones, bigger ones, institutions, activists and this makes every day different, more or less. But I agree these times have less in-person meetings and more online meetings; there are some practical things about it. Some of the meetings are even better, they can be more concentrated and productive, but our bodies are missing. The real feeling, the real sense and smell and the hugs and the small talks outside for the smokers, which are informal and important, are all missing.

I find it very tough for students. I haven't been teaching during the pandemic, but I gave input on some lectures and heard this from my friends who teach. I think it's hard to grow your identity under the pandemic, and this will have an impact on our design, most likely. Maybe there's a good side of it which we don't see today.

I actually think for young people one good side of it is there's a lot less social pressure. I mean there's other pressures and anxiety around lots of things, but I think, particularly for younger kids, it's good to spend a couple years where you're not getting bullied or pressured to be a certain way. When you're around your peers all the time there's a push towards conformity. A lot of younger kids have gotten weird which I think is a really good thing. But overall, I think it's been really challenging. Let's jump in and see if anyone has any questions.

Jeffrey Kenney: [Laughs.] Sandy, you have a question?

Always. What happened to your kid?

Jeffrey Kenney: Yeah, I was just being bothered by a cat in his place, but he's here.

Josh MacPhee: It looks like Don has a hand up.

Don Russell: Josh and I talked a little about how images get recuperated into media. You'll have a radical image and then all of a sudden it's advertising a shoe or some kind of a brand. Initially, I think one's first reaction might be, "how do we own these images?" But Josh countered, saying that it's better that you don't own them, that they go out there and carry the original association and, in fact, enhance the association. I was curious if you had anything along those lines and this idea of image recuperation or assimilation, whether it's a good thing, or how to use that in design.

Well. This can happen on all different kinds of levels, so it's a bit difficult to talk about this on an abstract level. Certain social images we believe in, we want them to enter the mainstream, flood the world, and create solidarity. And there's images which are—I don't know the word, recuperated, I think it means taken over or something like this?

Josh MacPhee: Yeah. It gets used often in a Marxist context in which it is argued that capitalism recuperates its opposition and uses it against that opposition.

This is definitely happening and I don't have a good answer; I think we should be more relaxed about it. I'm quite relaxed about it, I feel.

When I started working, the focus in advertising was on products and campaigns and producing some kind of an image around the product. What we've seen in the last few decades is a shift to values, i.e., capitalism is entering all spheres of our lives and social institutions. That's actually what I find more challenging and threatening, when terms like solidarity, or social, or friends, or family get into advertising. I mean, family has always been in advertising, but you get my point.

I actually believe that when we feel threatened by these things it means we don't trust the recipient, and my experience is that the people, the recipients, are much smarter than we imagine as leftists. So, I'm actually quite relaxed, even though I'm pissed and irritated. Don, I don't know if this answers your question in a fulfilling way.

I used to get really angry when I saw advertising that had absorbed May '68 imagery, like you had mentioned, Sandy. When Occupy happened in 2010 and I joined the Occupy design group here in Zuccotti Park, I was the only one who hadn't gone to design school with formal training. And I realized that May '68 showed up in hamburger advertisements. It wasn't because Burger

King was interested in recuperating May '68, but because the person who was tasked with designing that ad campaign was bored to death, and this was something they were actually interested in, and so they just brought it into the ad campaign to make their work more interesting. From that perspective, May '68 was being used as a way to make life worth living.

There's competing valences on how to read recuperation at all times, and I'm not trying to say that this should be the dominant one or that it's necessarily good or bad. Everything that we make, everything we think, everything we do, is commodified. That's life under capitalism. If we don't like that, it seems to me the way to address it is to actually overthrow capitalism. All the other stuff is almost abstraction. Not to say it's not worth questioning, but ultimately it comes down to power.

Well, as mentioned earlier, I think it's always important to look at the context. We're talking about advertising because it's the closest we can think of at this moment but as I mentioned earlier, it can run the other way. Activists also use branding and techniques from capitalist culture and apply this to activist design.

How do we push certain images into the mainstream, how do we get recuperated in a positive way? This is what I find interesting. It is still a difficult question, one which has always been around, and the core of the question is that we fear that something real is being sold out to something *unreal*, emptied and turned into a product. I think there's too much fear in this. I don't have this fear and it's an important thing to question.

This dovetails with a question from David in the chat; they ask, "What is the best way to spread artwork with a message?' Could you share an example where you've successfully pushed something out of a milieu and into the mainstream, or status quo? What were the tools to make that happen, what was the leverage, how did you get under the image to pop it into that place?

I don't have a good example for one image because—

Maybe a campaign, then.

Well, when I think about politics and design, I have a hard time thinking of anything other than Kotti & Co. We started with this sticker, and I think by now most Berliners understand that in Kottbusser Tor there are not just problems but rather an intersectional community. It's not necessarily one image, it's a flood of different media and formats and events and strategies which then create a more sensitive and complex image—of a neighborhood in this example. There is no one best way to distribute an image. It depends on your aim, where you're talking about; sometimes certain images should stay in

one room, they're very private, you take them to the bathroom. Some images want to be shown to the whole world. It's a huge question, I can't answer the question simply.

What I've always found interesting though, and I explained this a few examples earlier, is challenging the core audience. When you design for the Right to the City movement, or for some leftists, for instance antiracist activists, they have certain expectations of how images should look and what the content is—as we just talked about with the fist. But life is so complex, and never single-issue. I want to distribute images which don't preach to the converted, but convert the converted again, let's put it this way. The question is very big.

Huge.

Huge, sorry.

No, no, no, no, I was agreeing.

Jeffrey Kenney: Guys, I think that may be a good spot to end today unless anyone has any last questions for either of our guests.

I would like to point out something maybe at the end Jeff—oh, you have a cat.

Yassmina Youssif: Yes, so my question real quick was you mentioned at the beginning that you were influenced by the student revolution, or like the French graphic tradition, if you could elaborate a little more on that.

The '68 revolt in France, and especially in Paris, also reached the art schools. There was a student revolt and also a working-class revolt going on in the country. That's the starting point where artists and designers go out in the streets and confront themselves with social conflict, so this was interesting to look at. Some images still circulate from the Atelier Populaire; they held popular studios, open studios, where they silk-screened posters and brought them out to the streets, to demonstrations.

Growing out of this context, there was a group of graphic artists who called themselves Grapus. They were called Stalinists by right-wing people, so they made their name a play on the words "graphic design" and "Stalinists," merging them into "Grapus." What interests me about this group is that on one side they were, aesthetically, strongly influenced by poster design from Poland, but they also worked in a collage style, with influences from John Heartfield and the 1920s, but also with image inventions. When we talked earlier about social images, we talked about working with image inventions which challenge our brain to see the world from a different angle and Grapus was very much about this.

I'll give you a story which I like to tell because my professor was Alex Jordan, a member of this group. A couple years after they founded the collective they were asked to do an advertising campaign for a rundown neighborhood in Paris—I think it was in Paris, maybe a different city. They were asked by the city council, "could you make us a poster campaign for this neighborhood?" They went to this neighborhood and saw that the whole place was already full of advertising posters, and so they imagined what would happen if they just added another—of course a great one, much better image-wise, an interesting poster—but then they felt, "well, what are the problems of this neighborhood actually? What are we communicating here? Are we doing an image campaign or are we making some kind of change, are we helping to make things better in this poor neighborhood?"

They took the budget of the poster commission and organized a street fair with hundreds of people, and they invited social workers, politicians, teachers, children, schools, and they handed out a questionnaire about this neighborhood. People filled out all these questionnaires, Grapus had meetings and discussions, and at the end decided, "well, we're not going to design posters. We're going to design a book about this neighborhood where all the knowledge we assembled during the street fair is put together in one publication. And we're going to try to force city council to give this publication as a present to every newborn child in this neighborhood and to their family."

This was very inspiring to me because it was not, "oh, you're a designer, make a poster." It's not about designing posters, it's about locating problems and digging deeper into what they really are. Posters are great, no doubt. Design is great, no doubt. But what's really interesting is what's behind the posters and the problems.

There was one saying about Grapus, "You order underwear but you get a jacket." I liked this attitude, to challenge the client and to work beyond the contract and that was beside all the political context and the content. I always found it interesting to not only go beyond the edge of the paper, but also beyond the contract.

The second interesting part is that Grapus worked as a collective. They had started very small and became very big. They designed the Louvre, for instance, big city campaigns for Auberville, and cultural centers. But they also worked for the Socialist Party, the Communist trade union,[7] and they always did a lot of things for free.

When I traveled to Paris in 1999 or 2000, I visited a lot of collectives which emerged out of this group and I was super welcomed and people took time, one of the greatest things was everybody had presents to give away, and everybody had examples of what they did for free for activists, and then at the same time, for huge museums. French-style, you'd sit together and drink wine at noon and have some great cheese and bread, which you will never have in Germany or in the US. Well, probably now thanks to globalization, we have that.

On my website you can find a catalog with interviews I did with these French designers. It's a shame we haven't translated them because they're quite simple, in a positive way. I don't know if you say that, but they're quite strong in their language and very much to the point.

Josh MacPhee: You have this un-manifesto, this thirteen-point (not) program that you wrote.[8] One of the points in it is that you work for society, not for your clients, and I think that that's exactly what you're addressing and is a good sort of final statement. You said you wanted to say something also, before we sign off.

I still want to know what "graphic liberation" can be, but maybe we have to make another appointment for this. I just wanted to point out that we are probably mixing up several things: we're talking about graphic design, we're talking about art, we're talking about communication design, but there's also information design, there's now user experience, user interface, social design, strategic design, and there's typography. It's totally fair to say I'm an illustrator, I draw images; or I'm a graphic designer, I want to make posters; this is totally fine. Everybody has to find their own passion and be happy about it. But when we talk about the field of engaged visual communication and politics, then we have to be specific about these categories, because they can have different meanings. I should have said this in the very beginning, I suppose.

We can also mark up the sandbox by crossing the paths. Maybe things can come out of that as well.

NOTES

1. The exhibition Signs of Change: Social Movement Cultures, 1960s to Now, September 20–December 6, 2008, Exit Art, New York City.

2. Flyposting is a term for wheatpasting posters on the street.

3. The reference in the catalog is actually French designer Pascal Colrat paraphrasing Cieślewicz; see Sandy Kaltenborn and Holger Bedurke, Politisch/Soziales Engagement & Grafik Design (Berlin: nGbK, 2000), 59.

4. While Jeffrey Kenney, the gallery director who hosted the talk, was attempting to introduce, his son was wriggling around in his lap and making loud kid noises, productively interrupting—to everyone's delight.

5. A4 is a European standard paper size—210 x 297 millimeters or 8.27 x 11.7 inches—the formal equivalent to a North American letter-sized sheet (8.5 x 11 inches).

6. Cerberus Capital Management is a US-owned, international private-equity firm.

7. Referring to the national trade union center, the General Confederation of Labor [Confédération Générale du Travail], or CGT.

8. As of today, this document has still not been translated and published in English. I had intended to publish an annotated translation in Signal: A Journal of International Political Graphics and Culture, but for a number of reasons, this still hasn't happened.

ALISON ALDER

THROUGHOUT THE LATE 1990S AND the early 2000s, I obsessively collected books about political posters. I had heard of poster collectives in Australia, and even caught glimpses of their output in surveys of political posters, but it wasn't until I was at a used bookstore and stumbled on Anna Zagala's <u>Redback Graphix</u> (Canberra: National Gallery of Australia, 2008) that I truly began to understand the breadth of the country's poster tradition. Not only is it a comprehensive overview of Redback—one of Australia's most important and impactful print collectives—but it was my introduction to the work of Alison Alder. My fascination with Australian posters, and their copious use of neon inks, sat on the back burner until 2018 when who walked through the door of Interference Archive, but Alison Alder!

We hit it off immediately, and she donated a copy of Chris Wallace's book <u>Megalomania: 33 Years of Posters Made at Megalo Print Studio 1980–2013</u> (Canberra: Megalo, 2013) to the Archive. With this I discovered that not only had Alison been a part of Redback Graphix, she previously cofounded Megalo in 1980. After Megalo and Redback, she worked within Indigenous Australian communities, as well as teaching printmaking at multiple universities. Although she was only in the US for a brief period, we made plans to stay in touch and pull together an exhibition of Australian posters to hang at Interference. If anyone had the ability to quickly produce a forty-piece, deep history of Australian political posters, it was Alison. Less than a year later, <u>Hi-Vis: Australian Political Posters 1979–2019</u> was the result, running from February through April 2019.

It was a real pleasure to reconnect and converse with Alison on March 2, 2021, and learn about her new work focusing on archives and feminist histories of Australia.

Q. If the unemployed are dole bludgers, What the fuck are the idle rich?

Michael Callaghan, <u>If the Unemployed are Dole Bludgers</u>, screen print on paper, Australia, 1979.

↑Alison Alder: I thought this image might be of interest. It was produced in 1979 by Michael Callaghan, who was one of the founders of a poster collective called Redback Graphix. It is an indicator of the vibrancy of the printing process that was used at Redback Graphix in the early 1980s and also the directness of the messages. I think the message is still totally relevant, especially in light of what is currently happening in Australia, which I can talk more about later.

↓&→I created these screen-printed posters—decades apart. The one on the right, *When they close a pit they kill a community*, was produced at Redback Graphix in 1984 when I worked with the Miners' Women's Auxiliary, who worked alongside the Miners' Union. The poster on the following page is a reprise of the original poster which I produced a couple of years ago in recognition of the achievements of the Auxiliary and to encourage action now. I was trying to pay homage to their work and not lose sight of their legacy, as the Women's Auxiliary were an integral activist organization, from the early 1930s onwards, who contributed richly to many campaigns.

Alison Alder, When they close a pit they kill a community, screen print on paper, Australia, 1984.

Alison Alder, _Treaty Time_, screen print on paper, Australia, 2019.

→ This poster, _Get Out_, is another recent work that was produced for social housing residents in Sydney, in a neighborhood undergoing extreme gentrification. If you know Sydney, there is a beautiful area on the harbor, underneath the harbor bridge and opposite the Australian Opera House, called The Rocks. It is an historic area which traditionally provided housing for maritime and waterside workers, and it has included social housing since the nineteenth century. The New South Wales government, the state, decided to sell off the public housing assets, and this poster was created as part of a campaign to try and save that housing. It is a screen print which reproduces and includes annotations on a letter sent to a resident from the government.

**Family &
Community Services**

NSW GOVERNMENT

19th March 2014

The Rocks NSW 2000

Dear

GET OUT

MOVING TO A NEW HOME

I am writing to you today to inform you that government owned properties in Millers Point area will be sold, including the home you occupy. I want to assure you that we will help you to r**TO GET OUT**e and to also try and help reduce the stress involved in moving as much as we possibly can.

The decision to sell properties in Millers Point was balanced against the costs associated with keeping these properties in government ownership compared to how many more people we **GET OUT** who need our assistance.

For some tenants, n**GETTING OUT**e will be a welcome opportunity to move closer to family or friends. For others, we recognise that this will be a difficult process.

We have an experienced specialist relocations team available to help you to **GET OUT** You will have your own dedicated person who will work with you to **MAKE SURE YOU GET OUT** You will be given as much choice as possible about the area you want to move to and the home you want to live in.

Your Specialist Relocations Officer is there to make **SURE YOU GET OUT** le and assist you to settle into your new home.

In the next week, we will call you **TO ENSURE YOU GET OUT** nt so you can discuss where you want to live, including any support you currently have in place and need in your new home.

So this is not a financial burden on you, we will pay for you **YOU TO GET OUT** at includes removalist costs, redirection of your mail for 3 months, improvements to your home (in certain circumstances) and reconnection of electricity, gas, telephone and internet.

You may choose to have someone else present at the meeting with the Specialist Relocations Office **TO MAKE SURE** e **YOU GET** our **OUT WITHOUT A FUSS**

We will be in touch with you in the next week to s**GET OUT QUICK** ng. In the meantime should you have any questions please do not hesitate to contact the specialist relocation team on 1800 153 033 or via email on relocationteam@facs.nsw.gov.au.

We will make every effort to ensure **YOU GET OUT** f**QUICK** ossible for you.

Yours sincerely

Family and Community Services, Housing NSW

Alison Alder, Get Out Quick, screen print on paper, Australia, 2015.

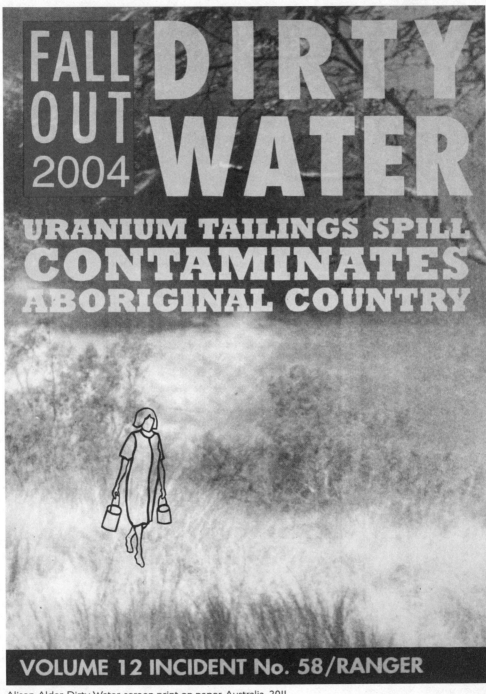

Alison Alder, <u>Dirty Water</u>, screen print on paper, Australia, 2011.

Alison Alder, <u>Still Waiting for Tomorrow</u>, digital and screen print on paper, Australia, 2020.

←I lived in the Northern Territory for many years, which, as the name implies, is in northern Australia, where I worked with Indigenous communities in art and cultural centers. I became involved in a nationwide movement campaigning around the impact of uranium mining and nuclear waste being dumped on Aboriginal country. I made a series of about eighteen posters (and animations of these posters) to distribute and show in civic centers, on shop-front windows, and in city galleries to stop the dumping of uranium waste on Aboriginal land, in particular on a government-identified site called Muckaty Station about 250 kilometers north of where I lived. The traditional owners of that area had only recently been given the land back, so it was particularly galling that they would lose it yet again. Fortunately, the campaign was successful.

↑This work is really recent, and it is having its first outing on Saturday, in a couple of days' time. I have been looking back through archives at feminist campaign ephemera and attempting to demonstrate how relevant these works are to issues today by reprinting and then annotating the documents. The earliest piece I have worked on so far is from 1927. The documents are spread

out and installed as though you have walked into a feminist meeting room or something like that. I want people to be able to read and handle them in order to reflect on what has and hasn't changed.

Josh MacPhee: This is a great space for us to jump into this conversation. When we did our Australian political poster exhibition here in Brooklyn I was not surprised, but a little distressed, at the level of ignorance that myself and almost every single person that came to the show had about Australia. My guess is that a lot of people who are reading this don't have much history about not only Australian graphics, but probably almost anything in the Australian context, so I was hoping that you could start us off by giving us the lay of the land, so to speak. Like a lot of countries, Australia has this amazingly rich poster and graphic tradition, screen-printing tradition, that goes back to the late 1960s and early seventies. If you could give us the boilerplate history, where you enter into it and some of your experiences?

Well, I think the graphic tradition in Australia has been strong since probably the 1920s or thirties, but in terms of screen printing, which is where my interest arose, it would definitely be from the early seventies. There were poster collectives because there was no access to the mainstream media. There are a few key poster collectives that started in the 1970s in the major population centers like Sydney and Melbourne, like Earthworks for example, and then in the eighties, those collectives expanded to just about every major population center in every state. There was a huge network of screen-printed graphic material being produced around all sorts of social issues. Posters would advertise dances or events, for example, but also social movements like anti-uranium mining, prison reform, or rape crisis centers. Indigenous Land Rights were a big focus for a lot of people, and still are.

Every country has a style and in Australia it was very, very bright colors, very bold, straightforward images. At Redback Graphix we used fluorescent inks at the beginning because they were cheaper than standard ink, and then it just became a style. You could lay colors over each other and make supplementary colors. It was an economic decision, but they also really worked on the street. Most poster collectives lasted until the late 1980s, early nineties, when digital printing or offset printing became cheaper and then of course online media. However, there are quite a few artists still producing screen-printed posters. There is a keen interest in a do-it-yourself ethos and distribution of work that has a longer shelf life than a digital image. That really interests me—that it's coming back. A lot of the students that I work with make posters and use them for things like climate action strikes, all sorts of things. It's quite an interesting cycle, and it tends to be ten years as people rediscover posters over and over again. A lot of the screen-printed images from the 1970s and 1980s are now shown in galleries because there is an increasing interest in activism.

To my understanding, almost all of those posters were produced in some form of collective context—the groups and print shops were organized collectively. It's interesting because from what I've read about Redback and Megalo and Earthworks, most of the posters on the street would be anonymous, they would have a logo that was from the studio, but now when you see these images, they are all attributed to specific artists. What is this tension between anonymity and attribution, or collectivity versus authorship, to put it another way? How did that play out on the ground?

It was very contentious, actually. I wasn't part of Earthworks Poster Collective, I'm the next slight generation along, but Earthworks organized an exhibition that was held in a private commercial gallery. I remember that somebody graffitied on the gallery wall: "posters don't belong in a gallery, they belong on the street." There was tension there which included institutional galleries becoming interested in posters, because they were describing an aspect of Australian cultural life that wasn't represented in the mainstream institutional art sector, and how collectives and artists managed that interest.

Josh and I were talking before that collectors were building poster collections by ripping posters off the streets. There was a discussion about how we navigated that, because at the same time the Art Workers Union was agitating for artists to be paid appropriately for their work. Artists were starting to recognize their own rights in terms of being adequately compensated and recognized for their intellectual labor. Slowly people started to put both the collective symbol and sometimes their name on their work. You were part of a collective but you were also recognized for your own artistic integrity.

The Art Workers Union started a campaign where we stamped the back of the posters we sold, so if the poster hadn't been stamped and signed, we knew the institution hadn't bought the work. People got pretty upset. For example, we would sell a poster to an individual person on the street for fifteen dollars [AUS], but we might charge an institution $200. The institutions were pretty pissed about that, they thought that was pretty rough. But we thought it was fair. You know, they were prepared to pay an artist who makes a painting $2000, but they weren't prepared to pay a poster maker $200, so it was an equity campaign. Obviously, people did the wrong thing and posters got into the galleries through all sorts of means, but generally speaking, most people started to recognize that the screen prints were bona fide pieces of art that deserved a proper price if they were going to go into an institution.

We don't have a coherent Art Workers Union in the US at all, so could you—

Ever? Have you ever had one?

I mean not in the same way, maybe back during the Works Progress Administration (WPA) in the 1930s. Could you walk us through what that campaign looked like, how did people organize to get institutions to play ball?

I wouldn't say it was a big campaign; it's not that many people, you have to remember that. Australia doesn't have the same population base as the US. In Sydney, for example, the Art Workers Union was a small number of people agitating on specific issues. There is no Art Workers Union now, but there is a National Association for Visual Arts (NAVA) which is similar to a union in that it recommends pay rates for artists, lobbies the government regarding funding and cultural policy, etc. If somebody wants to engage an artist, they can look at the pay rates that NAVA has put forward as being adequate recompense for that sort of work. The Art Workers Union grew into those more formal industry bodies that still operate. For example, if you are an independent artist and you get a job to paint a mural or something, you probably need liability insurance, so NAVA can help you get that. It is an industry organization, not a union per se, but they still agitate on our issues. For example, if our government decides to defund the National Arts Funding Organization[1]— which they do regularly—NAVA lobbies the government over that. So those things still do operate in Australia. I would have thought the US, with its strong history of unionism, would have had an Art Workers Union.

Within applied arts there's more formal structures. But in the contemporary art world in the US, I mean, let's just cut to it, it is one of the world's largest money-laundering operations, it's not a particularly easy site for organizing.
 The other thing that is striking to me about the posters within the Australian context is how the collectives, seemingly pretty quickly moved from doing individual works that were speaking to outrage around social issues—with a pretty strong anti-authoritarian, almost anarchist perspective—to becoming, from the outside at least, what looks like designers and printers for social services and the nonprofit sector. How did people negotiate that?

It's quite interesting, actually. Redback Graphix is a really good model for that. When Redback Graphix started, the idea was that it wasn't ever going to be what we call an "open-access print studio"—nobody could just come in and use the studio; it was a defined group of people and its charter was to be an advertising agency for the left and for social issues. Most of the work was produced through a network of associates or friends who worked in different social organizations—like maybe a housing organization or a women's health center or a remote Indigenous media organization or something like that. We would support each other; they would say we need something to promote our housing association needs, they would find some money to cover costs and we would print the work. We would keep aside a certain number of works

to sell to try and increase our income. The income generated, and the maintenance of a functional studio, also enabled us to make work around issues important to us as a group or individually.

We individually and collectively applied for, and sometimes received, government grants at the same time as taking on government contracts to plough back into the studio—it was quite a flamboyant business model. It worked really well for quite a long period of time. We actually employed ourselves, with everyone on the same, admittedly low pay rate, which was remarkable because a lot of collectives either relied on voluntary labor or totally on government grants. Redback Graphix had a mix of cooperation, government support, business, and entrepreneurship. We would do things like approach the Australian Council of Trade Unions (ACTU) and say, "we think you need to promote your aims, why don't you get us to make you four giant prints? They are going to be the best thing you have ever seen in your life, and you should pay us a lot to do it," and they would go, "oh, okay." And then we would. That work would not only promote their aims, but also engage our skills in forwarding a left agenda to a really broad audience. In fact, a lot of those posters are still on the walls in major union offices around the country.

Was that work put up in the street as well?

No, the work we produced for the ACTU wasn't for the street. But for the majority of work we made it depends on what you call "the street." For example, we did a major campaign for the Australian government on HIV/AIDS and those works would be in health centers, the Navy ordered a whole set of them to put up on ships, they would be on walls outside community centers, and in shop fronts. The government paid for a lot to be printed in different iterations for different sectors of society. The work was ephemeral but some lasted longer than others. You can still go to outback health centers in remote areas and see those posters on the wall, thirty years later.

That arc sounds a lot like what happened with movement print shops here in the US that emerged out of the New Left in the 1960s and '70s, but they were almost entirely offset shops. There was very little sustained use of more traditional or fine-art printmaking in an ongoing, consistently political way.

It was definitely not just agitprop, it was people making these posters as a high-end art form. I was talking to a curator of Australian prints recently who underlined that the content of these works was so considered and so conceptually rigorous and so beautifully printed, and also useful at the same time. It is quite remarkable that so much care was taken with this work that was ephemeral, and the editions were relatively small. Well, some weren't small. Are you aware of the poster *Condoman*?

Probably one of the most famous Australian political posters.

Alison Alder: Yeah, so *Condoman*. I started to really, really hate *Condoman*.

Can you describe it really quickly?

Yes, *Condoman* was an Australian government initiative/campaign that was originally started for First Nation people in North Queensland, to alert them to the dangers of HIV/AIDS and to wear condoms.[2] The first one was a very small edition which was loosely based on the Phantom superhero, of the *Phantom* comic, because Northern Australian communities really loved Phantom. And then unfortunately King Comics, who owned Phantom, decided to sue the Australian government and us for developing an Australian version of Phantom, but fortunately a lawyer in the Attorney General's office convinced King Comics that it was their duty as part of this public health campaign not to do that. Which was lucky, because they were a multinational corporation with heaps of money and there is no way that we would have survived a lawsuit. We had to adjust the artwork a bit, but *Condoman* went on to have numerous editions—we probably printed a couple of thousand of them in the end, maybe more. He was printed on t-shirts and on caps and badges and frisbees and all sorts of things in the end, and he went all over the place, internationally as well. That started off as something quite small, but then became a really, really big thing and generated a lot of interest for those sorts of projects as it was such an effective work. They were all screen printed, which was remarkable and probably crazy. I don't think that would happen now, but it is why the posters had that intensity of color, or similar sort of high-key colors.

This feeds right into another question. I'm personally very interested in the way images get repurposed and reused and reimagined. There's a long tradition of that in most of the world and there are certain images that we see over and over again, whether it's variations on things that were created in May '68 by the Ateliers Populaire or Gran Fury graphics from ACT UP, Posada's images from the Mexican Revolution or Constructivist imagery from the Russian Revolution. It's interesting that as far as I can tell, Australia has an almost entirely unique set of visual signposts. I haven't seen anything that references May '68 directly, for instance, and even the posters that are very punk don't look like US or UK punk, they look uniquely Australian, particularly with the neon. Are there examples of posters you made getting redesigned by other people? Is there the same kind of cannibalizing of a political poster canon?

I am not aware of people cannibalizing our images and I think you might be right that a lot of them were unique, but at the same time I must admit we would cannibalize images from, for example, 1930s Australian union

movement graphics, which were slightly more British than American in their style. We would steal Posada, for example, that was quite common. We would also use the May '68 graphics, you know the raised fist or factory outlines, roofscapes. But I think you are right, generally speaking, we were fairly independent in our outlook. Rather than political graphics, we drew a lot more from 1950s magazines, ripping off women's magazines or *Home Beautiful*;[3] newspapers, we would pinch graphics from there. It was fairly open slather.

One of Michael Callaghan's more famous posters was for a dance called *What Now, Mr. Mao?* which featured a photograph of two Chinese people holding up cans of Coca-Cola that was lifted from a Chinese newspaper or something. So you know, we would rip off other people's work, but I'm not that aware of people ripping off our work too much. I don't know, maybe the work wasn't that great [laughs].

I wonder if it has to do with these questions of authorship, that a lot of the visual material that really circulates has been untethered from its original authorship on some level; people use it and reuse it without realizing where it's come from. It seems like you had such a unique and indelible stamp of "we made this" that it was harder to incorporate without the original intent overcoming the new meaning that people wanted to put on it.

Yeah. It's also maybe because Australia has a smaller population. Most poster makers would know each other, or at least know of each other. It's a pretty small community in that respect, mainly clustered around the southeast coast of Australia, so that's likely part of the reason. I'm not sure, it's an interesting question. I'll think about that.

Taking a bit of a detour—what was it like to be a feminist in these collectives that were mixed gender and seem to have had very strong male figures that tended to be more recognized than a lot of the women?

When I started at Redback Graphix, the two people that started it, Michael and Gregor, were already very well known. Redback Graphix was quite famous, it had been going for four or five years before I came on board. I joined as a trainee; I had gotten some funding from the Australia Council for the Arts so I could apprentice for a year. At the same time, some others joined and one of them was a terrific artist, a woman named Leonie Lane.

It was a bit of a boys-y culture and Leonie and I were pretty determined to have a feminist impact on the organization, not only in the culture of the collective, but in the type of work that we made. Some of the work became a bit softer in ways and we tried not to imitate the style of Michael and Gregor, so there was a concerted effort to put our own mark on the "style."

At the same time, there were a lot of explicitly feminist poster

collectives, places like Women's Warehouse and Jill Posters for example, there were heaps. There were a lot of women working in the poster area, and I would contend that the work made by the women was often better than the men, it's just that it wasn't picked up at the time, although now it is being reevaluated. There have been exhibitions of all the work that the women at the Tin Sheds made, which is where Earthworks Poster Collective, Lucifoil Collective, and the Tin Shed Art Collective were housed.[4] That work has now been elevated and lifted up with new scholarship surrounding the production of those works by women. That history is being redressed as we speak.

An academic, Louise R. Mayhew, recently undertook research for a PhD on feminist poster collectives in the 1970s and eighties in Australia. Megalo, which was a poster collective in Canberra where I worked, did a lot of work for feminists—like the Women Against Rape (WAR) movement, women's housing movements, anti-sexual harassment campaigns, and work for rape crisis centers. I suspect those works are probably more well-known than perhaps the work that the men were doing, which was more about general issues, I suppose, rather than such specific ones. I haven't really thought about it that much, Josh.

It is all being reappraised now. Maybe back in the day if you asked who the Australian poster makers were, people might have just said Michael Callaghan, Gregor Cullen, Chips Mackinolty, Paul Worstead. But now they're more likely to say people like Marie McMahon, Jan Mackay, Annie Newmarch, Mandy Martin. There is a whole legacy of amazing women poster makers whose names are probably better known now and increasingly being put forward. There is a big exhibition on at the moment called *Know My Name*, at the National Gallery of Australia, and it is an exhibition of women's artwork from 1900 to now.[5] Its main goal is to redress the gender imbalance within the collection of the National Gallery, so they are trying to bring forward that work. There is a big wall of work made by women poster makers, which is about collectivity and collaboration. It's really interesting that this is now being put forward as a major moment of Australian cultural life.

Yeah, that's high profile.

It's fairly common for artists with political commitments to jump around and address many different issues—"Oh, there's a war happening, how can I do something about that?" Most artists do that to some extent, but you invested decades into doing some very focused work with Indigenous communities, around mining, antinuclear activity, and feminist issues. Do you have some lessons learned or ideas to bring forward about the joys and difficulties of what it really takes to work closely with people who are organizing politically on the ground?

I think when I first started at Redback, I got a little bit uncomfortable. I didn't

want to be a hired gun for any left-wing organization that needed my graphic services. I felt uncomfortable if I wasn't really invested in the issue. In fact, that poster that I made for the Miners' Women's Auxiliary I showed earlier is a really good example. When I made it, I had only been working at Redback a couple of months; the Women's Auxiliary approached the organization and they wanted a woman to do this work for them, so I got the job. I really didn't know anything about the Miners' Union or the Auxiliary or Wollongong, which is a steel city south of Sydney where the organization was based, and I had to throw myself into this job without actually knowing anything. I was very naive and pretty gauche, and I felt completely intimidated by these very strong union women who were a lot older than me, they were probably in their mid-fifties and no doubt thought I was a really gormless, stupid girl. I felt pretty anxious!

I had already worked for First Nations people in Indigenous organizations and I was interested in First Nations rights because it was and is such a huge issue in Australia. After a couple years I decided that I needed to know more, and that I needed to commit to understanding the issues from the ground up. I ended up working for Indigenous organizations directly for many, many years. Your life goes through all these twists and turns and learning about that side of Australian history was probably one of the more important pivots in mine. It engendered an interest in how history is presented, both through the media and literature, but also graphically. I wanted to learn how to put forward a perspective that was mine, built from knowledge, rather than talking for other people. I wanted to talk from my heart, rather than just present somebody else's idea. That was a really big leap for me, which I still aspire to now.

I work at a university now, and quite a few students are interested in getting involved in campaigns, and I tell them they need to know everything they can about that issue from a place of knowledge and commitment, not just a show pony position.

When I look back now, after forty years of working as a poster maker, there are key themes that are consistent throughout that whole trajectory. There are a couple of little pivots here and there, but generally speaking it's feminism, rewriting Australia's history, and First Nations issues—how Australia needs to wake up to itself. Anti-men-in-power is becoming increasingly part of my campaign these days!

How long did it take to make that Women's Auxiliary poster?

Oh, it took quite a while because I was super anxious. It was a test in so many ways; a test of whether I could make a decent screen-printed poster for this organization that was already pretty famous, a test to see if I would make the women happy because they're pretty tough clients, and a test of how I would

put forward their ideas. To put it into context: the Miners' Women's Auxiliary is based in Wollongong, it's a steel city, and there was coal mining up and down the coast between Sydney and Wollongong. The district has a really strong labour history and that is where Redback Graphix was first situated. I didn't really know that much about that union history. I was only a young girl, really.

I went back recently because Wollongong had an art project called Future Feminist Archive, and part of that was to get me to look back at the archives of those women and think about the work I made and make new work in response. Looking at the archives was amazing because their activism was so inspiring, and I didn't even know about it when I made that poster. The Auxiliary had been involved in First Nations issues, land rights struggles, since the early 1950s. They had been part of this major campaign called the Wave Hill Walk-Off or the "Gurindji strike,"[6] which started the whole First Nations land rights movement. They were involved in housing issues, feminist issues; they used to type resolutions on scraps of paper and send them off to people like the President of France about the nuclear testing in the Pacific, for example, or they would write to the Australian Prime Minister about land rights and all these replies would come back. That is when people wrote letters and you would get an answer back, rather than when I write to politicians now and I don't ever hear back.

When I presented the new poster at the launch of the Future Feminist Archive project in Wollongong, one of the key organizers of the South Coast Trades and Labour movement[7] came to the opening and he said that the original poster—which had been made nearly forty years ago—was still used as part of the campaign, they just changed the text in the box. It was always really popular, carried in marches and campaigns for many, many years. He said the woman whose image is on the poster was an incredible person and she really loved the image. I guess I was lucky, Josh. I was lucky that I managed to do something that they liked, because I really didn't know anything.

I love that poster, I love the tactility of the dress, the patterning on the top and bottom. And I'm really knocked out by the reimagining. The original poster illustrates how quickly our understanding of things can change. We know a lot more now than we did in 1980, and right now we know we need to close the mines if we're gonna survive on this planet. It's a really interesting example of how to negotiate having created a very powerful image for something that you ultimately realize you don't want.

Yes, we were wrong. We didn't know. Well, actually, some people probably did know, but the general public didn't know. Coal mining in Australia now is a hugely contentious issue that is fraught with political interference and misinformation. It is probably one of the biggest, ugliest issues the nation is facing at

the moment, so it is interesting to see that poster now, in that context.

Is that tension articulated in a First Nations versus working-class Australians framework—

No. It's mainly a political construct, which is based on misinformation and vested interests of the mining industry, I would say.

DeWitt Godfrey: I'm curious about the last image Josh showed, the new project that you're working on and the way in which it taps into the idea of mining one archive to generate another. Could you talk about that a little bit?

I was thinking about how ephemera can so easily be lost. Some of the graphic material in this ephemera I find fascinating—and I'm going to sound like a university academic now—I just love the materiality of the objects themselves.

There is a fantastic union archive, called the Noel Butlin Archives Centre, here at the Australian National University and I just chanced upon some feminist ephemera there and I was amazed as I was looking through it. Ninety percent of the issues are still relevant today, even with the material going back to 1927, the earliest piece I have found so far. It was a fantastic document, its title in this really spindly typography, *Militant Women of Australia Must Never Give In* or something like that, and I just thought, too right, sister!

I decided to reprise some of it, and coincidentally another organization called the Gender Institute was interested in the project, as well as another woman thinking through the same issues. I have been part of this art working group called Future Feminist Archive for quite a few years now, which is part of another collective called Contemporary Art and Feminism, which investigates hidden archives. For example, in Wollongong, the city that I was talking about earlier, there are archives of feminist housing organizations that aren't really ever going to be public or collected by institutions—and will in all likelihood just disappear. We are trying to save them because we want to preserve the cultural history and memory of those women.

That is what I felt about these graphics I have been working on. They are so strong; I think they deserve to be seen and reimagined. Of course, I have anxiety about using other people's work in some ways, but I have made sure that I gratefully acknowledge the original artists, even if I don't know who they are, and hope that they will be happy with what I have done to their work [laughs].

I just read an article about the *Know My Name* exhibition at the National Gallery, which posits itself as the first show of Australian women artists—and of course, it is not the first, there have been surveys of women artists' work going back decades. It is a constant amnesia about what has happened before.

We need to look back to know how to move forward and not reinvent the wheel over and over again.

Audience: Community has long been a popular political buzzword thrown around by exclusive neoliberal institutions to craft their public image, but actual community powered, grassroots, artistic and political organizations, like Tin Sheds and the Australian poster workshops are usually among the slowest to be recognized as relevant and visible by the same institutions. Tin Sheds was once attached to the university, then abandoned, then reabsorbed once it became useful again for historical bragging rights. There're so many other examples of this kind of dynamic. Do you think we can recharge or recapture community as a political and artistic term and strategy that is meaningful, rather than just for show?

Oh yeah, definitely. That's the thing, when organizations start, they might not be known or recognized. Like Megalo Print Studio when it was first operating in the early 1980s, it was very much on the sidelines and not recognized as being a bona-fide community organization, employment organization, art organization, or anything. I think those things come later, just by dint of hanging around perhaps.

 I don't think we need to grovel for institutional recognition, either. Maybe if you're trying to push your work towards receiving that recognition you are not making the right sort of work because you are not targeting the right audience. The fact is, there are lots of community organizations doing meaningful work right now; they exist, whether or not they are recognized by the mainstream.

Josh MacPhee: Slow recognition can actually work to an organization's benefit, because when big institutions come in with budgets and a promise of big platforms it's really easy to lose direction or get sidelined. Sometimes working in the margins, while it could limit your impact in some universal sense, can actually maximize your impact in a much more local, direct way. Not your rhetorical or conceptual community, but the physical group of people that you work with, who are affected by your work, who are impacted by being able to do it with as little intervention as possible. That can sometimes really help build the base needed to scale up at some point.

I totally agree. I am going to be leaving the university shortly, because I want to get back into more grassroots, community-based work. I don't want to have to put my work through the research office or whatever. I want to do it without the constraints of institutional approval. It is important to think where you want to situate your work, how you want to make it, and where you want it to go. Institutional applause isn't necessarily the best thing. It can be useful

when you go for grants and things, but it's not the only thing.

Josh MacPhee: And we need to fight for our language. The art world has done a tremendous amount of violence to our shared understanding of even simple words. There are hundreds of art collectives that are just one person. That is, by definition, not a collective! We have so few words and resources to actually describe our sociality, I don't want to give those up—we need them, we need to be able to actually talk about us rather than just me. It's not a question of do we or don't we give up on the word "community." It's essential that we figure out how to give it its meaning back because it's central to who we are.

Audience: What are the challenges of using political graphics against the overwhelming amount of imagery seen on social media today, in comparison with the use of graphics in the last century? How do you negotiate the digital world?

I really do think there's room for both. I love the fact that I can make a physical object, and then I can also distribute it digitally and it could have ten times the impact. Yet digital is more ephemeral than even a piece of printed "ephemera"; it's very hard to go back and find digital material again. That is why I still like making objects—they're there, they exist. I've been making these pieces of physical ephemera recently and it is amazing how many people want to hand them around or put them on a wall or keep them so that they are not lost. But maybe I'm just showing my age with that, I don't know. I just like having the physical thing.

My partner publishes a newspaper, so the idea that somebody can leave that on the table and then twenty other people can just pick it up, without actually having to know ahead of time that it exists—I think it is important that it is there without having to search for it. What do you think, Josh? You think more about this than me, maybe?

Josh MacPhee: There's no doubt that almost everyone I know feels completely overwhelmed by the sheer amount of information that bombards us, and images are an increasingly large part of that. The physical allows us to take a moment with something that has limits, there are edges to the page, and to actually enjoy it within its own limits rather than as part of the endless scroll.

I'm amazed at how many things I've made as physical prints, which are then put online as graphics, get downloaded by people from halfway around the country or even the world, who print it out again and bring it to a demonstration. There are ways that the digital can facilitate the physical and vice versa, we just need to maybe let go of some control in order for that to happen. It becomes what happens, happens. I offered it up, but I certainly

didn't negotiate it, I didn't talk to those people, I don't have a relationship, and that's fine.

Audience: Australia is not without its own racial tensions woven with deep colonial roots and Indigenous trauma. Of course, being a woman brings its own difficulties and intersected with race the oppression multiplies. How have the communities you're a part of fought for reparations and justice for Indigenous peoples and women of color? Are there collectives for these communities and the artistic currents in Southern Australia?

That's a very complicated question. First of all, I haven't been part of a collective, but I have been employed by and lived in the community. One huge project I worked on was to develop a cultural center to present the First Nations' perspective on the history and culture of a large region in Central Australia. The community negotiated with major museums in the southern states for the return of material objects stolen early last century and, using a visual language (which was developed collectively and approved by elders), create works that presented Warumungu facts regarding the land pre- and post-white settlement to be displayed at Nyinkka Nyunyu Art and Culture Centre, which was conceptualized in 1995 and finally opened in 2003. During this project I learned to listen and step back. The older women very firmly told me that I needed "lifting up" as they were going to teach me the proper, *Wumpurrarni* (or blackfella) way of doing things.

Some posters from back in the day are now being questioned: "Why wasn't this poster, about First Nations issues, created by an Indigenous person?"; or "Why did you make a poster championing coal mining?" These are interesting questions to consider. Information and attitudes change as the decades pass. Looking back now, I am happy to review what I did in the past, not to decry or feel overly anxious about the work but to consider the context of how and when the works were made, heed the lessons learned, and try to keep learning. What else can you do?

NOTES

1. This organization is now known as the Australia Council for the Arts.
2. Condoman Says: Use Condoms! is a screen-printed political poster initially printed in 1988 by members of Redback Graphix for the Commonwealth Department of Community Services and Health and the Aboriginal Health Workers of Australia. In a 1950s style, it features a cartoon Aboriginal superhero, with a large C on his chest, handing out condoms and stating, "Don't be shame, be game: use condoms!"
3. Founded in the 1920s, Home Beautiful is Australia's longest running home and interior decorating magazine.
4. The Tin Sheds is often used as shorthand for the Sydney University Art Workshop, founded in a series of corrugated iron sheds on university grounds in 1969. The sheds themselves no longer exist, but the name has been moved to the Tin Sheds Gallery at the University of Sydney School of Architecture, Design and Planning, as well as the Tin Sheds Poster Collection held at the university.
5. Know My Name: Australian Women Artists 1900 to Now began as a two-part exhibition at the National

Gallery of Australia which was an attempt to address the significant underrepresentation of women in their collections and programming. Part one ran from November 2020–May 2021, and part two ran from June 2021–June 2022. The project has now become both a traveling exhibition and a larger program used to highlight Australian women's contributions to the arts.

6. A strike action initiated on August 23, 1966 by 200 Gurindji stockmen, domestic workers and their families who walked off Wave Hill station in the Northern Territory and refused to keep working for the station owners. Negotiations with the station owners—the international food company Vestey Brothers—broke down, leading to a seven-year dispute. This eventually led to the return of a portion of their homelands to the Gurindji people in 1974, and the passing of the first legislation that allowed for First Nations peoples to claim land title if they could prove a traditional relationship to the country, the Aboriginal Land Rights (Northern Territory) Act 1976. For a summary of this historic struggle, see the National Museum of Australia's Digital Classroom initiative, https://digital-classroom.nma.gov.au/defining-moments/wave-hill-walk-off.

7. Initially called the Illawarra Trades and Labour Council, now the South Coast Labour Council.

DIGNIDAD REBELDE
MELANIE CERVANTES AND JESUS BARRAZA

IN THE FALL OF 2008, I traveled to Mexico City with a group of politicized art-
ists, including Melanie Cervantes and Jesus Barraza. I had known them for a
number of years, but really only got to connect on a deeper level on this trip,
while we wheatpasted posters across Ecatepec, north of the city. Individually,
and together as Dignidad Rebelde, Melanie and Jesus are paradigm-defining
as politically engaged community culture makers. Their print work is rooted
in their local community, from subject matter—friends and comrades often
show up as subjects in their posters—to pedagogy—they are always bringing in
younger artists to learn screen printing and agitprop—to distribution—much of
their work is distributed as part of local California Bay Area struggles.

Dignidad Rebelde draws direct inspiration from the Latinx—and in par-
ticular, Xicanx—poster tradition, and see themselves as one link in the long
chain that is the history of the self-expression of their communities. Their
self-awareness of and positioning within a lineage has been a big influence
in my thinking around social movement culture, and the idea that political
graphic production is itself a living tradition, with a history built on the collec-
tive shoulders of those that came before us.

In the past Melanie, Jesus, and I all traveled much more than we have
been able to as of late; we used to cross paths at least every couple of years.
But between all of us—health issues, the pandemic, and parenthood have got
in the way. That made it even more fulfilling to get to reconnect with them as
part of this conversation series, chatting on April 14, 2021.

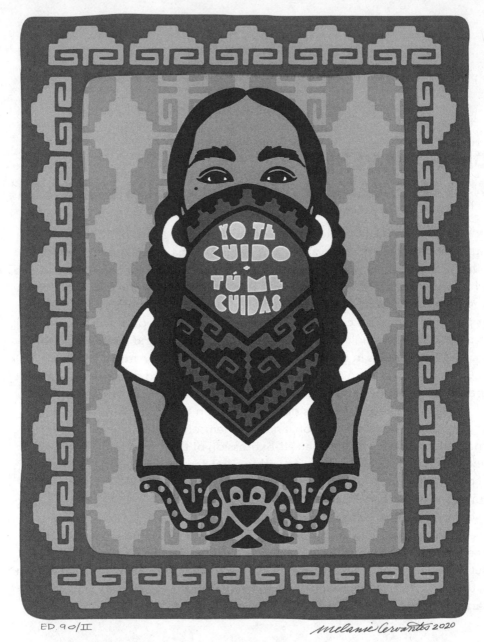

ED. 90/II

Melanie Cervantes, <u>In Lak'ech</u>, screen print on paper, USA, 2020.

←Melanie Cervantes: This is the first piece that I did under the conditions of COVID, which for me meant that I hadn't stepped outside of my apartment except for the first dose of the vaccine, so over a year confined in the same space. At the beginning of shelter-in-place here in the Bay Area, I was painting, and I was trying to stay creative, but I really missed printmaking.

I saw people on social media using vinyl cutters or plotters to create stencils in order to screen print by basically affixing sticker stencils to their silkscreens. This piece was the second I did like that, and the first multilayer piece using the vinyl stickers. I was reflecting on the way that corporate and noncorporate media focused on these belligerent people who would totally have meltdowns about wearing a mask—like I've seen children do in toy stores when they don't get a toy they want. I really wanted to switch gears and represent what I saw in my community, because what gets media play are those meltdowns and just an egregious sense of not caring how other people are affected by one's actions.

There's a Mayan precept, *In Lak'ech* [you are my other me]. This print reflects on what I saw in my community, the folks that I know, and it was this great sense of interconnectedness; a sense of responsibility for each other. I initially created the portrait to show how people couldn't access protective equipment, like there were no N95 masks, so they were using bandanas. I just wanted to reflect the idea that community care was really central in a lot of the organizations and a lot of the communities that we're close to.

It was a bit of an experiment, technically, because I didn't know how to translate our printmaking process into using this new tool, the Cricut vinyl cutter. These machines are really geared towards homemakers; they're in craft stores and for people to make mugs that say "Happy Fourth of July" or Mother's Day gifts. I was like, "Well, I want to do something different with it. I think I can still use it to make prints."

This is the second edition of the print. With the first edition there was a lot of troubleshooting on how to actually use the machine and stencils; like, we had to get screens with bigger mesh and all different kinds of troubleshooting. It's both marking this time and figuring out a way to pivot in the process, and then also reflecting on what I was seeing that wasn't getting airtime.

Jesus Barraza, Covid & Capitalism, screen print on paper, US, 2021.

←Jesus Barraza: This is a more recent piece, I think I did it in the last month. Early on, like Melanie said, we didn't have access to our screen-printing studio, so I switched over to doing different stuff and I started doing a lot of linoleum cuts.

I hadn't done anything yet that addressed COVID, but after I had my first dose of the vaccine, I started thinking about how all of a sudden we're going through another wave. I wanted to address that, because I see people say, "There's a vaccine, cool; we can go out again," and everybody starts to get sick. To me, it was a reminder that we're still dealing with this; we're still dealing with COVID, we're still months away from things being okay. People should be able to go out and enjoy themselves, but just because a few people have vaccines doesn't mean that everything's okay.

So, this is a piece about that, but also thinking beyond COVID because COVID is just one of the symptoms of capitalism. I didn't want to think about COVID as *the* thing we're dealing with right now. How do I connect these two? There's no definitive answer to how COVID started, but generally these kinds of epidemics start because people are doing things to survive capitalism.

Josh MacPhee: Moving around.

JB: Yeah, moving around, having to go different places to source food. It's capitalism that drives it, capitalism is what drives the spread of it, capitalism has, from the beginning, been the thing that made people have to go to work and it has ended up getting people sick. Capitalism has driven people to say we need to reopen. Why? Because the government would rather be open than put money into people's hands so they don't feel the need to go to work, right? These businesses reopening are more important than people's lives.

This is actually an image of a couple of my friends, Isella and Barney, who are organizers in the community. I remember Isella, when the uprisings were happening in Oakland in 2020—she was someone who was out there making sure that people stayed safe, that they had a place to use a bathroom, that they stayed hydrated, got masks if they didn't have them.[1] Barney has been working around the criminal justice system with Communities United for Restorative Youth Justice (CURYJ). It was really about how I could uplift the people who do the work in the community.

Jesus Barraza, <u>Juntos Somos Poderosos</u>, screen print on paper, US, 2020.

And this classic.[2]

↑JB: That classic. Yeah, this version came out last year, I think it was when the uprising started. As printmakers, as screen printers, we're always out there making stuff and putting stuff into the world, but we were really trying to stay safe, and that meant not being able to go to the studio and make prints to give away in the streets.

So, this is a piece that I designed to put online. Melanie had the idea of doing a fundraiser, so I made little 5 x 7-inch digital prints to start and sold them online. Initially they were for Reclaim the Block and Black Visions and we raised something like $2,700 to share with these organizations.

It says, *"juntos somos poderosos"* ["together we are powerful"]. It's about remembering that as people, our liberation is tied in with each other's; it's

Dignidad Rebelde, <u>Bringing Back Ourselves</u>, screen print on paper, US, 2011.

thinking about Black/Brown solidarity. That's really been important during this time, both of these communities are dealing with the same kind of issues and really all communities of color in this country are dealing with these issues, right? Eventually, as Melanie was saying, when we got our Cricut vinyl cutter, I was able to make some prints and I was able to do a fundraiser again for the Black Organizing Project (BOP) and CURYJ. This piece was really about solidarity and taking that to another level with the community by fundraising to help these organizations who are in the fight.

↑ Melanie Cervantes: This is a piece called *Bringing Back Ourselves* that we did collaboratively for a museum in Long Beach, the Museum of Latin American Art. For decades they didn't actually exhibit Chicanx art at all, it was all Latin American. It was a point of contention, being in Southern California, where

the majority of Brown folks identify as Chicanx. I think this was one of the first group exhibits that they were hosting. It was part of a project called *Graphica America*. When we were invited to do this portfolio exchange, because there's like twenty-nine different *tallers*[3] and artists that were invited—it was a pretty open call—we started talking about what we wanted to say. What does "Graphica America" mean? It's really broad.

We started talking about, as Chicanx artists, as being Indigenous in diaspora, what do we have that we can still hold on to? I'm the first in many, many, many generations of women who was born off of the land my mom was born on, and so I have a very different experience than my mother and my grandmother, her grandmother, and *her* grandmother. They all lived on the same terrain.

In the conversation Jesus and I had, we reflected on what of our heritage is left for us, and a lot of it was food. It's the corn, the nopales, the plants, the aloe, the things that are so quotidian but come from very old ways of being in a relationship with the land that you're from. This was a juxtaposition of those things built into an altar. The piece is based on an altar that we built and then photographed from a second story.

Another aspect of the print is rooted in the idea that naming is part of the colonial project. We really went into reclaiming the names of places, rejecting and discarding some of the colonial names which are then inverted and crossed out on the print. I did graffiti when I was in high school and there's a whole thing around crossing out other writers. That being part of the print just occurred to me right now! We should also acknowledge that we're calling in from Jalquin, the unceded territory of the Jalquin Chochenyo Ohlone, which is known as San Leandro, it's just east of Oakland.

What I've been continually impressed by in the work that both of you do is how you always embed overlapping senses of community, whether that's Chicanx, Latinx, but also geographic, the Bay Area. We've entered this period where, both because of the explosion of social media, and then more specifically because of COVID, increasingly we function to the outside world as disembodied heads. How have you struggled with maintaining your embedded-ness in an economic and political context that's literally pushing against it all the time? I'm really interested in hearing from you about the ways that you—or we—maintain and build our communities in times where that's increasingly difficult, if not treacherous.

MC: In 2017, I was diagnosed with a rare form of lung cancer, and in order to get that treated, I had to have major surgery. It felt like a dress rehearsal for COVID. I had to be isolated, because if I caught a cold, I could end up with pneumonia and in the hospital. So I was, for a good part of that year, very disconnected from a lot of our community. Then entering this period where

the world started to feel how I felt, that sense of isolation and the challenge of not being able to do things you normally do and having to learn how to adjust, I think it allowed me to pivot under COVID quicker than most.

In some respects, it didn't make it any less difficult or challenging because, like you said, so much of what we do is relational, it's all built on relationships and trust. And maintaining that hasn't been easy. I think it happens in waves, and it's a long-term game, that we have been building relationships, I mean not even "building" them, as they're really friendships, a lot of the stuff is based on friendships. Yes, we're kind of political allies to folks, but I see it as deeper than that; like we're friends with folks that are trying to change the world we live in. I know Jesus has friendships that are decades and decades long that started when folks were in college. People have evolved in what they do, but that friendship endures at the core of it. And so, because that's our orientation, it's not just about transactional relationships, where we're like, "oh, we're going to do a poster with this group," and then, "see you later!" It's easier to roll with the punches.

One example is after George Floyd was killed, there was momentum to change things, and locally there's Black Organizing Project (BOP), which since Oscar Grant was killed ten years prior had been organizing to eliminate the police department presence within Oakland schools. The Oakland Unified School District had its own police department—its own budget for its own police department!—and BOP was finally getting traction to shut it down. Some of the teachers here in the Oakland union asked if I could do a poster, but then we had all these bumps in the road. Like we can't get into our studio; we're in a shared studio space that, under normal conditions, is elbow to elbow, because the reality of gentrified Oakland is that every time we're displaced from a space, we get squeezed tighter and tighter like sardines in a can, and so under COVID conditions, it wasn't possible. So right away we had to figure out how to do a relay race: I can design it, but then I'll pass it on to folks that actually have access to the studio to print it, and so on, and so on.

One of the strategies that's been used a lot here are these car caravans. They're instead of doing marches. You had posters on the outside of the cars, which was wonderful, I kept dreaming about making prints for these caravans. Then someone reached out to us about doing a poster for one. I'd known them for a long time and there was already an established trust. That was the spark that made me determined to figure out how we can screen print in our house. Them asking for help, it actually sparked something amazing because figuring out home screen printing has actually helped us figure out how to do more with organizations under difficult circumstances.

JB: The other cool thing was that Melanie, early on, started going back to old-school mail art. That was just really cool. Within the first couple of months, we had all these postcards that we made, and at some point, I started making

little linoleum prints and we would take addresses through Instagram and open it to the first twenty people that would hit us up, and they would get a little piece in the mail.

It's been a challenge of like, how do we do all this? Like what Melanie was saying, sometimes it was making a design and handing it off to someone who could go into a studio, have them print it, and have these posters end up on cars at a car rally at Santa Rita Jail. Some of it was making prints to send out around the country through the mail and it's shown what we can do—it's shown that although there are a lot of limitations, we can do stuff.

MC: When I saw other people start their own little initiatives, for me it was a sense of, I know the desperation people are feeling, they need to be doing something. Like I said, I feel like I had a dress rehearsal, this isolation is really hard psychologically. I would send out quotes from people in history, just a little bit of encouragement, and I might focus it differently, send this one out to someone who's called an essential worker, send this one out to a teacher, a healthcare worker, and so on. It was just something I could do every day that could help us feel connected beyond social media. Social media, it's fleeting, and I think taking the time to hand write a card is important. Like my grandma knew that; she sent me cards and I remember what it felt like to get mail from my aunts. I'm in the generation that still experienced that. Something simple, a small act, and then it just started multiplying. That was a nice little experiment.

It seemed like it was just seconds after posting those calls for postcards on Instagram that twenty people would ask for them. The popularity was intense and immediate, which was amazing to see. At the same time, people's desire to have a gift delivered to them seemed to dovetail into the larger explosion of online shopping that came out of COVID. This has its pros and cons; people could get important stuff directly delivered, but now Amazon is that much closer to choking our planet.

I want to talk more about that, but I also want to look at this from a different angle. Right now the biggest exhibition ever on the history of Chicano printmaking is at the Smithsonian, Printing the Revolution, and you're both included in it.[4] There's a beautiful catalog of 400 massive, full-color pages and I was thinking about the conversation that I had with Avram Finkelstein in which he was very, very critical and suspicious of the role that institutions play in collecting and re-displaying material that comes out of movements. He was speaking about that from the context of ACT UP.[5] I'm interested in how you all felt about this new scale of institutionalization of Chicanx posters, and how it relates—or doesn't relate—to being grounded in communities.

JB: It's weird because it's always a double-edged sword, right? We're in *these* places, but what happens when you have this work in these *other* places?

The way I became an artist and whatever I am today—it goes back to when my sister went away to college and would bring her books back to me, which somehow inspired me to be a Chicano. One of the books she brought back was an exhibition catalog to the *Chicano Art Resistance and Affirmation (CARA)* exhibit that happened in 1990.[6] She was using it in one of her classes, probably a Chicano studies class and that's the way I found art. I was just like, wow, this is freaking amazing. This is how I found Rupert Garcia's work, how I found Juan Fuentes' work. On one hand it was amazing, because you had the Wight Art Gallery at UCLA bringing all these Chicanx artists together, showing their work, showing their legacies, highlighting their work, twenty or so years after it was created, bringing up new work, installations being added in, it was this great thing to see. But then what happens, you know? It leaves people out; it does all these things that looking back as art historians we can see as problems.

Looking at the positive side, it exposes the world to the work, it creates these little bursts of academic scholarship, but once the exhibition goes down, what happens? The books stop coming out about it. I go back and forth on it, this is one of the conversations Melanie and I always have—what does it mean for us to be involved in the art world, what does it mean to have our work hanging at places like the Smithsonian, at the LACMA, at the de Young, at the SFMOMA, is it good, is it bad? What does it mean to put this work up in white-walled, mainstream institutions; does that depoliticize it?

I think that's always been the question: does it take away its meaning? Exhibitions allow people to go in and see the work—but people just don't have enough exposure to the community this work comes *out of*. What does it mean to have these old posters displayed when so much has changed in the world? These exhibitions, going back to *CARA*, have mostly looked at work created fifty years ago about politics that are no longer of the time. So, we're looking backward, not that the art isn't relevant today, but it's different. For example, institutions will always include things that were going on in the past, but they won't include Malaquías Montoya's poster about police kill-ings of Brown kids in Fruitvale because that's too much, too close to us today. Instead, they'll include the cool cultural celebration posters that he did. We're thinking about how it's okay nowadays to have stuff that shows the radical politics of the 1960s and seventies—

MC: But it's all selective. We argue a little bit because I think I'm more am-bivalent about the institutionalization, or worse than ambivalent—I make a poo-poo face, let's put it that way. I guess it's good to be included, but the piece that I had included in the Smithsonian exhibit wasn't a movement piece; they bought two pieces and didn't include the movement one.

Part of the reason we like printing is because the multiple allows for the work to exist in many places at once. These pieces get to have lives of their own. There's one poster I did in 2011, after the revolutions in Tunisia and

Egypt, and this same poster carried by women in CODEPINK at a protest on the San Francisco Bridge was also carried by a young Chicanx organizer that went to Cairo on the year anniversary of Mubarak's ousting. Then the PDF that I uploaded was downloaded by organizers in Bangkok and printed out at some printshop there and was used outside of the Egyptian embassy in Thailand. That one poster had so many lives, and that piece could also eventually end up in an institution. It's who holds a poster that makes it meaningful to me. How it lives is what makes it meaningful to me. I don't feel like it loses its power in the streets because it's in an institution.

I hate writing because I have a lot of insecurities about it, but I was trying to rewrite a section of my bio, and there's a standard form in the art world—list these things, list the institutions that your art ends up at. I was trying to write that I've had work up in the streets, not in the street-art-trying-to-get-into-the-fine-art-museum way, but to say both of these sites are important, and not even equally important. Like when we're working with a domestic workers organization—when those workers come up to us and say it's meaningful to them to see themselves, that's what I care about.

There's one organizer, her name's Yermina, and she always comes up to us and there's just this exchange, she feels like an auntie in some ways, there's this encouragement and we really see each other. Those fleeting moments, that's what I'm trying to make happen. The institution is a secondary place where we can maybe get it in front of some eyes. I think a lot about what Jesus says about his experience of being a child, and you know it's true, these art institutions are where you get taken on field trips, I also went on those field trips. I try to hold that as well.

JB: What does it mean to continue on the path of the work that we've done with Mujeres Unidas [Women Together] and the domestic workers here in California? What would it mean to have those works hanging in places like the MoMA? Our work is always reflecting the people who are in the streets doing the organizing, so what does it mean to have those peoples' images hanging in these institutions? What does that do to the movements? Does it truly amplify them?

MC: That's a good example because a bill was just proposed about getting protections for domestic workers and Governor Newsom vetoed it, so it went back to the Senate where it got approved, and now they're in the second cycle of organizing. It would be great if that poster made it into an institution because it's usually wealthy people that hire domestic workers and those are a lot of the people who have museum memberships, those are the people that are donors to those institutions. I think that's a good example—if a made up one—of the friction in movement artwork.

JB: The other thing that I'm thinking about is that *Printing the Revolution* is ethnically based, which is problematic; it risks just lumping all Brown people together and saying, "hey, this is the shit Brown people make that's political." Within the art world we have these cycles of multiculturalism where Brown, Black, Yellow people were allowed into these museums. The 1993 Whitney Biennial, right, that was a big deal collecting all this work about identity. The period *after*, then, becomes, "Oh, why are you still talking about identity? We did that already."

Similar cycles happen with political work. The Occupy movement was so important culturally that we had these big institutions suddenly saying, "We need to show some political posters. We need to show our relevance." All of a sudden, artists in the art world are following the trend and making political work; it's okay to be political again.

I was in my MFA program when it was okay to be political. I was encouraged to be talking about Marxism and capitalism. Somehow never actually talking about it, but talking about it—you know, it's always like that. To stay relevant, big institutions were having street art shows and wanting to collect the work that's in the streets. To me, I think that's great, and it says a lot, but what does it mean? Is it about co-optation? I don't even know anymore. It's so complicated, we're always trying to figure out what the intentions behind it are.

MC: And there's always the role of capital.

That seems like one of the big parts of this double edge—representation very easily gets manipulated, so that the appearance of something somewhere gives the impression that there's been change. There's a change on the flat field of the wall and people walk away with the idea that somehow that change is also embodied in the three-dimensional world we live in, but of course it isn't. That slippage happens all the time.

MC: Not just museums.

Yeah, it's in everything. I can see with the example of the domestic workers, how people could go into a museum and see those women on the wall and say, "this shows how much things have changed." If it doesn't actually engage those people in the mechanisms that are moving to pass those bills, then in fact it can actually turn people away from doing anything: "why do we even have to think about this anymore? I just saw them in a museum, it's done."

MC: Right.

It's such a huge issue, and this gets into another big question; one which has been part of all of the conversations. If we're talking about images getting

distributed through prints you make—through institutions, through social media, through PDF downloads—it gets into these really thorny, interesting questions about who owns these images, who gets to use them, how do they get to use them, what are the permissions necessary for that use? What are your thoughts on celebrating the use of our images in movement work but also being concerned about uses in other contexts?

MC: Right. Yeah, I mean I think we're big fans of Copyleft and Creative Commons. We're huge, huge fans of folks like Rini Templeton who was really ahead of her time in creating her Xerox art and getting it out for people to use as needed in movements.[7] I think that's the spirit of how we work. For us the line is around corporate exploitation of images. We've never had, as far as I know, Walmart taking our images—because I've seen that a lot, where someone working for Walmart will take an image from social media, recreate it, and then sell it on Walmart-branded clothing.

Folks remix stuff. There are things I make that will live beyond what I am even aware of. We've had this conversation across generations, because when we talk to some of the artists that created key politically engaged graphics fifty years ago, they couldn't have known about all the different ways that technology would allow their work to be so quickly repurposed and reused. There's a lot of grumpiness in some of these artists around trying to control those images now. I think there have been folks younger than us that are pretty good about these issues. I've seen them on social media saying, make sure you're at least crediting where you got an image from. It's a lot around acknowledgment.

JB: I'm someone who came of age during the beginning of the Internet. I was part of the Napster generation where we just downloaded music, and then there was Metallica who was like, "no, we got to control this, it's ours." I don't say this very often, but fuck dude, use whatever you want. I feel like I never had that kind of thinking that everybody should attribute everything. The other day I saw one of my images on the cover of a zine, and I was looking at it, if it had any attribution. It didn't, and for a moment I was just like, it's kind of cool that my work is so out there that this person can know it without knowing me, because they're young and they were probably a little kid when I made that image. But it also feels kind of weird.

MC: You're old! [Laughs.]

JB: I'm old. And to me, for the most part, the work is not going to end up on the Army's website, on Coke's website, so as long as it doesn't end up there, it's cool. On the other hand, it's not only about will the work get subverted by a corporation, but will it get subverted by all the little bootleggers created by

inexpensive, print-on-demand technology? Most of the work of mine that's been bootlegged has been in Russia, where they are doing those weird, one-off, t-shirt print things. It happened a lot during the height of the Standing Rock movement, fly-by-night companies creating these Native American pages where they would sell all this movement stuff. The range of what can happen to images once they're out on the Web is infinite.

MC: And with NFTs they'll sell things that aren't even things.

Magnus: Is it possible to start your own institution or should we abandon institutions altogether? Is the institution just distorted by capitalism? Is it better just to recreate?

MC: I think they point to the answer, we gotta get rid of capitalism first. Everything, everything is mired in capitalism right? Under capitalism everything gets skewed. I don't think it's the institutions in and of themselves that are the problem. You can look at other models like Cuba, they have institutions that work but they're under a different economic model.

JB: During the 1970s in California, we had all of these cultural centers that were created. One quick story is when René Yañez, who passed away a few years ago—rest in peace, brother—came back from a Mexico trip with all these posters of Frida Kahlo and went to the SFMOMA and said, "hey, how about an exhibition of this of this kind of work?" And they—capitalism right here—said "no, we don't have the audience for that—we can't make money off of it." He goes back to the Galería de la Raza in the Mission, and they have a Frida Kahlo exhibit, probably one of the first Frida Kahlo exhibits in the US.[8] It's huge, it's iconic of the time, one of Rupert Garcia's first Frida Kahlo posters, all this other work comes out, and jump forty years into the future, the Kahlo exhibition at the SFMOMA is one of their biggest hits, one of their biggest exhibitions to date, made them the most money.

Countercultural centers can share the work and bring it into the community, and that's what it was about. They don't need to justify it via profit. It's important for us to have our institutions now be able to do that. Like in New York, you have El Museo del Barrio with a really important exhibition right now on Latinx art.[9]

MC: These alternative spaces or oppositional spaces were actively destroyed by federal funding and then the withholding or the threat of withholding those funds. and the way it caused friction between people because of resources, individuals were always trying to keep our head above water because of capitalism.

JB: The conservative 1980s.

Josh MacPhee: How to maintain those institutions is a whole 'nother set of questions on top of how to create them. I'm thinking more and more about coming at it from both directions. What if we demanded these larger institutions not function like corporations that had to find the most mass audience? Then maybe the Smithsonian collection could be broken up into 1,000 smaller collections that went into 1,000 different cities around the country in which the communities had some say in how the work was displayed. That would have so much more impact than forcing everyone into DC. I mean maybe we don't make enough demands on these institutions, while doing our own thing on the side.

Protest Stencil: Could you chat about your work and international solidarity, how you draw connections between anticolonial and Indigenous struggles worldwide? Thank you for your work.

JB: I'll go back to the early work that I was doing. It was around Palestine. There's the classic line, "If you have come here to help me, you are wasting your time. But if you have come because your liberation is bound up with mine, then let us work together."[10] Palestinians deal with the same issues as my people have been dealing with here, so it's important for me to be in solidarity with people in Palestine because the work that they're doing is just as important to my liberation as my work here is important to their liberation.

 I've been wanting to make something around what's happening in India with the farm workers, it goes around to thinking of the Zapatistas, it goes around to thinking about what's happening throughout Africa, so it's almost like there's not enough time to make all that work, but there's just all of these important connections to make.

MC: I grew up in Southern California, and I think about looking at one of Malaquías Montoya's posters critiquing the Vietnam War by emphasizing solidarity between Chicanos and the Vietnamese. I was in an ESL (English as a Second Language) class coming into school and a lot of my classmates were refugees from the war in Vietnam. Understanding that you are my other me, that sense of interconnectedness, pointed out to me that struggles here are intrinsically linked to struggles elsewhere in the world.

 In fact, there's concrete things we do that illustrate that. We were part of this group called Stop Urban Shield organizing against this policing mechanism, a kind of trade show for repression, really, which brought police from Israel to Alameda County. They worked with Morton County sheriffs in North Dakota who arrested Standing Rock water protectors; they had training about how to use those tactics in Oakland. That's very concrete. There are many

examples of how our fates are intertwined, and I think we have to have strategies for the graphic work we do that are just as complex and multifaceted.

DeWitt Godfrey: I just want to finish up with one final question. From the very beginning of your talk, Melanie said she loved an old way of being in relationship with the food from the lands we come from. I'm struck by all the things you've been saying, about interconnectedness and this notion of home, these signifiers, things that say something about us and where we've come from.

JB: Food's interesting. I remember when I was young, twenty years ago, I was talking with a scholar, Adaljiza Sosa Riddell, and talking to her about indigeneity. For me it was about reclaim this, reclaim that, I was just so gung-ho. And she said that when you think about it, it all goes back to food. That's not what I wanted to hear, but it made sense. As a Chicanx person, I'm still eating tortillas, I'm still eating nopales, I'm still eating tamales, I'm partaking in these things that my people here in the Americas have been eating for thousands of years. Things that have stayed with us are a kind of a resistance. It's silly that every time you have a tortilla it's a sense of resistance, but it's a way to maintain who you are, you maintain that "corn culture," as Roberto Cintli Rodríguez calls it, that "maíz culture," that has spanned thousands of years.

MC: When we talk about indigeneity and Indigenous sovereignty and decolonization, land and the food that comes from it has to be part of the conversation or it's not actually an accurate depiction of what decoloniality is. No matter where you go in the world. That, I think, is the easiest way to understand who we are as human beings. Most Indigenous cultures in their original languages, they more or less translate to people of the earth, people of that land, and so to me—when we were doing that piece in particular, but generally as we are living in the world—that was a good place to start to understand ourselves, because if we don't understand ourselves, then I don't think we really are going to understand our place in struggle.

NOTES

1. Here Jesus is referencing the national uprisings in support of Black Lives Matter, which occurred in Summer 2020 after the police killings of George Floyd and Breonna Taylor.
2. Although he doesn't discuss it here, Jesus has been making variations on these stacked slogan posters printed in a rainbow color scheme for over a decade. He introduced the overall design in 2011, for posters printed as part of the Occupy movement.
3. A taller, or workshop, is a popular term for a cohesive group of Latinx printmakers, often because they work out of the same physical printshop.
4. ¡Printing the Revolution! The Rise and Impact of Chicano Graphics, 1965 to Now was on display at the Smithsonian American Art Museum from November 20–22, 2020 (for opening events) and ran from May 14–August 8, 2021. It is now traveling to other institutions across the US.
5. See my conversation with Avram Finkelstein in this book, pages 23–40.
6. Chicano Art Resistance and Affirmation, popularly known as CARA, was the first major US exhibition

to document Chicanx art and culture. It traveled to ten venues in the US between 1990 and 1993, and a significant catalog of the show was produced in 1991. Revered by many young Chicanx and Latinx artists that grew up in the 1980s and nineties, the book is now long out of print and has become an expensive collector's item.

7. See Rini Templeton's website, riniart.com, as well as Rini Templeton, The Art of Rini Templeton: Where There is Life and Struggle/El Arte de Rini Templeton. Donde hay vida y lucha (Seattle: Real Comet Press, 1986).

8. Homenaje a Frida Kahlo, curated by Carmen Lomas Garza with Kate Connell, Rupert García, María Pinedo, and Amalia Mesa-Bains, Galería de la Raza, November 2–December 17, 1978. The exhibition combined contemporary artists' works inspired by Kahlo with information and material related to her life and work. See http://www.galeriadelaraza.org/eng/exhibits2/archive/exhibits.php?op=view&id=104&year=1978.

9. Estamos Bien—La Trienal 20/21, March 13–September 26, 2021, El Museo del Barrio, New York City, https://www.elmuseo.org/exhibition/estamos-bien-la-trienal-20-21/.

10. Often attributed to Australian Aboriginal (Murra) artist Lilla Watson, from a speech she delivered at a UN conference in 1985, she states the concept was developed collectively by an Indigenous Rights group she was a part of in the early 1970s in Queensland, Australia.

TINGS CHAK

I FIRST CAME ACROSS TINGS CHAK'S work while visiting my Toronto-based friend Jesse Purcell's screen-printing studio. He had recently printed posters of some of the images from her Undocumented graphic novel, to be used by the group No One Is Illegal in their organizing for immigrant justice. It wouldn't be for another five or six years until Tings and I met in person, but I was already energized by her cross-pollination of the fields of architecture, design, and community organizing, all within the framework of the graphic novel. It's this refusal of siloed disciplines that is a hallmark of movement culture, where efficacy is defined by what people need in struggle.

Tings and I started up an email exchange, and then she came to visit Interference and we got to have a much more in-depth conversation. We shared our mutual love and respect for the design of OSPAAAL, and what the new Tricontinental organization has begun to build on the foundation created by Cuban internationalism. I then started reading the Dossiers she has been putting together for Tricontinental on various histories of socialist cultural work—they are an incredible resource. When it came time to choose conversants for Graphic Liberation, I immediately thought of Tings. With such a varied practice that overlaps organizing, research, writing and design, we have so much to learn from her experience of pulling together a global cultural project rooted in people's struggles for liberation. We held this conversation on April 15, 2022, and it was no surprise that by the end, we were discussing the possibilities of an "Artists' International."

Tings Chak, <u>Undocumented: The Architecture of Migrant Detention</u> (Architecture Observer, 2014/Ad Astra Comix, 2017), Canada.

↑ Tings Chak: This image was made a decade ago when I was heavily involved in migrant justice organizing in Toronto, where I grew up. At the time there was a large hunger strike organized by immigration detainees—191 people went on hunger strike. I was in graduate school studying architecture and didn't know what I was doing there. Somehow, I ended up merging those aspects of my life together, using the visual language of architecture and my organizing work to try to unpack the prison industrial complex and how it works, specifically with the migrant experience. These are hand drawings that I did looking at the reality of the detention centers. I went into the details, from the doorknobs to the stainless-steel toilet seats to the security glass, thinking that every decision about how these institutions are upheld is a design decision as much as a political decision. The text on the right is in contrast and was constructed through talking to a lot of detainees. It's the stories of everyday objects as the symbols of resistance in the face of the concrete, steel, and glass that those places are built of.

Josh MacPhee: And then this got compiled into a publication, right? It functioned like a graphic novel?

Yeah, I never quite found the words to describe it. Novel makes it sound like it's fiction—we wish it might be a scary work of fiction—but it's not. It is a kind of comic, using the sequential art format to walk us through a generic fictional detention center, almost as if you're getting processed through the system, from the entrance into what would be your deportation. At the same time there's a lot of interviews and stories about how life is lived within that

The art department of Tricontinental: Institute for Social Research (Ingrid Neves, Daniela Ruggeri, and Tings Chak), Portraits of revolutionary leaders, 2018-2022.

space, as an act of everyday resistance. It did end up being published as a graphic novel, first in 2014—then the most recent edition was published by Ad Astra Comix in 2017, which is a lovely political comics publishing house. [1]

↑ The portraits. These were made after I joined Tricontinental: Institute for Social Research, which is a research institution that seeks to produce knowledge towards social transformation and from the perspective of people's

movements and their aspirations. We focus a lot on the visual because the visual is an important part of the battle of ideas. Now we have hundreds of these portraits, and the reason we started making them is because, as designers who also illustrate, we often get asked to do portraits and posters—and it's often the Che Guevaras and the Marxes and the Lumumbas, a lot of men. Oftentimes, I wonder, where are the stories of revolutionary women? It started that way. I think many of us would be hard-pressed to name by name, or even by face, a revolutionary woman from Brazil or, I don't know, from South Africa, or China even, you know?

These portraits were a process of learning, and sharing, and trying to recover images—just finding a good-quality photograph, or often any image, is difficult, even with all of our access to the Internet. That's one of the reasons we had to draw the images: we're drawing them back into existence, into our common narrative. I didn't do all of these, we're a team of three designers, so some of them are also made by Ingrid Neves, who's in Brazil, and Daniela Ruggeri, who's in Argentina. The portraits really need to be seen together. We started doing these weekly, and now they're not about just uplifting individuals, they're about collective histories and struggles and moments. That's part of the reason I wanted to make sure we saw them together here.

→ I want to give a shout out to Junaina Muhammed, who's here listening. She's a lovely painter from India from a group called Young Socialist Artists. Last year for the 150th anniversary of the Paris Commune, Tricontinental, along with twenty-six left publishers from around the world, created a volume that was made available online. Because we believe in collaboration, and we try to meet and work with young artists and activists—specifically those working in movements who might not be trained designers or artists—we made an open call for the cover art of the book. I actually have a copy of the book here that was printed in Brazil.[2] There were forty-one artists from fifteen countries who submitted art, and we really loved this one. The art ended up being the back cover of the book, while for the front cover we chose the artwork from a Cuban artist, Jorge Luis Aguilar. We used Junaina's art as the basis for an animation that Ingrid and Dani worked on re-collaging—if anyone wants to check it out, it's on Tricontinental's website.[3] I think it speaks to this spirit of collaboration, there are many hands that actually worked on this, referencing historical images and reworking them. I thought this was a great image to illustrate what we want to do collectively, engaging the question of how to bring some of these histories forward into our present and make them relevant, make them alive. This was a great experience for us.

Just as a little sidenote, in the book, we got a chance to republish the manifesto of the Federation of Artists that emerged out of the Commune. I also contributed a short essay to the book on the Federation and the cultural impacts internationally. It might not be a history many people know but in

Junaina Muhammed, art for the <u>Paris Commune 150</u> exhibition and book cover, Brazil, 2021.

The art department of Tricontinental: Institute for Social Research, <u>The Anarcho-Capitalist and the Interventionist,</u> artwork from Dossier 47 "New Clothes, Old Threads: The Dangerous Right-Wing Offensive in Latin America" by Tricontinental: Institute for Social Research, 2021.

the trenches, in the barricades, there were artists getting together and forming this group. The leader was Gustave Courbet, who masterminded that whole act of toppling the Vendôme Column. It's a message for us today, to envision a different future, a socialist future that is about toppling the culture and the symbols of the old, and then erecting new monuments. I think that's the spirit of the Commune. So, we really tried to bring that into the book itself, but also in the exhibition of cover designs accompanying it.

I'm just happy that Junaina could join us today so I could give a shout out to her, she's an inspiration.

And then now, we've got the interventionist and the anarchocapitalist.

↖&↑ [Laughs.] This was probably us being our bolder selves. One of the things we work on in Tricontinental is our flagship publication, the monthly dossier,[4] produced by regional or international teams of researchers. Each month is a very different theme—it could be agrarian reform in Brazil or feminist struggles in Argentina or the Shack Dwellers' Movement in South

Africa—a variety of issues facing social movements today. We always try to think of an artistic concept that goes with each one.

These images were made for a dossier that came out three or four months ago, focusing on the rise of the right wing in Latin America. One of the lines that we were really thinking about is from Antonio Gramsci, the Italian Marxist. He said, "The crisis consists precisely in the fact that the old is dying and the new cannot be born; in this interregnum a great variety of morbid symptoms appear."[5] We thought about this concept and what are the new monsters—or morbid symptoms—emerging in this particular moment of capitalism. The rise of fascism is a real thing. We also thought about the use of satire and how it has always been key in terms of revolutionary resistance imagery, including against fascism in the 1930s in Europe. So, we made collages using photographs of different right-wing or semi-fascist leaders that are emerging in Latin America, but turned them into these tarot card icons—or maybe anti-icons—thinking about the values and political projects that they represent. They're much more than the individual, right? They represent a movement. This includes the interventionists who use "lawfare," or the legal infrastructure, to subvert or undermine an elected government, not just arms or military force. This is what happened with Lula in Brazil. We're also thinking about the role of social media and the concept of hybrid warfare in electing these right-wing forces and bringing them to power. We played with all these ideas and I'm very proud of the work. Daniela from Argentina led the design as well as the collaging of this, and it was a very collaborative and fun process.

You mentioned satire, but these really engage humor of all kinds. The fun that went into creating these is so apparent. It makes them really enticing images to try to parse and figure out what they're saying.

Let's start our chat by going back to the beginning. You said that you were a grad student in architecture when you were working on Undocumented. In North America, the average path of an art, design, or architecture grad student is not to end up in an internationalist socialist organization that is building culture around people's struggles. How did you get from A to B? And it's probably more like, how did you get from M to Q, so wherever you want to jump into the alphabet?

Oh, that's a hard question. I mean, it's kind of funny you put the last image first. So maybe that's the way it's supposed to be. I'm originally from Hong Kong. I grew up as an immigrant in Canada, and that experience informed a lot of my own journey and politicization. I got involved in my early twenties in migrant justice organizing in Toronto. I was always the person that liked to draw and make things, and therefore, you become the person that makes the flyers and the posters, and you go wheatpaste. And so that's my own formation as a "political artist." I see Ryan Hayes[6] in the chat here, who's an amazing

political designer in Toronto, and we go way back! Cultural work has always been part of my political life and part of my politicization. The process of making artwork has never been separate from being an organizer; it's actually how I entered and developed my own political consciousness. *Undocumented* was a product of the migrant justice work and my studies in architecture school. Over the years I continued working with movements from a variety of countries, in the area of design and culture but also in political education. And so, some years later, here we are.

I think joining with a project like Tricontinental, which was founded in 2018, was one of the best things that happened—like, where else is there an institution that is focused on people's struggles and thinking about how to produce intellectual knowledge, not from academia but from the perspective of movements, and *for* them, going back to the movements? It's not a kind of extractivist model that just takes from movements. And on the other side— this is also a credit to Vijay Prashad, who's our director—we firmly believe in the battle over imagery, and the battle over visual culture.

So Tricontinental takes its name from the publishing wing of the Cuban entity Organization of Solidarity of the Peoples of Africa, Asia, and Latin America (OSPAAAL), which put out multiple print publications entitled <u>Tricontinental,</u> and then tucked into those publications are posters that have become internationally famous in both political and design circles. The architect of this was the designer Alfredo Rostgaard, who set the aesthetic terms of that project. You seem to be the Rostgaard of the new Tricontinental, right?

No.

[Laughs.] So, what does that mean? I've done a lot of research and studying and writing about the original organization, as have you. One thing that is interesting about it is the tension between it being an articulation of international solidarity, yet fundamentally being a Cuban project—all of the designers were Cuban, all of the editorial work was done in Cuba by Cubans. So, what are you doing today that is both inspired by that, but also different?

Okay, I'm going to pretend you did not just compare me to Alfredo Rostgaard.

I knew that it was going to push a button. That's why I had to do it!

I started just sweating here, and it's pretty chilly in Shanghai today. But joking aside, I think for so many people, OSPAAAL represents much more than a Cuban project, it represents the possibility of a socialist project bold enough in its visual language to say, "from psychedelic art to Afro-Cuban references, from Indigenous to European references, these are part of our rich collective

tradition." And not in irresponsible ways, but to intentionally help us imagine and create new human beings and a new society. So definitely; even the name Tricontinental is a clear homage to that political project and the conference that happened in 1966 in Cuba.[7]

Our art team now has three of us, spread out in different countries, and each of us brings a different experience, visual language, and spoken language. So, the knowledge produced and the visual language produced carries that framework. Tricontinental has its roots working closely with social movements across the continents of Latin America, Africa, and Asia. It isn't centered around one particular nation or social movement or political project. Perhaps that's one of the differences, that it emerges fundamentally as an internationalist project, and that is probably why the imagery also reflects that.

So, the art exhibitions, and to some extent even the dossiers, they're much more inclusive. It was easy for the Cuban designers, right? They were doing all the work and making all the decisions, they weren't filtering other people's work other than as raw source material. The design was all centralized. But you've decided to do something very different. Do you want to talk more about assembling these projects and why these projects have been chosen as the focus for cultural production?

Well, maybe the exhibitions are a good example because for us it was a completely new experience. At that point we were working closely with a platform called Week of Anti-Imperialist Struggles, an international platform of over 200 social and political movements mobilizing and coordinating activities around the struggles against imperialism in their respective realities. The actual "week" was supposed to happen in May 2020, but of course, the pandemic hit hard, and we had to reassess how to carry on the cultural mobilizing. We connected with movements online, wanting to know, in the different organizations and regions: who is that person that is doing the wheatpasting? Or, who is making the flyer, and what are ways we can get to know them? And so, slightly naively, we put out this call to people who had been following the work of Tricontinental and its extended network, to get art that articulates the anti-imperialist struggles in their regions.

We did a series of four online anti-imperialist poster exhibitions around four broad themes and as a reflection of the current moment and reality. Especially because the COVID crisis deepened so many preexisting social and economic crises. The themes were: capitalism, imperialism, hybrid warfare, and neoliberalism. We just tried to see where that would go. And we were happy with the interest we got.

What's really interesting is who participated. Some were professional designers, others had never made a poster in their lives but felt emboldened to try. There was a former car factory worker and Communist party member

in India who's in his seventies—he's now become a friend of mine and we talk often—who told me, "This call made me feel like I could pick up a paintbrush again, which I hadn't done since I was a kid. I always liked to do that and I support the political message." He's been one of the most avid supporters of all of these projects and has made several beautiful paintings with each poster call. I got to meet people like Judy Seidman, who you had a conversation with, a long-time revolutionary coming out of the Anti-Apartheid Movement in South Africa who was part of the exiled cultural workers group in Botswana called Medu Art Ensemble.[8] We got to connect with young, up-and-coming artists in Latin America who were involved with social movements, and people who are professionally trained designers as well.

We didn't want to have a strict curatorial line defined by any specific aesthetic or technical quality. We had some common basis, for example, about the type of content and political orientation, but we really think the openness made it richer and created a different type of aesthetic. When you look through one of the exhibitions, it has a really wide range of work, and I think that gives a fuller sense of the lay of the land of what the struggles look like today and who's able to and wants to create images for furthering our struggles.

But that's different from the direct publications of Tricontinental, especially the dossiers. Most of the time, we just produce it in-house. We have also done collaborations and invited collectives or individuals we've built relationships with—exactly through these kinds of exhibitions—where it aligns and works well.

I want to note another thing that might be interesting: every year one of our dossiers specifically focuses on art and culture. And we've done three so far, one on OSPAAAL, and another one on an Indonesian group called Lembaga Kebudajaan Rakjat (LEKRA), which emerged in the 1950s and '60s with 200,000 members! The last one was on the Yan'an Forum on Literature and Art that happened here in China in 1942, where hundreds of artists came together for three weeks and Mao Zedong gave a summarization of his thoughts on the role of art in the revolution. We think that there are interesting ideas from the Forum to revive and think about today.

I find this really exciting because I love the design work of OSPAAAL, but I wish that there was more content <u>about</u> culture, not just culture as an element that drives people to the content. The ways culture gets produced are in and of themselves political, and you can learn just as much through looking at LEKRA as you can looking at an armed struggle organization or some other aspect of people's struggle. There is still such a difficult perception that there's hard politics on one side, and then all that art stuff on the other. This feels particularly true within the context of North America.

I actually think that's true in many places. It's often treated as an after-thought, the beautification factor. For me, what drove the desire to dig into these histories was part of my own anxious cry of, "No! Culture is political, and forms part of the political process from the very beginning, not just an afterthought at the very end!" Tricontinental, as a research institute, tries to revive the histories of national liberation from a Marxist, socialist perspective—this is not a romantic look into the past, but it's about what it can teach us about today and tomorrow. When you go deeper into that, you realize, wow, there are leaders—from Mao Zedong to Amilcar Cabral—who were not only thinking about the armed struggle or the political struggle, as in how to take power, but also thinking about cultural work, ideological work, artistic work, literary work. This included hosting a three-week forum, for example, in the middle of a civil war, while fighting imperialism and struggling against Japanese occupation. It's a way of saying, "Yeah, we need three weeks to dis-cuss what is the role of literature and art, let's hold the cultural work to a level of attention that we think it deserves." We see the images of revolutionary struggles, and sometimes we celebrate the cultural products—like a poster—but I'm interested in the debates that were being held in the trenches about why this poster, why this form, why this music, and why this poem are neces-sary and what kind of new culture was being struggled for and being created in the process. That's fascinating. All the contradictions and all the possibilities these cultural works were filled with, and that today we often don't have access to, and I certainly didn't feel like I had access to for many years as a young polit-ical artist. So, we're excited about being able to help recover these histories and share them. The annual art dossiers that we produce are no less important than any other dossier, or any kind of intellectual production that we might publish.

Much of my work is about trying to crack open the visual language of social movements and talk about it as a fundamentally open and democratic lan-guage, rather than an exclusionary one. It's a language that we all can use. Part of that is its iterative quality, that so much of the visual language of move-ments is the reproduction and evolution of images. Changing them, evolving them, building them, re-tweaking them for different contexts. And that shows up in the image you showed from the Paris Commune, a reimagining of a well-known image, which, in and of itself, is a historical reference—the woman with the flag is a nod to Delacroix and to the French Revolution. It's turtles all the way down, right? There's an image under an image under an image. How is that showing up in your work? You can start to see a little bit of that in the portrait series and in the exhibitions. Is this of interest, have you noticed this in the war of images?

I think that's really interesting. I was recently talking to some friends in Europe, and they were talking about the history of the red flag as a cultural

symbol. From Delacroix to the Paris Commune to now, the red flag has shifted in meaning. It wasn't always necessarily a symbol of the left, it was a symbol of the bourgeois revolution, like in the French Revolution, of overthrowing the monarchy, but then it became a working-class symbol in the Paris Commune not quite a century later. So, what does the red flag mean to us today? It is constantly changing and contested, and of course, I think, for anyone who's made a poster before, sometimes you get tired of the red flag, just like you are tired of the raised fist. Are these just tired symbols or can they inspire a different imagination? Are we tired of the hammer and sickle, do they keep us in the past, or do they give a sense of a tradition that we belong to?

What I think is interesting is that some of this was being debated in 1942. Eighty years ago, here in China, artists were debating about the symbols that are relatable to workers, peasants, and everyday people. Symbols endure because there is something accessible about them, because they carry a resonance, and a human feeling, not just an ideology. They mean something to us as human beings, and to the people before us who literally lived and fought and died for these symbols. We have a responsibility to carry on and care for these symbols. It's always a balance between so-called artistic quality and creativity with human relatability. As much as I love their work, I think the early Soviet designers like the constructivists and the avant-garde struggled with that—how to bring in abstraction and new forms and new symbols, but still, when you take a piece of artwork to the factories, people respond, "That's cool, I get that, that relates to my reality and struggle."

These were huge debates a century ago that we still haven't resolved, and I don't think we need to resolve them. But it's important to be aware, to be humble, and to not be dismissive whenever we see another raised fist or red flag, because they mean something and serve a purpose. Sometimes they can be reinterpreted in different ways or reincorporated or iterated upon, but those are enduring symbols, we're not going to say, "We can replace it with, I don't know, a blue square!" [Laughs.]

Historically, capitalism tends to resolve these questions, because it recuperates these images and resells them back to people in ways that are more comfortable. If you look at the history of Soviet posters, there's not a lot of red wedges, even though El Lissitzky's Beat the Whites with the Red Wedge is one of the most famous pieces of Soviet graphic design.[9] There was a sense amongst the Soviet leadership that the wedge was too far ahead of the people, but eighty years later it was certainly not too far ahead to show up on a Macy's bag or in a grocery store advertisement. That's the sort of thing that I've been trying to think about and explore, the way that there's this constant dialogue between movements and their recuperation, and then sometimes even the re-recuperation of these symbols back into movements.

I think that's a good point. That's the general co-optation or depoliticiza-tion of a lot of our revolutionary history. This is why I think there's a strong interest in historical recovery. Like March 8th, it can be the commercialized event of International Women's Day that has Hillary Clinton or someone as its spokesperson. But look at its origins as International *Working* Women's Day, with its roots in socialist struggles, and how that is forgotten or actively erased if we aren't the ones continually telling and retelling our history. It's not a one-time thing, so I absolutely agree. And this goes for every symbol that is taken out of context, that's why we have to constantly claim and re-claim them.

Some of the exhibitions seem like they have participants from eight or nine countries, some of them including people from up to fifteen or sixteen differ-ent contexts—have you found any sort of conflictual imagery, things that seem to have a lot of meaning in one place and not in another? Or are we really working with a common language?

Sometimes we make stuff that goes on the Internet, but we rarely know where it goes or how it is used. We had this really nice experience. One of the largest social movements in South Africa is the Shack Dwellers' Movement [*Abahlali baseMjondolo*], and they held an important anniversary event during the pandemic. I started getting a few images from friends or people linked to the organization saying, "hey, we've found that some of the posters from the Anti-Imperialist Poster Exhibitions were printed, and they're decorating the walls here." I asked if someone at the event could share pictures of what people put up, and the exhibition consisted of A4 printed pages taped onto a tent wall.[10] It was very organic. They chose images from Lebanon, Brazil, and other countries. There was a natural resonance because most of these images had almost no text in them. It was a very organic way of saying, "these posters from very different contexts relate to my reality."

What was really nice, and I had a chance to tell Judy Seidman too, is that one of her posters, unbeknownst to her, found its way back to South Africa, on the tent wall, active in a current struggle. I find these kinds of moments really beautiful and exciting.

There have been a few exhibitions like that, where people exhibited the whole collection, including in Spain and in Malaysia. People have, in these specific instances, taken the initiative to do something with the posters. In that way we can't quantify or qualify exactly how a poster or an exhibition res-onates, or how it will land, but there are moments like this one in South Africa that really makes it all worthwhile.

Absolutely. I love when those things happen, when someone sends you a photo of something that you are a part of that's halfway around the world in

some context and in some place, like a sticker on some object you would have never imagined it being a part of.

Yeah, absolutely.

What about struggle around these visuals? Like internally, with the three of you, do you argue about what to do and how to do it or what images to amplify? Do you have ideas or plans for pushing these projects in a way that encourages debate around imagery? Or is it really just like a "try and see what sticks?"

I think we're really lucky, the fact that we actually have a lot of fun, and we just like to nerd out together and give feedback when someone's working on something. Not everything is centralized here, and it can't be since we work in different countries and continents. We've developed a process over the last two years of working together where we're really respectful of difference but also share a very common aesthetic. Very rarely is there a heated debate because we're really interested in the process and there's enough trust that one of us can just say, the idea isn't great or a design isn't working. It's fun and we laugh, though it's a shame we don't get enough opportunities to work together in person.

Well, maybe that gets to the next phase of this question. When we turned Justseeds into a co-op, it was sixteen people who were all in the United States, and we all had the sense that if we wanted to be internationalists, the best way to negotiate or figure that out was through practice. We invited people into the group from Mexico and Canada to turn it into a continental organization. And there's a lot of struggle that comes with that; it's difficult. The contexts are different, the economies are different, and people have access to different things. From the very beginning, you've all been in different locations, not just the three of you who are working on the art and design end, but the whole organization. How does that practical internationalism structure not just what you think, but what you actually do? What are the challenges to that? How do you work around those challenges? If you were going to talk to people who really want to figure out how to do that, what are ideas for pushing internationalism from an idea into a practice?

I think a lot about translation, which isn't a literal, one-for-one thing. It is the process of understanding that we come from different epistemologies, worldviews that are conditioned by the language, history, and socioeconomic factors of a particular place. And this diversity shouldn't be flattened when contemplating how we produce knowledge, how we understand the world, and how we create images from these realities. But it is challenging.

I don't know if I have good advice. I'll need to sit with it a bit more. Perhaps it's also because of my own upbringing. I've lived between worlds my whole life as an immigrant child, who then lived and immersed myself in different countries in my adulthood. In a way, I think it made it easier to understand that there are valid and vastly different ways to see the world and adopt an internationalist outlook. I don't want to give a really generic answer, but I think that just comes with time, through working together and building trust. In the Tricontinental, I think it's always a process we're still constructing.

That makes a lot of sense. And it is a dense question to dump on you.

Mmm [laughs].

Yeah, I know comrades in Greece that go to twelve-hour meetings. That's not something I'm probably ever going to do, certainly not in the near future.

[Laughter.] Really, no?

No, not with a six-year-old!
Well, then what if we bring it down from there into the personal. You are creating imagery and culture, but you're also functioning as an organizer, curator, facilitator, and designer. These are all overlapping, but also different hats to wear. How do you balance those things? Is it not about balance? Is it about need, like what is demanded at the time? What's your way of negotiating this hybridity?

Often people who do any kind of creative work tend to do it on an individual basis, and it's quite isolating. Working at Tricontinental in a collective setting with a small team changed my capacities and actually gave me some space to think. At the point I joined Tricontinental, I'd been doing design or graphics for political movements that I was involved in for about ten years, largely figuring it out by myself, clicking away on some bootleg version of Photoshop or something, while also accumulating experiences, knowledge, practice, and questions, and that could be explored more.

You have to consistently apply your thinking to your practice and ask: why are we making this stuff? What traditions are we drawing from? That line of questioning is even more interesting when you work collectively. From that you also realize the process of thinking and of doing can't be separated. Anyone who's engaged in creative work knows how much of that process that's behind creating something and that doesn't come up to the surface. Sometimes the product may not be as interesting as the process itself.

My head's really deep into the research on the Ya'an Forum in 1942, because the dossier is about to come out. I was thinking one of the reasons the

forum was organized is because Mao understood the importance not only as a political leader but also because he was an artist, and a poet specifically.

Sadly, the part of cultural production that gets articulated the most here in the US tends to be the capitalist part, the neoliberal brand-building and identity construction that evacuates the social content. It makes it very hard to tap into those process questions. It's almost de-incentivizing, like those process questions aren't going to get you a paycheck, so don't even worry about those things. Pretend they don't exist.

Yeah, it's about the deliverables.

I'm interested in hearing more about 1942, since your head's in it. But more broadly, is the idea to continue with the publishing and exhibition projects as they are? Or do you want to make them bigger, or smaller for that matter, or broader, or tighter? What's your dream development out of this? Is there an Artist International that's going to be convened?

How we got to 1942—one of our first research projects was OSPAAAL in Cuba in the 1960s, and then we went to the 1950s with LEKRA in Indonesia, and then we went further back to the 1940s [laughs]. I didn't know where we were going to go. But one of the things—

There's a lot in the thirties—

Yeah, exactly. [Laughs.]
 One dream for the future is to continue doing this research to understand how these particular historical moments came to be, and what we can recover and learn from them today. What did it mean that in the middle of the conditions that China was experiencing, one of the leaders of the largest peasant movements of the world said, 'let's spend three weeks convening the most important writers and artists in the country, let's be serious about art and having those twelve-hour meetings.' It took at least a year of preparation, sitting one-on-one with different writers, listening to different opinions, and a lot of criticisms.
 So how could we stimulate that kind of conversation today? I think this conversation we're having today forms part of it, about how the struggles of the left around the world can't be separated from the cultural and ideological battles. So that's why looking to the past is important and they were able to find common points of collaboration and possibilities with artists internationally that are asking the same questions. There were different platforms during those historical moments for people to be known to each other. Because there was the Soviet Union, which put huge amounts of resources

into international artists and writers' organizations. Today, where is this found? In many ways, we have the Ford Foundations or the NGOs, and other organizations of the West whose interest is to turn any kind of political, radical, or revolutionary work into a commodity and to neutralize them. Today, we don't have the international platforms that allow us to do our work on our own terms, on our own turf, based on our own ideas and our own visions. So that's one of the big things I think Tricontinental as an institute is trying to build and is part of, including the International People's Assembly, which is a platform of over 200 people's struggles and movements around the world, and as a part of that, the artists, designers, writers, and dreamers involved.

Junaina Muhammed: I think the constructivist poster style, the Soviet poster style, can still be considered one of the best political graphic arts styles. With today's technical resources, I think we can bring that back and re-innovate it. I would like to know your opinion on this.

So Junaina is the wonderful artist we've already discussed here, who did the cover artwork of the *Paris Commune 150* book that I mentioned. So, thank you for the hard question, Junaina.

I agree. I'm a big constructivist fan. I think back to what the constructivists were trying to do in the 1920s, but on an easel, through painting, and how painstaking it must have been to create those perfect geometric shapes and lines. Now we live in a digital world of vector graphics, and with just a few clicks we can make those same forms. So, we are working with new tools that allow for different innovations. It's funny, I don't know if it's my own bias because I am really a pen-and-paper person and reluctantly entered the digital world, but I think there has always been this balance of trying to maintain the hand-drawn feeling within the mechanical. But I'm looking forward to Junaina's next constructivist re-innovated poster. Maybe it can be the cover for the next book!

Josh MacPhee: I think this raises a really key question for artists and designers. Can an aesthetic, in and of itself, articulate a politic? Constructivism has been absorbed wholesale into capitalist commercial art and design. It was quickly absorbed into product design in the Soviet Union as well, it was used far more in selling cigarettes within the Soviet republics than it was within any sort of agitprop. We can bring it back, but how do we imbue it with a content that gives it back its initial thrust? I think that's the real challenging part. How do you wed these things together in a way that speaks beyond just another style?

Yeah, because the palette or the toolbox we have seems almost infinite. I remember even the early days of plugging away at Photoshop and realizing, wait, these are not just commands you can click with your mouse, each of

them relate to mechanical and material processes, each with a rich history. This is the risk we have when everything seems to be at our disposal, but we don't have any sense of the history that comes with it. Tricontinental's logo itself, which I designed, also pays homage to constructivist history and incorporates Lissitzky's red wedge into the logo. Each time we talk about the logo, it is an opportunity to talk about what the red wedge is, and how we are using that wedge to symbolize how we imagine ourselves to be in a battle of ideas.

I look forward to the dossier on the social history of Photoshop.

OK, wow, that would be a good one.

What are the histories of labor that have gone into each of these tools? Yeah, I don't have any knowledge of anyone who has looked into that—

Well, noted in the notebook [laughs]. Yeah, I don't know either. For anyone listening out there—

It's a great dissertation topic.

Louis: Many of our political spaces encompass graphic and cultural work, but it is not being recognized or included organically into political discussions. I love the calls for artists that Tricontinental puts out, but is there any future space where artists involved in social struggles can meet each other and discuss our processes and possibilities?

I feel like this is the same as the thing that you said, Josh. The Artist International. I think we're in the early phases of seeing who is out there, and these calls for art and conversations like this are a part of it. There are way more artists than we'll be able to reach, but certainly, I think it's a start. It's been a long time since there were international platforms where artists of the left can meet, those who are connected either more organically or are sympathetic to social struggles and movements.

This is something that we have to build, and I think why we're having this chat today, why I'm really excited to be here, is exactly to find the Louises, Junainas, and Joshes of the world. Hopefully in a different place, we can figure out how to have more concrete dialogues. I think that's something we're really interested in at Tricontinental. We don't have a platform or program yet, but it's already started putting us into dialogue.

Josh MacPhee: It seemed like there were some gestures towards this in the Social Forum structure from the late nineties, early 2000s, but it never quite coalesced. I know that there's been gatherings in the Philippines and other

places, internationalist cultural gatherings connected to specific communist parties, but there hasn't been an International, so to speak.

It's such a fascinating question. What does that look like? Who's invited? How do you navigate the striations of power in terms of geography, when you feel like people coming from the Global South are more than likely going to have significantly less political and economic power than people in the Global North, but they're going to be way better organized and less individualistic in their thinking.

Yeah. Tricontinental is part of a new political platform, International People's Assembly, and we're beginning to think about these exact kinds of questions. In this conjuncture, what is the role of artists and cultural workers internationally and what are the formats that we can gather in?

So Louis, let's continue building together. Louis [and I] actually, we initially connected through an important space in New York, the People's Forum, that organized a cultural resistance program online. It's nice to connect again here.

Awesome. Do you have any last comments, last words? We're at the end here, but I want to make sure that if you have anything you want to say, I would love to hear it.

I don't have any wise last words. But I guess I just want to invite anyone to check out Tricontinental's work at thetricontinental.org. My email is up on the website if anyone ever wants to write, give feedback, say hello, or tell me what you're working on. I just want to extend an invitation. I think my last words are to invite conversation.

Well, I really look forward to the upcoming dossier. And I look forward to the next one after that. There's so many places it can go—I'm looking forward to learning about the 1930s, and then the twenties, and so on!

Yeah, we'll have to keep going a decade every year.

NOTES

1. Tings Chak, Undocumented: The Architecture of Migrant Detention (Toronto: Ad Astra Comix, 2017).
2. Karl Marx, V.I. Lenin, Bertolt Brecht, and Tings Chak, Paris Commune 150 (New Delhi: LeftWord Books, 2021), https://thetricontinental.org/wp-content/uploads/2021/05/Paris-Commune-150-Tricon.pdf.
3. See https://thetricontinental.org/text-paris-commune/.
4. To view or download Tricontinental's monthly dossiers, see https://thetricontinental.org/dossier/.
5. Antonio Gramsci, Selections from the Prison Notebooks of Antonio Gramsci, ed. and trans. Quintin Hoare and Geoffrey Nowell-Smith (London: Lawrence & Wishart, 1971), 276.
6. See https://www.blog.ryanhay.es/
7. The Tricontinental Congress, originally proposed by Moroccan revolutionary Mehdi Ben Barka as an extension of the converging Third Worldist international liberation movement. Barka was assassinated

by Moroccan intelligence agents with Israeli and French collusion in 1965, but the conference was still convened in 1966 in Havana. The Congress, which featured representatives from dozens of anticolonial struggles and newly formed postcolonial nations, led to the formation of OSPAAAL.

8. For more information on the Medu Art Ensemble, see the conversation with member Judy Seidman in this volume, pages 185–201.

9. El Lissitzky, Beat the Whites with the Red Wedge [Klinom krasnym bei belykh], 1920, poster, color lithograph, printed in red and black on off-white woven paper.

10. A4 is an international paper-size standard that is roughly comparable to an 8.5 x 11-inch, letter-sized sheet in North America.

JUDY SEIDMAN

I AM NOT SURE WHO first put me in touch with Judy Seidman, but when Dara Greenwald and I were organizing the Signs of Change exhibition in 2007, she became our go-to for South African movement culture, ultimately shipping us an incredible collection of t-shirts created as part of the anti-apartheid movement in the 1970s and eighties. As I've so often found, I had actually interacted with her work previously, as she was a co-author of one of my most treasured books, Images of Defiance: South African Resistance Posters of the 1980s (Johannesburg: Raven Press, 1991), brought back for me in the late nineties by a friend from a trip to South Africa.

After Signs of Change, Judy and I stayed in touch. She has an encyclopedic knowledge of artists and movement cultural producers from Southern Africa, and she generously wrote a heartfelt overview of the life of Mozambique's key revolutionary artist, Malangatana, for the second issue of Signal, the journal I co-edit. I also learned that not only was she part of historicizing anti-apartheid culture, she had also been a key maker of it during her time with the Medu Artists Ensemble. The story of Medu is one which intensely illustrates just how impactful movement culture can be: enough for the South African government to raid the community where Medu was centered and murder several of its collective members.

I had the privilege of finally meeting Judy in Johannesburg in 2014, and learning about much of her work since Medu—particularly, feminist art and organizing while working closely with the HIV and AIDS movement, mining communities, and the One in Nine Campaign. We got to continue our conversation as part of this series on March 9, 2022, and touch on her recent autobiographical book Drawn Lines (Johannesburg: CreateSpace, 2017). It wasn't under the most ideal of conditions, with Johannesburg facing rolling blackouts we feared that our discussion would be cut off at any moment, a profound reminder to most of us in the Global North that cultural producers in other contexts often face very different obstacles than we do.

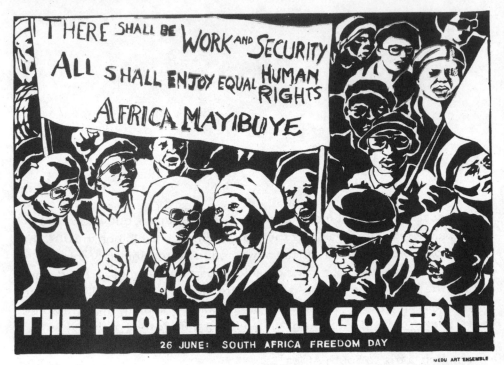

Judy Seidman, <u>The People Shall Govern</u>, screen print poster, 16.5 x 23.4 inches, Botswana, 1982; poster designed with Medu Art Ensemble commemorating South Africa's 1956 Congress of the People and the Freedom Charter.

↑ Judy Seidman: This is a poster done with the Medu Art Ensemble, which was a collective of artists based in Gaborone, Botswana, nine kilometers outside of the South African border. This was 1982, so it was when South Africa was still under apartheid. This poster was designed to commemorate and to mobilize around what's called the South African Freedom Charter, which was drafted in 1956 and became one of the founding documents in South Africa's liberation movement and later of the democratic state. All of the slogans in the poster come from that document.

This poster was the result of a collective discussion around wanting to produce a poster commemorating the Freedom Charter. At that stage it was highly illegal to do anything advancing the African National Congress (ANC) inside South Africa; you could—and people did—get sentenced to five years in jail for "advancing the aims of a banned organization," which the ANC was.

The drawing was based upon a photograph by Eli Weinberg, who took photos of the Congress of the People on June 26, 1955, when the Congress formally adopted the Freedom Charter. The perspective of the photograph (and the poster) is from slightly overhead, because Eli was banned by the government at the time, so he was not allowed to be amongst the crowd of people. He took the pictures of the crowd through the window on the second story of

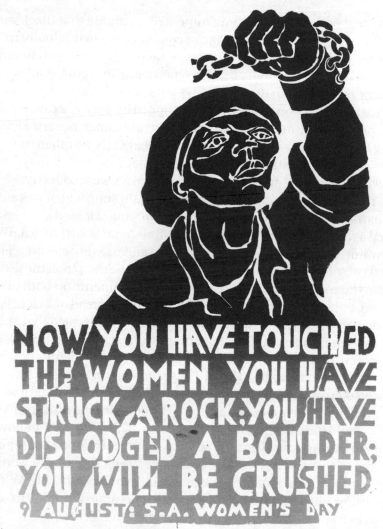

Judy Seidman, <u>You Have Touched a Rock</u>, screen print poster, 16.5 x 23.4 inches, Botswana, 1982; poster designed with Medu Art Ensemble; the words are from a song sung at South Africa's 1956 Women's March on Pretoria.

a building across the street from the square where the Congress met. Having discussed the content of the poster as a collective, the Medu graphics unit gave it to me to do the artwork and develop the silkscreen.

Over the years that Medu existed, we explored different ways of doing collective work. This process—having a group discussion, then tasking one person to do the drawing, then discussing the outcome, then printing it together—was one of the ways that worked quite well, actually.

↑Okay, this one is also a Medu poster, also 1982, which is exactly forty years ago. We agreed to do a poster commemorating the very strong South African women's movement during the 1950s. On August 9, 1956, women marched on

Pretoria, the seat of the apartheid government, demanding that Black women should not have to carry passes. The racist colonial system originally ruled that Black men had to carry "passes" to prove they had permission to work in urban areas. At that time, most Black women were not actually allowed to work in urban areas at all, so the early "pass laws" did not require Black women to produce identification when they got stopped by police because women were not supposed to be in urban areas at all. But as women nevertheless began moving into urban areas, the government decided that women must also carry passes; and women started mobilizing against this.

The wording, image, and symbols on this poster were collectively discussed. The words are a translation from the Zulu song which was sung at that demonstration in 1956: "*Umthinta Wafasi, Umthinta Mbokodo*." The song was directed against John Vorster, the Prime Minister of South Africa. We agreed we would do a picture of a strong woman and use those words. The group asked two of us to work on possible designs. We then took these designs back to the collective and the collective had comments on both of them.

My proposed design was basically this one, but instead of a clenched fist the woman was carrying a gun, an AK-47. The group decided that showing people carrying guns would further enrage the apartheid regime about the work we were doing; we should avoid printing posters openly showing support for the armed struggle. Also, because most of these posters were smuggled and distributed inside South Africa, if the poster showed a woman carrying a gun, the consequences for people caught with the posters inside the country would have been much more serious. This policy about how to portray our support for the liberation struggle continued for all the time that I was in Medu. In this case, we decided to change the picture from a woman holding a gun to a woman with a clenched fist and a broken shackle. With that change the group agreed to go with this design; it became one of the best-known posters from the South African liberation movement.

Josh MacPhee: It's interesting, I wonder whether it would have aged as well if it had the AK-47?

→ This one is much more recent, about ten years ago. It was with a South African feminist group called the One in Nine Campaign—they were formed in 2007. The name comes from the fact that, at the time, only one in nine women who were raped in South Africa reported it to the police. And of the ones who reported to the police, one in fifteen actually got a conviction, so you can work out for yourself how bad it actually was. The One in Nine Campaign started just before Jacob Zuma was elected president, when he was tried for raping a much, much younger woman (who was HIV-positive and openly lesbian). Zuma ran a very politicized defense against the rape charges, attacking the young woman as somebody who was sleeping around, and claiming that

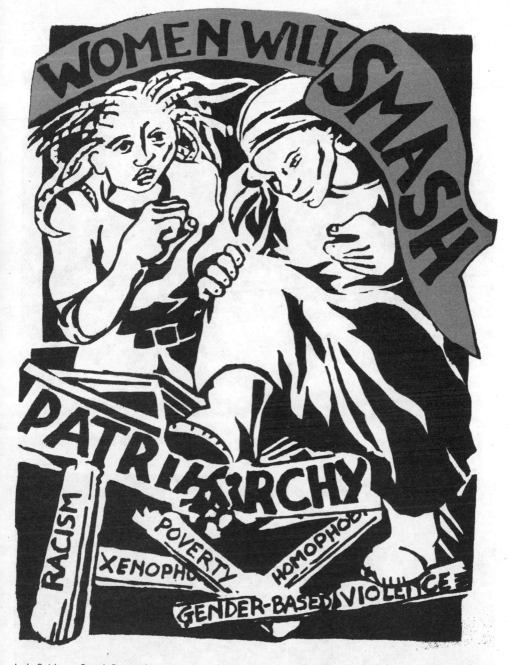

Judy Seidman, <u>Smash Patriarchy</u>, screen print poster, 16.5 x 23.4 inches, Johannesburg, South Africa, 2013; poster designed with a One in Nine Campaign workshop and printed by AMPS studio.

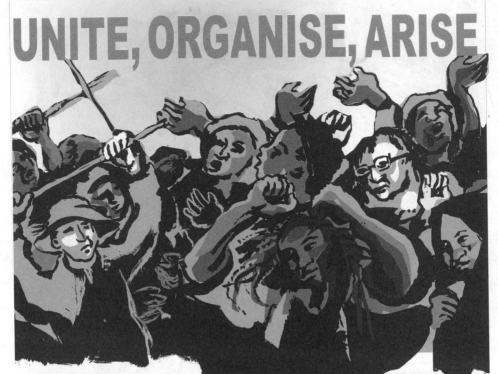

Judy Seidman, Unite, Organise, Arise, pastel drawing and computer layout, 16.5 x 23.4 inches, South Africa March 2020; contribution to Tricontinental: Institute for Social Research's "Hybrid War" theme, as part of its Anti-Imperialist Poster Exhibitions series of open calls.

the charges were a setup to keep him from being elected president. A lot of the women's movements and the activists working on gender issues came together to form the campaign.

This poster was also discussed collectively. We had about thirty people talking about it. We wanted to do a poster that was not only anti-rape, but anti-gender-based violence—all of the issues around patriarchy had to be addressed, and we had long discussions about each of the words in the slogan. About a year after it was done there was a big debate on whether to add transphobia and so forth. They didn't want to change it, having already made the decisions, and it went back and forth but remained this way in the end.

← This one is very recent; I think it's from last July. This was for the organization that Tings Chak is a part of, Tricontinental. They were doing an international exhibition which asked for international artists to work on the theme of imperialism's hybrid wars—it was in the middle of COVID, and as a result not a particularly collectively designed poster. I thought it would be interesting to show today because of what's going on in Ukraine. I've always thought that posters change as time changes and issues change, and what people read into them will also change. For me, looking at this six or nine months after we made it, it raises a whole lot of other questions about the particular war that's going on at the moment.

One of the ideas that came out of the work we did with the Medu Art Ensemble, forty years ago, was that there are different kinds of posters. There are some posters that are just telling you about an event that you had to go to. There are some posters that are educating you. This one was intended as an educational poster. The intent was that it would be on the wall of a building people walked by, so you could talk about it and think about it a bit.

What strikes me about all this work, the final piece aside—although I think you could argue it was still collaborative in some ways—are these ways of creating posters where clearly your individual hand is a part of, but which come out of collective processes.

I think that we could probably make a grand argument that all cultural production is collaborative in some sense, because we're always absorbing influences and having conversations and things like that, but the collaboration here is clearly much more intentional. I'm wondering if they could be a lens to jump back to the late 1970s and Medu—could you talk about how you got involved in Medu, and the social organization that was in the background which people just looking at the images might not be able to see?

We used to call ourselves "cultural workers" in Medu. There was an artist named Thami Mnyele; he used to say that Medu was, for all of us, "a university education in art." I had always been interested in political art, even as a

child. When I started studying arts seriously at the "official" university level, it was during the antiwar movement at the University of Wisconsin. That's where I learned to silkscreen posters.

But in Medu, we actually talked about how to make artwork collective, and what it means to make it collective. So, we would talk about the ideas that went into our art, what we wanted to say with the work, and the message that would get across to people who saw it.

We experimented with different ways of working together. Sometimes one of our members would come along and say, "I've got a great idea for a poster, I want to do this," but then we would talk about that idea. Other times, as with those first two posters, *The People Shall Govern* and *You Struck a Rock*, we decided on the subject as a group—in the first instance on the Freedom Charter and in the second on mobilizing women in South Africa. At that time, South Africa had not declared August 9th as Women's Day; I'd like to think that that poster was one of the things that made it into Women's Day. The August 9th march was important, but more than just commemorating that march, the poster put the date, and women's issues, back on the calendar after a gap of whatever it was, fifteen years, in the history of South Africa.

So how do you come up with a collectively conceptualized image that speaks to people? Well, you have to think about what you're trying to say, and how you see the imagery, but also how other people will interpret the imagery, and that changes all the time, as with that picture on imperialist wars. I would like to think that if the image is effective, those changes in how it is interpreted over time actually strengthen the picture.

But I think I've lost my train of thought here. We're talking about how I got into Medu. I have this rather weird background. I was brought up by a more or less left-wing American family in Connecticut until I was eleven, and I'm ancient, I was born in 1951. I was raised in an interracial cooperative set up by people who were essentially trying to get away from the McCarthy era, to put it simply. Not retreating, but making a place where there was at least some space to interact. It's called Village Creek. It was actually the first interracial cooperative on the Eastern Coast of the United States, I believe, and it was set up the year I was born, in 1951.

Nevertheless, my parents were quite dispirited about the things that were going on. This was just at the beginning of when John F. Kennedy came into the US presidency, but it was also the time of the Bay of Pigs invasion. The civil rights movement was successful, but it wasn't clear where it was going at that point. In any case, my parents got offered a job in Ghana in West Africa, and they decided, "Right! We're packing up all five children and everything else and going to Ghana."

So, I went to secondary school in Ghana, and my interest in African art particularly came from there. My first teacher in boarding school was somebody named Kofi Antubam, who was, and still is—I mean he's long

deceased—but he was one of the leading African artists looking at what it meant to do art in independent Africa. I was a small child in his classes. I'm not sure he was particularly aware that I was there at all, but I certainly learned a hell of a lot from him.

I was fascinated by what was going on around me; and the issues of race were always very upfront in my life. They had to be: first in the US in the late-1950s civil rights movement, and then when I went to boarding school in Ghana. Out of the 450 students in the school, my sister, my brother, and I were the only white students for almost the entire four-and-a-half years I spent there. That kind of experience gives you a different perspective on what race prejudice and discrimination are all about.

I was always fascinated and horrified by what we saw coming out of South Africa. There was a flight that went from Johannesburg to Ghana, and then flew on to London once a week. After the apartheid regime's Sharpeville massacre in 1960, and the crackdown on the ANC, you were getting refugees from South Africa flying into Ghana on that flight every week. My parents were part of a team of people who welcomed refugees getting off the plane. I was in boarding school, so I wasn't part of that, but I was very aware of it. I admired the courage and strength of people who were organizing against institutionalized racism of absolutely the worst sort, which is what we all felt apartheid was.

At the same time, I was interested in how the visual arts spoke to how the world was changing around us, and how people dealt with that. So, my ideas about art came from there.

In 1966, when [President Francis Kwame] Nkrumah was overthrown, my parents went back to the US where my father got a job at the University of Wisconsin. I went to university there, in Madison, which is where I was involved in the antiwar movement and all that—which helped me begin thinking about making political art.

And when I graduated from Madison I went to Zambia! My parents were then lecturing at the University of Zambia. For a whole series of reasons, they had quite a lot to do with the ANC, and South Africa's liberation movements there. The ANC had an office in a building called the Liberation Center in Lusaka; one of my sisters got a job as the secretary in that ANC office.

The story behind the first poster that I did for the ANC starts with a letter bomb in the office, in February 1973. I was driving my sister to work, after she came home for her lunch break. She was seventeen at the time, taking a gap year between high school and university. Just as we arrived back at her office, a bomb went off, killing a young man who we called "JD," or "John Dube" (his real name was Boy Mvemve). He had been working at her desk while she was on lunch break. If my sister hadn't come home for lunch, she would have died. So, the first poster I did for the ANC was a poster for the funeral of JD. Because we did not have any photographs of him—the

movement didn't like to take photographs of people who were in exile—I did a graphic for the funeral. After that, I did other artwork for the ANC and the South African liberation movement.

I also got married. My husband was a historian, specializing in Southern Africa. In 1975, he got a job in Swaziland, where we lived for five years, then he got a job in Botswana, and we moved to Botswana, where I spent the next ten years. Botswana is where I got involved with Medu Art Ensemble, which was set up to make art about South Africa's liberation movement.

For me, that was my second university, a much more intense education in artmaking than the one in the US. I began to understand what, for me, making art was about; how I fit into what I was trying to say with my art. We experimented a lot within the collective. Like: was it better to draw an image together, working on the same picture at the same time? That didn't always work well, but when it did, it was amazing, completely mind-blowing. I think it's a bit like the difference between playing a piece of music that you're taught from a script or working in a group where you're improvising and sparking off each other in new directions. Once or twice in Medu, we actually did works like that, particularly me and Thami. Thami would start to draw something; I would take the pen and say, "we could do it this way," then he'd take the pen back and say, "yes, and we should add this as well," and it turned into a picture that neither of us could conceivably have come up with on our own. Some of the most exciting art that I have ever done was done that way.

Was the group drawing from particular examples of collective practice, or was it all just learning on the ground?

Medu came out of a whole series of things. Apartheid tried to crush the existing artistic expression amongst the Black population—and there's no other way to put it—apartheid was a vicious, truly vicious system on many, many levels, and art was one of them. The apartheid government refused to encourage creative arts made by Black people; they only recognized "traditional" crafts that were narrowly defined by "Language and Culture Boards" appointed by the ruling (white) government. To reject this limited approach, art makers who were classified as "Black" developed their own ideas about the art they should be making. There was quite a lot of discussion about what makes art "Africanist" as opposed to imported, imperialist art. There were also questions about whether somebody who was white should be part of that "Africanist" collective. There were no instant answers to these questions. These debates went on forever, and they're still going on today.

Obviously, I have worked out my own answers to these. But one of them is that, certainly in my experience—some strange white woman, born in America, brought up in West Africa, back in America, not speaking any of the South African languages, not having lived under apartheid as

oppression—my understanding of what I was seeing and doing was often very different from that of the people I worked with. That didn't make my art less valid; it made it different. And for me, working in a collective was particularly important because I was learning about how other people were experiencing things that I didn't know about. Experimenting with how all these perspectives worked together, collectively, how someone else's experience spoke to mine, especially sharing experiences across racial lines. It was incredibly intense. Medu as university was an overwhelming education in many ways. . . .

You mentioned the questions asked around imperialism, or the imposition of external cultural values and representations. I wonder how those questions dialogued with Pan-Africanist values of representation and aesthetics given that Medu had a music unit that was largely producing jazz, where there's already an established conversation between South African and American jazz music.

I think the short answer is "yes." The real answer is about four books long.

Jazz in the South African context is interesting because the apartheid government refused to accept it. They felt it was a racially mixed hybrid, and they didn't quite ban the music itself, but they didn't allow whites and Blacks to play in the same spaces. When people from different racial groups did, they had to lie about it. There were some "whites only" venues where there was jazz, where Black musicians had to play behind a screen, and no one ever admitted that they were actually performing the music. It was crazy. There were many things about apartheid that were crazy, in culture as much as anywhere else.

These were the strong, valid reasons why South African arts in the 1960s developed and supported the Black Consciousness approach. It was a direct response to the oppressive racist reality that people were living with. Pan-African art was something that people developed to speak about their own lives, as they were misshaped and damaged by imperialism.

Under first colonial rule and then apartheid, Blacks didn't have art schools, or rather they had very, very few; and those were private or run by missionaries, most often on the edge of being closed down. By the 1950s, there was no art taught in Black schools except for traditional crafts, which were very narrowly defined. The government schools for Blacks (the so-called "Bantu education system") replace artmaking with a course called "Skills and Techniques." Skills and Techniques aimed to teach children not to create art but to manipulate small things, so they would be able to work on an assembly line, accurately and without any creativity whatsoever.

One important idea that took hold amongst the youth who believed in an Africanist art speaking to their own community, is that the "formal" divisions assumed by the European colonialists between the types of cultural production—between music and visual arts and theater and poetry, etc.—were

artificial divisions. Historically, African cultural production moved between these divisions. Was a masquerade visual art, theater, dance, or all of the above? How should that work out in our work today?

As I said, for me it was completely different from my formal university arts education. Not that my university education in Wisconsin was bad, it was very good in many ways. But in Medu I learned to ask what it meant to be creative, and what one was trying to say through making art, in a completely different kind of way.

That stuff from the Medu years, by the way, still has to be written up and placed in the public domain. Now, today, we are finally making a website that will look at what Medu did in its years of existence, a project done with the University of the Witwatersrand's Wits History Workshop and Wits Historical Papers [in Johannesburg].[1]

That's great for people to have access.

We always said it needed to be publicized. But it's now forty years later. . . . I should also add, because I'm sure people don't know this history, Medu Art Ensemble existed from 1978—which was before I got there; I got there in 1980—until it was destroyed in 1985 by a military raid by the South African Defense Force, which killed twelve people on the 14th of June, including Thami Mnyele. Thami was by far our best visual artist (if there is such a thing), and an incredible cultural thinker. They killed a number of other people who were in Medu, some others who were political activists, and some innocent people who just happened to be in the way of the hit squads. Medu ceased to exist at that point.

Most of the South African exiles who had been in Medu then either left Botswana or went underground. I decided to stay in Gaborone because I figured as an American citizen I was probably much safer than South African exiles. I later discovered that it was true that I was safer, because that came out during hearings of South Africa's Truth and Reconciliation Commission (TRC) in 1998. There was a separate hearing on the 1985 Gaborone raid, as it was called. At that hearing, the apartheid security police described how they chose who would become targets in the Gaborone raid. To my shock and horror—I was sitting in the audience of that TRC hearing—this army officer puts up a PowerPoint with the first list of people they were planning to hit, months before the raid happened. My name was on it. The witness said they took some names off; of women who had children who were not known to be liberation fighters. So, because I was an American citizen, and a woman, and had two children, and was not known to be a freedom fighter, they took me off the list of targets by the time the raid happened.

To sum this up: I learned so much about what I know about art from working in Medu. Since 1985, when Medu was destroyed, I've been trying to

put some of those lessons into practice. I can't say I've found a collective that is nearly as effective as Medu was, although working with the feminist One in Nine Campaign and other artmaking workshops have been enlightening and exciting in their own ways.

The destruction of Medu seems like a powerful example of the stakes involved in culture-making that has social impact. Here, in the US and North America, artists often want it both ways. They want to talk about how political their work is until it has an effect that washes back on them, and then they want to say, "Oh, it's just art; you know, it's just art; it can't hurt anyone! I'm interested in it as an object lesson that you ultimately can't have it both ways when there are real things at stake.

There are different ways to deal with that. In July 1982, Medu hosted a sub-continent-wide, five-day conference called the Culture and Resistance Symposium, which more or less defined resistance art in South Africa for many years to come.[2] One of the resolutions of the conference declared that "art is a weapon of struggle." It's something that we need to think about: if we are involved in a life-and-death struggle, our art must speak to that and become part of that struggle.

The person who gave the opening speech at Culture and Resistance was an artist and poet named Dikobe wa Mogale [Ben] Martins. Dikobe started out his speech with a statement that went along the lines of, "Art won't win a revolution, but it gives you a vision for what to do about it and it inspires you."[3] That was a crucial understanding for us. But asserting that "art is a weapon of struggle" also works both ways: the apartheid military used this as justification for targeting Medu members during the Gaborone raid in 1985. After the raid, Major Craig Williamson—who planned the raid for the apartheid military—went on television and held up drawings from Thami Mnyele's portfolio, which the apartheid soldiers had taken back to South Africa after they killed him. Williamson displayed those artworks to show the kinds of terrible things the people they had killed were doing to destroy the apartheid government.

After the conference many more people made artwork supporting the liberation movements inside South Africa. They did this under conditions of apartheid, and obviously they were under far more danger of being detained, tortured, jailed, and killed than we were sitting across the border in Botswana. I mean, we knew it wasn't safe in Gaborone, there were South African raids all the time on the frontline states, but it was much safer there compared to somebody living in one of the townships. And yet people went back into the apartheid shadow, and made that art. There were maybe 1,000 people at the Culture and Resistance Symposium. Probably 800 of them came from South Africa, to which they returned and made art that undermined and attached the apartheid machine. That was incredibly brave,

incredibly powerful. Working under those conditions was itself a powerful statement of resistance and of hope.

One of the things that shaped me happened at the funeral we held in Gaborone for people who were killed in the 1985 raid. Medu literally closed down the day after the raid. When we organized the funeral, the Botswana government told us that we must not do any artwork or posters around the funeral, because the South African regime might use that to carry out another raid in Botswana. I decided I would make a visual memorial to our dead anyway. We printed a small run of posters and painted a banner for the funeral. We illegally hand-silkscreened those and we held them up at the graveside. But then, buses arrived with cultural activists from inside South Africa—people who were taking a chance coming to Botswana at all, showing their support for the liberation struggle. The ones from Johannesburg—from a group called the Screen Training Project (STP)—arrived wearing t-shirts which they had printed with pictures of Thami Mnyele and the slogan "Lived in the Struggle, Died Our Hero." They printed those in Johannesburg and carried them across the border for the funeral. Whereas we were being told by the Botswana government we shouldn't do any political work whatsoever; that it would not be allowed. People's courage with these things was incredible.

The ideas and artwork that came out of Medu actually infused a lot of the cultural work that was done inside South Africa through the 1980s. That has not been fully historicized or researched. As I said, we're only now, forty years later, putting together a collection of the work that Medu did. There is also this book that came out three months ago, at the end of December, called *Culture and Liberation Struggle* in South Africa. It's a collection that talks about the history of the culture of resistance and the culture of liberation; it is probably one of the best anthologies that I've seen on how the arts fit into the struggle within South Africa.[4]

It seems difficult to open up the conversation to everything post-Medu even though I desperately want to. But maybe it makes more sense to just ask one more question . . . Medu is remembered as a struggle organization, which of course it was, but also as far as I understand it, it regularly offered classes and artmaking for youth and everyday people in Botswana. It's usually dropped from the story, so I'm curious about its relation to the other work.

It was very important. The basic principle of Medu was that a cultural collective must also involve the communities that the artwork comes from. It was not just a group of artmakers working together; you must also work with people in your community.

Since most Medu members were exiles from South Africa, and still saw their home community as the struggle happening there, that left us with the question: how do we relate to the community actually around us in Botswana?

The first time I actually met Thami Mnyele, I had been given an introduction to him from someone in London who knew me and knew I was an artist—like, "You really ought to find out about Medu and join them if you can." [Laughs.] I had a letter of introduction to Thami, but I didn't know where to find him; he was living semi-underground, being in exile. I was told to go to the Botswana Museum and Art Gallery, which was quite supportive of Medu. The staff there told me, "Well, if you really want to see Thami Mnyele, he's teaching a class of Botswana kids at the Botswana Trade Fair." So [laughs], I got into the car and drove to the Trade Fair, and there was Thami, surrounded by about thirty-five kids, aged—I would guess—between about seven and eleven, all of them hanging on his every word. He was a brilliant teacher, and he loved teaching—amongst other things. [Laughs.] He basically said, "Sit down while I finish the class," and afterwards we talked about where I was coming from and about some of the work I'd done in Zambia, Swaziland, in terms of cultural stuff, and how I saw it. And he says, "Okay, I think you need to join Medu." [Laughs.] It was just like that.

But the answer to how we interacted with the Botswana community must be—in very many, different ways. It was sometimes tense. The apartheid government would go around and tell Botswanans that we were a danger to them, that one of these days they might do a raid, and if Botswana citizens happened to be living next door, they might get killed. And in fact, some of them were killed, that part at least was not false. Indeed, after the Gaborone raid, the apartheid government sent people to speak to the neighbors at a number of houses of South African sympathizers, including my neighbors, saying things like: "You know, this person is going to be next on a hit list, and your whole neighborhood will be endangered." My neighbors asked me to move after that. I moved house eight times over the next five years because of that.

But at the same time, there were people in Botswana who saw themselves as sisters and brothers, comrades to the struggle in South Africa, and who sacrificed everything they had to support it. We had Medu members who were Botswana citizens, who became very well-known creative artists in Botswana. And we, in principle, believed that the culture we made should speak to people in Botswana as well as people in South Africa. Obviously, the issues were sometimes different; but at times they were very similar.

One important case was that in the 1980s, in independent Botswana, there was very little art teaching in Botswana (following the apartheid pattern). We taught artmaking and music-making and theater, in Botswana communities and in schools, and even in the Botswana prisons system. Medu members helped develop the arts curriculums used in Botswanan schools.

What you just said struck me because it echoes with the work of the Zapatistas in La Otra Campaña [the Other Campaign] in Mexico over the last twenty years.[5] A central tenet to their organizing is the idea that art is

a human right and so they organized on the ground to set up art centers all over poor and working-class areas in Mexico. Halfway across the world, but very parallel struggles.

I think there's parallel development in a lot of these struggles. And some of it's not just parallel. In 1978, there were artists from Chile, who, after Allende was overthrown, moved to Mozambique, where they worked with a collective of Mozambican artists and some exiled South African artists to paint murals. Maputo became one of the major centers of art in Southern Africa for quite a long time. The main Mozambican artist working with them was Malagatana. But a South African, Albie Sachs, who later became Judge Albie Sachs, was part of the collective that painted the murals of Mozambique in the early 1980s. Albie corresponded with us in Medu about the mural-making process, so there was conscious overlap. Although, it was never enough. We all felt it was never enough. There was an awful lot of what you might call "simultaneous invention" in terms of the way one approached collectives. A lot of the work of communication got channeled not just through Medu but through the various Pan-Africanist conferences that happened. I think we all have things to learn from that history which has not been given the serious attention it deserves.

In Medu, we talked about the Mexican muralists and the Chilean muralists and said we would like to produce murals in a free South Africa, but that never quite happened the way we intended it for all sorts of reasons. I suspect most of my colleagues would say, "Yes, we won the elections, we forced a situation in which Mandela would be elected, and there was an end to the apartheid government." But there were a whole series of compromises, and some people feel that it didn't go far enough. The streets were not taken over with people's art!

Well, the long history of every form being banned: the banning of the poster, and then the banning of graffiti, and then the banning of t-shirts. It's difficult to come out of that without a hard break.

There was a song—written I think in the late 1950s in the United States, which I was brought up on by my fairly radical parents—that goes, "Freedom doesn't come like a bird on the wing, it doesn't come down like summer rain, you've got to work for it, fight for it, day and night for it, and every generation has to win it again."[6] I sort of look at the world around us and say, right, we have to win it again. It doesn't downplay the victories we've had, we need to learn from them, and we need to build upon them. But there are disastrous things happening around us all the time that also need to be understood and mobilized around, not just in South Africa. In fact, sometimes I think we've come out relatively well out of all of this. I mean it's not everything we thought it would be, that's still coming, I hope. I'm endlessly optimistic.

NOTES

1. See Medu Art Ensemble Consolidation Project, Wits University Research Archives, University of the Witwatersrand, Johannesburg, South Africa, http://researcharchives.wits.ac.za/medu-art-ensemble.
2. The Culture and Resistance Symposium, and the accompanying exhibition and festival of South African arts, was held in Gaborone, Botswana, from July 5–9, 1982.
3. "As politics must teach people the ways and give them the means to take control over their own lives, art must teach people, in the most vivid and imaginative ways possible, to take control over their own experience and observations, how to link these with the struggle for liberation and a just society free of race, class and exploitation." In Dikobe wa Mogale [Ben] Martins, "The Necessity of Art for National Liberation," keynote lecture delivered at the Culture and Resistance Symposium, 1982.
4. Lebogang Nawa (ed.), Culture and Liberation Struggle for South Africa: From Colonialism to Post-Apartheid, Vol. I (Johannesburg: Ssali Publishing House, 2021). Volume 2 is due out in late 2023.
5. For more on La Otra Campana, see: Subcomandante Marcos, The Other Campaign (San Francisco: City Lights Books, 2006).
6. "Pass It On," written by Millard Lampell and George Kleinsinger. The song was later popularized by Judy Collins on This Land Is Your Land: Songs of Social Justice, an album released in 1964 in the US by the United Auto Workers.

A3BC
(ANTI-WAR, ANTI-NUCLEAR AND ARTS OF BLOCK-PRINT COLLECTIVE)

I INITIALLY MET NARITA KEISUKE (Kei) in the early 2000s at the Bay Area Anarchist Bookfair, in San Franscisco. At the time, it was a huge, multiday gathering, and I would pack up tubes and tubes of political prints and posters and travel across the country to set up a table and try to sell them there. Kei would travel halfway across the world to come to the bookfair and buy up whatever he could afford of everyone's books, art, and ephemera for his Tokyo-based bookshop and social center, Irregular Rhythm Asylum (IRA). Kei and I struck up a friendship and started sending small packages of flyers and posters to each other, through which I learned that he was a designer himself. Dara and I not only included some of his work in the 2008 Signs of Change exhibition at Exit Art in New York City, but were able to bring him over to the US to do an event for us and discuss the social movement culture in Japan.

Meanwhile, I also learned that he was really interested in DIY craft, regularly hosting button-making, sewing, and other group art activities at IRA. The value of this ongoing DIY practice was put into stark relief in 2011 with the Fukushima nuclear meltdown. Kei and his companions launched into action, organizing and participating in a wide array of activities to address the disaster, from creative protest to home radiation testing. This is at the root of the A3BC project: it is as much an evolving social gathering and mutual aid structure as an art collective, a print project anchored in the community that uses IRA as much as the goal of producing prints. Ai, Aki, Kei, and Nia were able to discuss this at length on April 27, 2022.

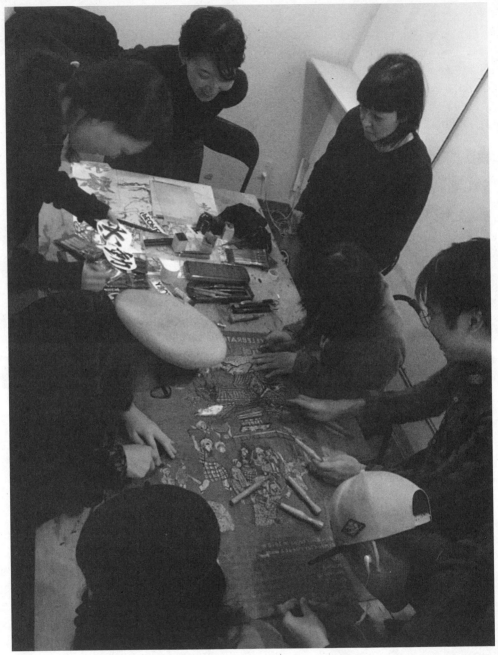

A3BC, a scene of production, Japan, 2019.

Aki: My name is Aki, I use he/him and they/them pronouns and I'm a part of A3BC, very happy to be here.

Nia: Hello everyone, my name is Nia. I've been a part of the collective for exactly four years, and it's a pleasure to get to share this with you.

Ai: My name is Ai and I'm a founding member of A3BC, starting in 2014.

Nia: Woo! [Laughter.]

Kei: Hi, my name is Kei. I'm a member of A3BC, and I'm also running an info-shop called Irregular Rhythm Asylum which A3BC is based out of.

Josh MacPhee: Great! So, tell us a little bit about this photo?

←Aki: Yes, so this is a typical picture of us working together on a Thursday evening before COVID. We were able to meet in person, and you can see all of us carving on a woodblock. It's actually the *Rice Riot* print we will look at in a little bit. It's a very fluid process—

Nia: [Laughing.] Chaotic!

Aki: [Laughing.] Chaotic, thank you. It's a chaotic process, all of us doing something different. Some people are watching, some people are carving, someone else might be thinking about what could look better, what else could fit in the picture. So, with that we have a rough sketch, but we usually build on top of it, as we carve along. I think this is also a nice picture of how many people there are in a typical meeting. This is a perfect picture where eight of us are fitting in very nicely and I'd like to say that we're having fun. We're laughing, it's a very casual process where I don't think anyone is feeling nervous or, well—I'm always nervous so count me out—but everyone is having fun.

→ Aki: This was made in 2020, and the title is *TOKYO 2020*. Some of you might recognize the motifs in the picture; a lot of them refer to the Tokyo Olympics that happened in 2020—or last year actually, because they were delayed. Right in the center you see two humanoid figures standing amidst a lot of things, and the idea was that they were two magicians trying to make everything that had to do with the Olympics disappear, the inconvenient truths, so to speak.

Nia: We should mention that the Olympic Games that were supposed to be in 2020 in Japan were surrounded with controversy and scandals and a lot of shady things, and so a lot of resentment was really built up. Because of COVID, we made up the sketch over emails and Zoom meetings and stuff like this.

Ai: And we also made it for an exhibition in Kuala Lumpur in—2020?

All (Ai, Aki, Kei, Nia): Yeah.

Ai: The exhibition showed work from art collectives and scenes in East Asia and Southeast Asia, like Taipei, Hong Kong, Japan, China, Malaysia, and Indonesia.

Aki: Right, it was a group exhibit, but the idea was that talking about the Olympics happening here in Japan made sense because they were only made possible by natural resources taken from throughout all of Southeast Asia.

This is on fabric and it looks like it's quite big?

Aki: Yeah.

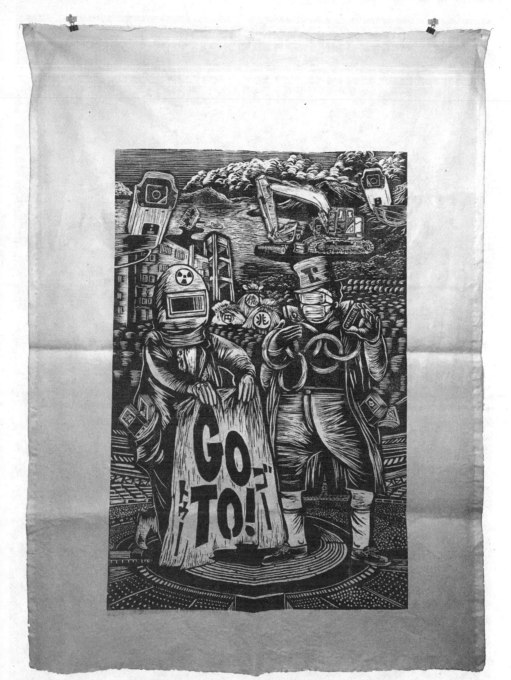

A3BC, Tokyo2020, block print, 37 x 48.5 inches, Japan, 2020.

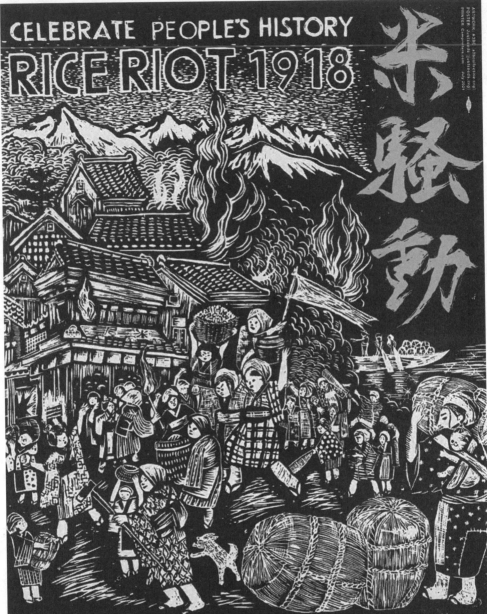

ARTWORK: A3BC [a3bcollective.org] POSTER: Justseeds [justseeds.org] PRINTER: Community Printer [communityprinter.com] July 2021

CELEBRATE PEOPLE'S HISTORY

RICE RIOT 1918

米騒動

Rice Riots began in 1918 when 10-20 female dock laborers made a direct demand for rice at a warehouse in Toyama, Japan. The demand was in response to merchants buying all the rice in the market so they could sell it to the Japanese government for their troops in Siberia, doubling the price and making rice inaccessible for the common folks. The demands turned into a massive uprising, inspiring more than 1 million people to take action all over Japan. These riots were no accident but an organized resistance led by female laborers, who only earned 60% of their male counterparts. The Rice Riots became a turning point for Japanese labor movements and class warfare.

A3BC, Rice Riot, block print, 11 x 17 inches, Japan, 2019.

←Aki: It's the same size as the image to the left: *Rice Riot*. You can see "1918" in the picture. We made this in 2019?

Ai: At the end of 2018.

Aki: Thank you. It was the hundred-year anniversary for the Rice Riot which [laughs, looks around]—would any of us like to explain? It was a monumental labor movement.

Ai: A lot of women participated in that movement, and it was a tipping point for social movements in Japan. We describe those women at the bottom of the poster. I wrote it and Aki translated it into English . . .

Nia: [Claps, laughter, Aki tries to stop her.]

Ai: And we showed this poster in the exhibition in . . .

Aki: It's a rather big gallery—

Nia: Fancyyy gallery . . .

Ai: [Laughs.]

Aki:—a rather fancy gallery in Tokyo.

Nia: It was really fun!

Aki: The translation was done by a lot of other people too, including Nia.

Nia: It was a poster to celebrate people's history! [All laugh.] The most important part!

Aki: It was included in Josh's Celebrate People's History collection of posters from artists all over the world and we were very honored to be a part of that.

Nia: Screaming, excited, yes.

The image is so visually coherent, which makes it hard to imagine multiple people carving it, even though we saw the picture of you doing just that. You hear artists all the time say it's not possible for a group of artists to draw a picture together, you can still work together but the labor has to be divided, one person drawing while another writes, but not actually drawing at the same time. But here you're clearly proving them wrong.

Aki: Thank you! Yeah, I think it's a successful case of all our talents coming together very nicely. [All laugh.] I'm very serious. The font at the bottom, for instance, all of it was hand carved. The font on the rough sketch was typed, but in the actual block print, there's someone who's really good at carving very detailed objects, Hiro-san, so he did a lot of that. That's one person with a unique skill using his talent. And for all of us, there's a lot of historical research that went into it.

Ai: Nia-san borrowed books on the time period from the university and we referred to the patterns on clothes actually worn or items actually used in the movement.

Nia: I don't want to speak for everyone, but the visual coherency was a bit of a worry and it's really nice to hear this. I was a little bit surprised! But I also want to say that there's something about woodcut that makes it easier—when you actually print it, it just kind of ends up working. Really, no matter how chaotic the process is, we're always delighted and impressed. You're not sure while carving but when you print, it's like, 'Oh! Congratulations, another masterpiece!' Just joking! [Laughter.]

→ Aki: The last image is *Severance*. I think it's one of the most recent prints that we've made and it reflects a post-COVID world. We wanted to express what COVID did and how big corporations manipulated our plights. So, in the image you see big skyscrapers in the background, looming over the depressed-looking alleyway where there's a lot of closed businesses and some rats that are thriving in the streets. But you see that a lot of us are severed. And the lightning-like severance in the very center, we didn't really intend it to be literal lightning but more of a—

Nia: A crack.

Aki: Yeah, a crack, thank you—that we felt was going on in our society.

Ai: During the pandemic we had a lot of different opinions—whether we should have vaccinations or wear masks—so there was a kind of separation between us, even within friendships.

Aki: Yes, it affected our relationships and we wanted to express the difficulties with that.

For me, it's hard to not see the center line as lightning because it goes right through what looks like a government capitol building. Whether intentional or not it creates a very clear reference to Bad Brains' first record cover, which

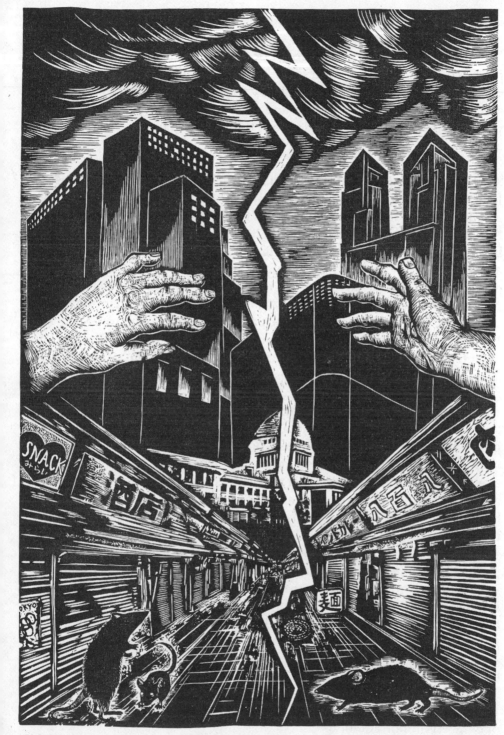

A3BC, <u>Severance</u>, block print, 30.3 x 42.1 inches, Japan, 2021.

anyone with a history in punk rock would see.¹ One of the great things about images is that the meanings pile up and you can't necessarily control them all.

I think that was a great introduction to your work. It sounds like a couple of you have been involved since 2014, so can you tell me about the arc of where the project came from? I know that you have a process of open membership, where people come and go to weekly meetings. That's one thing in theory, and then it's a different thing in practice, so how does that actually work?

Ai: After the Great East Earthquake in 2011, many social movements arose in Japan, such as those against nuclear power. There were large demonstrations against national registration and against the US military base in Okinawa. A3BC was officially founded in August 2014 when we conducted several block-printing workshops. The founding members, including me and Kei-san and others, decided to start regular meetings, in part as an extension of our participation in these movements. The founding members were inspired by political art collectives in Southeast Asia—such as Taring Padi in Yogyakarta, Indonesia; Marjinal, also from Indonesia; and Pangrok Sulap from Malaysia. We decided to focus on antiwar and antinuclear issues in the beginning. Then, recently, for maybe four or five years, we have stood for many other social issues, such as environmental issues, gender, poverty, etc.

Aki: Josh, you asked how the open membership system works. I'd like to say that there's not much of a technique to it, people come and go. I think those interested in collaborative work keep coming to meetings. There's no restrictions on how many meetings you have to come to or how long you have to stay in these meetings. I think that relieves people of the pressure to do things as if it is a job. I wouldn't come to a Thursday meeting—and our meetings happen Thursdays—thinking, I have to go to another political meeting? I think that makes it a very relaxed atmosphere.

Given what's happening with the pandemic, we were not able to meet in person, but some of us wanted to do something even with all of us quarantining in our own homes. We have an email listserv and a lot of passionate folks reached out to us online. We had a project called *Wood Block Quarantine*, where basically each of us would make individual works and hashtag it with the phrase "#woodblockquarantine." There's a lot of fluidity in the membership system but it's our passion and interest in the collaborative artmaking process that keeps it together.

Ai: We are not interested in a hierarchical system and we value DIY culture, so openness is important for us.

Nia: And I think that's possible because we're amateurs in terms of our

techniques. Somebody might have something they're good at, but there's no particular person that is always responsible for the same thing, so if they don't show up that won't stop it from getting done. It lifts the pressure off showing up, even though we do show up because we want to. Basically, if somebody really good doesn't come in it's gonna be a little bit shaky, but it will get done anyway, and there is no pressure.

Ai: And some parties just enjoy chatting while working. [Aki raises their hand.]

This gets into something else I'm really interested in. Just because you're not hierarchical doesn't mean there isn't conflict, and a lot of people use hierarchy as a way to resolve conflict—if you're higher up on the hierarchy, then you're the one who gets to decide. So, without hierarchy, how does conflict get negotiated when there's a difference of opinion or strong ideas about the politics within an image? Maybe that doesn't come up that much because it's collaborative enough that people just sort of weave in and out?

Aki: For me, personally, I like to think that we are collaborative enough but also friendly enough with each other that even if we feel a disconnect with one of the ideas, we would be able to consult with another member of the collective, and then together bring it back to the collective and revisit whether the idea that was put forth really works.

I think that there is respect and friendship between us, where we feel comfortable expressing our disagreements with something that is going on. Meetings aren't really structured either, so when some of us have a very sentimental thing to say about something that is going on and want the group to process that or navigate how we could address it, we do that. It's not always "business" as you might have figured out. There's a lot of space for difficulties and disagreements.

Nia: I think, maybe because there are no ambitions of making it big in the art world and money isn't involved, the stakes really are just our relationships. The relationship is the most valuable thing we have, and you would be compromising that. Sometimes people distance themselves for a period of time, and then come back and leave again, that sort of thing happens.

Aki: Some pieces didn't come to fruition because we didn't come to an agreement. Like, we didn't do a cohesive rough sketch or the image of what the art was going to look like. Some projects we didn't move forward with because we didn't come together.

Nia, you mentioned amateur-ness; is no one involved working as an artist in a different context? Do people who see themselves as capital-A artists come

to meetings and how does that play out? This is a tension that exists in the US; there's a strong ego and identity connected to being an artist, and often makes it quite hard to collaborate.

Ai: In the beginning, there were artists from the fine arts field, but they just went out because they have a different opinion. [All laugh.]

Aki: Oh, I didn't know that. Kei-san and Nia-san and a lot of us do make art as professionals—

Nia: Freelance.

Aki: I don't think we will abandon the identity of "artist," but I think when we are making and putting forth our ideas, a lot of us are interested in collaborating and making a group picture rather than a hierarchical process of someone imposing their ideas on others.

How does money function in the system? Do you sell work to pay for supplies? How do you negotiate expenses? Is the work for sale, and if so, how do you decide on the details of that?

Ai: So, we run A3BC by sometimes selling t-shirts.

Nia: That's true! [Laughs.]

Ai: Members make creative individual works on the t-shirts and then we sell them on the Internet. Sometimes, when we join an exhibition or talk at an event or organize workshops, we have a little donation box.

Aki: Each of us making prints for t-shirts is one way we fundraise. Other times, we are commissioned and the work comes to us. My snobbiness here is a joke [laughs], but money is not the primary intent in our work.

Nia: Money helps us a little bit and we have this dream of using some of it to go meet other Southeast Asian collectives, and support the movement in that way as well, but these two years have been really hard for that. So, the money is just there in a shared bank account that we made. [Laughs.]

As you can tell, in some ways I'm less interested in the art object and more interested in the social process and the different aspects of what it means to work together. Imagine you did take that trip and you went to Yogyakarta and you went to Malaysia—who gets to go? How do you decide, especially when you have a rotating group of members? If someone shows up one Thursday

night for the first time and says, I want to go to Indonesia, how do the practical aspects work? I'm not trying to stump you, I'm really interested in the <u>how</u>. I think these social experiments are very important, so we need to push at them to see how they work and don't work.

Nia: When you guys went to London, how did that happen; who decided to go, who decided to stay?

Ai: It was just, if you want to go say, "I want to go."

Aki: Was there a voting process?

Ai: Actually, there was kind of a discussion.

Nia: And a little bit of voting? [Laughs.]

Ai: Yeah, yeah.

Aki: Right, so some of us went to London. It was an invitation by the company Lush, and so three members of A3BC went, and we were just talking about who would go in difficult but direct discussions, which wasn't the smoothest process. [All laughing.]

Ai: But actually most of the members have a job or go to school!

Nia: Not everyone can go on a trip on a whim.

Aki: I think, in the end, my impression is that with the London trip, it wasn't like we voted on who are the best members, but the people who wanted to go went.

I know that the origins of DIY punk culture have been important to A3BC. I'm really interested in who owns these images after you make them. Can anyone reproduce them, can anyone do anything they want with them? When Crass was doing that, creating iconic symbols that have been reproduced a million times, like the snake eating itself, it was at a very different moment than today.[2] So much of what passes as subculture now is enclosed by corporate interests, hoovered up, and used to sell impoverished versions of our own ideas and styles back to us. So, do you try to control who gets to use your images and how? Or is it just they're made, they're in the world, and what happens, happens?

Aki: The latter! We don't claim copyright to images. We don't attach individuals' names to any of our work. All of our work is made by A3BC. I think we've

just never had to deal with the problems of copyright and ownership. Partly that's because we aren't really interested in making it big in the art world. It isn't about putting it in a gallery or a magazine, it isn't about selling it. Our general stance is that if people like to use our work to make another piece of artwork, they can. Unless it's something that's horrible.

Nia: Well, there's no way of controlling what's horrible. I don't think we're gonna sue or pursue anything to stop it, and we cannot, really. In some cases, we make images specifically for the purpose of letting them out; for example, to use in demonstrations and protests and stuff like this. That's like a separate initiative, and we would scan it really well and put it online and say, "Please, pretty please, use this if you want." I think this is an idea that we all really admire.

We think about ownership as a way our ideas or images are recuperated by capitalism, but there's the other side of it—what happens when a movement feels like it owns something? With the banner you made for the protest movement in Okinawa, it seems there's developed a sense of ownership amongst the protesters over that imagery. What does that mean, what does that look like? Maybe you can explain a bit about that banner, so that people have some context.

Ai: So, we organized a workshop in Okinawa and then we went to Henoko, where the US military base was constructed. A3BC made a big banner, we called it *Okinawa Cho Xiuxiga*. It was sent to protestors in Henoko and Takae upon completion in June 2015, and they received it warmly.[3] However, in September, the tent village in front of the construction site for the US military base was attacked. Right-wing people used a utility knife to slash the banner, but the protesters sewed it up and lifted it back onto the tent. We sent them a new banner and they sent us back the slashed one, which we then exhibited at the Iejima Anti-War Peace Museum to show people there was a right-wing attack. And the protesters in Okinawa showed off their new banner to those right-wing people. So even just in Okinawa there are a lot of different political opinions.

We support the people who suffer from environmental destruction in that area. But also, in 2015 or '16, I forgot the actual time, Rizo Leong, who is a member of Pangrok Sulap in Malaysia, came to Japan and we invited him to go to Okinawa with us. We held a workshop together and made a new collaborative work called *DIY-Worldwide Woodblock-Print Movement*. That was a DIY banner to create solidarity between us.

Do you continue to have a relationship with the protesters in Okinawa? Do you still do workshops there? I guess COVID has changed things. I don't even know what the protest movement looks like in Okinawa now.

Aki: We haven't had personal interactions with them, but I'd like to say that what has been happening in Okinawa is in our hearts. We held a protest of our own in 2019 in Tokyo. A3BC went to the biggest station in Japan and we made a makeshift banner with paint and walked around as a collective. So, we haven't had personal interactions with the folks who are protesting in Okinawa but we are expressing our solidarity with them.

Ai: After the workshop in Okinawa, we also had a workshop in Tokyo to collaborate with protesters here. We had workshops and performances in different sites related to other military bases.

Nia: Because we print on fabric you can just fold it up however big it is, so then if you need it real fast you can just unroll it. We had this moment, in a recent Okinawa action that we did in Shinjuku, when our member Achako said, "Let's do it tomorrow! Or today!" So, we simply took it out and unrolled it, and it's in perfect condition—somewhat—and we were good to go with this huge, beautiful banner.

Aki: Yeah, and I think that it caught the attention of the people just walking around. It looks different from a typical political act in the streets. Usually there's someone with a megaphone doing a speech, but we made art on the streets and people were just interested in what we were doing; perhaps apart from the political message, just interested in what we were making.

I'm gonna ask one last question and then Kevin has a question from the audience. People who make protest prints here in the US, they're generally screen printing or maybe spray painting with a stencil. But you've chosen relief printing or block printing. This greatly predates screen printing as a political tool, but it's much less common, at least within the world I exist in. Some people obsessed with the Western canon think, May 1968 in France, one-color screen prints, that's where political posters came from. But you're going back to the eighteenth and nineteenth centuries—

Nia: Noooo! [All laughing.]

—and drawing on another tradition. So, why woodblock printing? Why woodblock instead of linoleum even? Why is that the core of the practice?

Nia: Wood is so much cheaper in Japan than linoleum. [Laughs.]

Ai: A3BC was inspired by Southeast Asian art practices that use wood cuts; their works are really cool!

Nia: And it's alive on the street; maybe not in Europe or Northern America, but it's really something that anyone can do and it's very organic.

Aki: There's something about woodblock that's very unique to the history of printmaking in Japan. There's been a back and forth between two sides when it comes to block printing in Japan: sometimes the elites make very posh, fine art with printmaking, and then there's a reaction from the common folk. So, there's always been a push and pull between fine art and protest or folk art.

Was there block printing that came out of the student movement in the 1970s? Was that part of the postwar protest movements in Japan?

Nia: In Japan, I feel like this is more related to the 1950s, and maybe in Korea in the eighties, and also obviously in China. I understand the Japanese wood-block sounds really nineteenth century, but what they were doing with the beautiful, colorful ukiyo-e prints is very different from what's going on here. It's not a process with a lot of different techniques involved; it's more like just getting a slab of wood and then cutting with a lot of passion and smudging some ink and getting yourself dirty and stuff like that.

Ai: Also, block printing is used for art education and in elementary school in Japan, so actually, I did it when I was a child.

So, it's something that everyone shares.

Ai: Yeah, it's quite a familiar medium for us.

Nia: Starting with China in the thirties, there's explosive connections between different protest movements sending prints to support each other and throwing something together quickly so you can take it out on the street. Screen printing is not so democratic [laughs]. The starting costs are a lot more ... that's my impression.

Ai: It's more difficult.

Nia: It is, isn't it!

Aki: Only some people know how to make it. I mean a lot of people can learn but—

Nia: And then the size is a tricky thing as well, if you want to make something big. So, a recommendation, anyone watching this [laughs], if you want to do something like this, do it on fabric and also email us with what you did.

Aki: It's like a YouTube channel [laughs].

Kevin Caplicki: I have a bunch of questions, but one of them is something that you haven't talked about yet: food. I know pre-COVID it was a big part of your practice—can you talk about food?

Aki: Oh, great question. Pre-COVID, part of our culture was this dinner routine called *makanai*, which in Japanese refers to folks who work in restaurants, when they get their own meals. So typically, one person could volunteer to cook for the evening, or sometimes it was more collaborative, where people bring in their own foods, and we just take a break from work and eat and get to know each other better and drink beer.

Nia: The good old days.

Ai: We started that kind of makanai in 2015, just one year after our founding. We have a lot of new members all the time, irregular participants, and they are often from abroad—they cook their own food and serve us, and we share that experience. That is also a collaboration with each other, of joy and chatting and good relationships.

Aki: Some people just bring in such good food and we've benefited a lot from that. Like you were saying, we share food from all over the world because we have many guests from all over the world. Some people stay here for like two weeks, so they come twice or three times during their visits and sometimes, as parting gifts, they make you food from their own culture and have a farewell.

DeWitt Godfrey: The graphic tradition in Japan is very strong—it has a pictorial language, there's manga, ukiyo-e, etc. Your prints resemble more so the woodblock prints from China in the 1930s. Colgate [University] actually has a very strong collection of woodblock prints from China. They're from a professor who traveled there and befriended some artists, so it was one of our unusual library gifts. I see in your work a Japanese influence on Chinese pictorial construction. It's interesting to see the two of those things together. In terms of historical precedents, are there other Japanese artists or artist collectives that are a model for the work you do?

Aki: Currently we don't know a lot of other block print collectives in Japan.

DeWitt Godfrey: What about Hi-Red Center or Japanese Dada, using high culture in a performative, political way?[4] Do you see a relationship between those practices and what you all do?

Ai: Personally, I don't think we have a strong connection with postwar Japanese art practices. I think we're more inspired by the woodcut art in the 1950s in Japan and the Chinese woodcut art movement in the 1930s and 1980s, as well as the Korean Gwangju Uprising in the eighties.

Nia: What was really wonderful about the 1950s period in Japan is that a lot of amateurs were involved in making these print circles, just like we are—groups getting together after work. So, this kind of thing is not a big deal, really. I personally feel a shared history with people who saw this medium as something that they could own. Give them a pencil and they say, "Oh, I can't draw for the life of me," but you give them the knife and they can do anything. I do feel that kind of spiritual connection.

Ai: Yeah, it's also my personal opinion that our activities are closer to contemporary art projects, socially engaged art practices of participation—like sharing food with someone to create a new relationship and community and doing workshops with other people.

Aki: I think our bonds are strong with other collectives in Asia in general. There's a lot of solidarity in the connections built with artists and scholars in China and Hong Kong, Taiwan, Malaysia, Indonesia, and there's been zine projects like the three issues of the Inter-Asia Self-Organized Woodcut Mapping Series.[5] The Inter-Asia Woodcut Mapping Series editorial team organized a series of publications where folks would write essays and submit artwork to make a zine embodying our solidarity. I think a lot of our influences come from outside of Japan as well.

Ai: Taring Padi use woodblock printing as a medium, but they also use different media like puppets. And Chinese woodcut art collectives also used zines and other modes of print. There is some variety of media that woodcut collectives use, and we at A3BC don't restrict our choice of medium as well.

Aki: I also wanted to add that people from collectives in other countries, like Pangrok Sulap, come to A3BC meetings sometimes when they visit Japan, and they are a part of the A3BC work—like the DIY peace banner we mentioned; we also made a piece called *Solidarity*. We are influenced by other collectives in Asia because members from other collectives come to our meetings and work with us in our artworks. There's a direct connection and influence there as well.

Josh MacPhee: Maybe we could talk a little bit about what's next. How are you reorganizing for the post-COVID landscape, and what do you hope to be doing for the rest of the year? Over the next couple years?

Aki: A lot of our activities have shifted online. When we get commissions, or when we get interested in making artwork, we have online meetings where people will talk about what they want to make, what kind of images they want to put in these prints and then by the next week, or in two weeks, we come up with some rough sketch and discuss.

Nia: We're having a workshop really soon, for the first time in three years. Resuming workshops will be really fun. Especially stationed here in this beautiful bookshop in Shinjuku. We used to have so many random people come and do all kinds of crazy prints. It's really something that brings a lot of joy and confidence.

Ai: There are some exhibitions planned that will pull from the network of East and Southeast Asian woodblock art collectives in June 2023 in Taipei. We don't have a concrete plan at the moment, but I hope it demonstrates the transnational network in Southeast Asia, and the practice in Japan, and has workshops.

So, a combination of exhibition—so people can see the work—but also the social aspect, so people will come together and make things as well.

Ai: Yeah, yeah.

That sounds great.

Aki: I don't know if any of the listeners or viewers are in Japan [laughs], but just to advertise: there's going to be an exhibit in Tokyo University of the Arts and we'll be having a workshop at the exhibition, which is the first in so many years.[6]

DeWitt Godfrey: Right, I hope that goes well.

Josh MacPhee: Congratulations!

NOTES

1. Bad Brains' self-titled debut (released in the US in 1982 by ROIR records) depicts the US Capitol being blown up by lightning.
2. Founded in 1978, the UK band Crass was the progenitor of what is now called anarcho-punk. The band members lived together in a communal house and worked together to not only write and perform music, but also to press the records themselves and take as much control over the production process as possible. The band's logo—an ouroboros of a snake consuming itself threaded through a cross—has become so popular that it has transcended its source. It's often associated more broadly with anarchism or punk than specifically with Crass. The same is true for one of their most popular slogans, "Fight War, Not Wars."
3. Henoko and Takae are villages in the Okinawa Prefecture that have played longstanding roles in resistance against continuous US military presence in the area.

4. Hi-Red Center was a short-lived Japanese art collective founded in 1983. Their work was conceived of as public happenings. Their most well-known and final action was when they scrubbed the streets of Tokyo during the 1964 Olympic Games hosted by Japan. The action was an ironic and anti-authoritarian reaction to the government demanding that the country should present a clean image to the rest of the world.

5. Krystie Ng, Li Ding, and Lee Chun Fung, eds., Mapping on the Development of Self-Organised Woodcut Collectives in Inter-Asian Context (1990s–2010s) (Hong Kong: International Center for Cultural Studies, 2019).

6. Debordering: Woodcut Printmaking Practice in Inter-Asian Context, Chinretsukan Gallery, Tokyo University of the Arts, April 28–May 8, 2023.

INDEX

A

A4, 109, 122, 176, 183
Abbie Hoffman, 31
abortion, 36, 37
Abortion-Death, 36
ACT UP (AIDS Coalition to Unleash Power), 23, 28–30, 32, 35–36, 134
Ad Astra Comix, 164, 165, 182
African National Congress (ANC), 186, 193–194
Afro-Asian Writers' Association, 91, 97fn3
AIDS, 23, 28–29, 36, 40fn4
AK Kraak, 115
American Express, 37
American Nazi Party, 95
Amilcar Cabral, 75, 174
anarchism, 222fn2,
anarchocapitalist, 169
Anti-Apartheid Movement, 173
Arai, Tomie, 13, 41–56
art school, 49, 66, 117
Art Workers Union, 131–132
Artist International, 179, 181
Ateliers Populaire, 134
attribution, 92, 131, 158
Australian Council of Trade Unions (ACTU), 133,
authorship, 12, 14–16, 19, 31, 35, 89, 131, 135

B

"Bantu education system", 195
Basement Workshop, 41–42, 49
Black Consciousness, 195
Black Organizing Project (BOP), 151, 153
Black Panther Party (BPP) [also Black Panthers; the Panthers], 14, 33, 57, 59, 62–64, 66–98, 70, 72–73, 75, 76fn2, 76fn4, 76fn6, 77fn9, 77fn11, 87
Black Visions, 150
block printing, 212, 217–218
Buckley, William F., 37

C

Callaghan, Michael, 6, 124, 135–136
Capital, 10fn2, 18, 30, 34, 122fn6, 157, 213
Celebrate People's History, 209
Chicano Art Resistance and Affirmation (CARA) exhibition, 155, 161fn6
Chinatown Art Brigade, 19, 41, 51, 55
Chinese Revolution, 66, 71
Cieślewicz, Roman, 101, 122fn3
Cityarts Workshop, 41, 51–52
civil rights movement, 68, 192, 195
CODEPINK, 156
collective cultural production, 28
commons, 6, 15, 19, 31, 34, 37, 39, 158
common use, 36
Commonwealth exhibition, 92, 97fn4, 142fn2
community, 9, 13, 15–16, 33, 41, 45–46, 48–49, 51–52, 55–56, 63–67, 70, 72–73, 79, 88–89, 93, 99, 107, 115, 119, 124–125, 133, 135, 140–142, 145, 147, 149, 152–152, 155,

159, 163, 185, 195, 198–199, 203, 220
actual, 140
conceptual, 140
rhetorical, 140
-based work, 49, 72, 140
Communities United for Restorative
 Youth Justice (CURYJ), 149, 151
Condoman, 133–134, 142fn2
consciousness-raising, 29–30
collective, 13–14, 16, 18–19, 23, 25, 28–30,
 32, 35–36, 38–39, 41–42, 47, 53–55,
 56fn3, 63–64, 70–71, 73, 85–86, 89,
 91–92, 100–101, 121, 124, 131, 135–136,
 196, 141–142, 145, 166, 171, 178, 185–188,
 191–192, 194–195, 197–198, 200, 203, 205,
 213, 217, 222fn4
constructivism, 180
Contemporary Art and Feminism, 139
Copyleft, 158
copyright, 12, 15, 19, 31, 36, 75, 89–90,
 215–216
copyright-free, 34
Courbet, Gustave, 168
COVID[-19], 11–12, 49, 54, 60, 79, 82, 86,
 147–149, 152–154, 172, 191, 205–206, 210,
 216, 219–220
Crass, 215, 221fn2
Creative Commons, 6, 34, 158
cultural worker, 113, 173, 182, 191
Culture and Resistance Symposium and
 Festival, 197, 201fn2, 201fn3

D
Dakota Access Pipeline, 17, 97fn4, 160
de Young [Museum], 155
Dignidad Rebelde, 16, 145
Dikobe wa Mogale [Ben] Martins, 197,
 201fn3
DIY culture, 212
Documenta, 103
Dossiers, 163, 172–174, 182fn4

E
Earthworks Poster Collective, 131, 136
Emily Carr University, 93

F
Finkelstein, Avram, 6, 15, 23–40, 40fn1,
 40fn4, 154, 161fn5
fist, 86, 90, 108, 110, 114–115, 120, 135, 175,
 188
First Amendment, 36
First of May, 115
Flash Collective, 23, 28
Floyd, George, 153, 161fn1
flyposting [or flypostering; see wheat-
 pasting], 15, 38, 101, 105, 115, 122fn2, 172
Fruitvale, 155
Future Feminist Archive, 138–139

G
Glaser, Milton, 110, 114
Godzilla, 41
Gran Fury, 19, 23, 27, 32, 34–35, 39, 134
Grant, Oscar, 87, 153
graphic liberation [as theme], 11–12, 31, 99
Graphic Liberation [project], 11, 23, 25, 99,
 122
Graphic Liberation [book], 89, 99, 163
Graphica America, 152
graphic novel, 163–165
Grapus, 101, 120–121

H
Heartfield, John, 101, 111, 120
HIV [and HIV-positive or HIV+], 28–29,
 37, 133–134, 185, 188
Holocaust, the, 36–37

I
"I Love Kotti", 110, 114
I Love New York, 110
infoshop, 205
intellectual property, 12, 34–35, 89–90
International People's Assembly, 180, 182

Internationalism, 90, 163, 177

Interference Archive, 21, 23, 31, 41, 43, 57, 66, 123

J

Jalquin, 152

Jalquin Chochenyo Ohlone, 152

Jamaa Al-Yad, 11, 14, 79–97, 97fn4

Justseeds [or Justseeds Artists' Cooperative], 21, 97fn4, 177

K

Know My Name, 136, 139, 142fn5

Korean War, 95

Kottbusser Tor, 107, 110, 119

Kotti & Co, 99, 106–108, 110–111, 113–114, 117, 119

L

LACMA, 155

La Otra Campaña [the Other Campaign], 199, 201fn5

Lembaga Kebudajaan Rakjat (LEKRA), 173, 179

Let the Record Show, 32

linoleum, 94, 149, 154, 217

Lissitzky, El, 175, 181, 183fn9,

Lotus Magazine, 91, 97fn3

Louvre, the, 121

Lucifoil Collective, 136

M

mail art, 153

Malcolm X, 74, 77fn9, 83, 92, 94

manga, 219

Mao [Zedong], 77fn7, 173–174, 179

March of Return [poster series], 80, 90, 94

Marjinal, 212

Marx [Karl], 35, 182fn2

Marxism, 157

May 1968 [May '68; the '68 revolt; '68 student revolt in Paris], 101, 118–120, 134–135, 217

Medu Art Ensemble, 11, 18–19, 173, 183fn8, 185–187, 191–192, 194–200, 201fn1

Megalo Print Studio, 123, 131, 136, 140

MFA, 52, 157

Metallica, 158

Mexican Revolution, 71, 134

Miners' Women's Auxiliary, 124, 137–138

Mnyele, Thami, 191, 196–199

MoMA, 156, 194

Mothers of East Los Angeles (MELA), 32

Mubarak, 156

Mujeres Unidas, 156

Muralists, 200

Museum of Latin American Art, 151

N

Napster, 158

National Association for Visual Arts (NAVA) [in Australia], 132

National Gallery [of Australia], 123, 136, 139

Nazis, the, 11, 37

New Left, 133

nGbK, 100–101, 122fn3

New York City

Chinatown, 19, 41, 45, 47–49, 52, 55–56

Lower Manhattan, 25, 32, 41

newspaper production, 11, 43, 57, 64, 73, 76, 77fn9, 77fn10, 87–88, 94, 135, 141

Nirvana, 40fn3

Noel Butlin Archives Centre, 139

No One Is Illegal, 103, 163

Nyinkka Nyunyu Art and Culture Centre, 142

O

Occupied Wall Street Journal, 94

Occupy movement, 94, 157, 161fn2

offset printing, 130

Olympics [2020], 206

One in Nine Campaign (OINC), 185,

188–189, 197
Opening Ceremony, 35
Operation Rescue, 36
OSPAAAL, 51, 89, 163, 171, 173, 179, 183fn7

P
Pacific Northwest school of painting, 93
Pangrok Sulap, 212, 216, 220
Paris Commune [the Commune], 166–167, 174–175
Paris Commune 150, 180, 182fn2, 182fn3
Patriarchy, 189, 191
Phantom [King Comics], 134
PhD, 136
Photoshop, 178, 180–181
pink triangle, 30, 37–38
Politisch/Soziales Engagement & Grafik Design [Political/Social Engagement & Graphic Design], 100–101, 122fn3
poster collectives, 123, 130, 136
 feminist, 136
poster tradition, 89, 123, 145
 Latinx, 145
 Xicanx, 145
Prashad, Vijay, 94, 171
Printing the Revolution, 154, 157, 161fn4
propaganda, 23, 35, 37
public domain, 31, 35, 196
punk, 134, 212, 215, 221fn2

R
Reagan's America, 38
Reclaim the Block, 150
Redback Graphix, 123–124, 130, 132–133, 135, 138, 142fn2
red diaper baby, 35
red flag, 115, 174–175
revolution, 14, 50, 66, 71, 82, 87, 91, 115, 120, 134, 154, 157, 161fn4, 173, 175, 197
Right to the City movement, 120
risograph prints, 97fn4
Russian Revolution, 66, 134

S
sans papiers, 103
Schulman, Sarah, 32
screen printing, 53, 99, 130, 145, 149, 153, 163, 217–218
Screen Training Project (STP), 198
SFMOMA, 155, 159
Shack Dwellers' Movement, 169, 176
Signal: A Journal of International Political Graphics and Culture, 122fn8
Signs of Change, 10fn3, 13, 99, 122fn1, 185, 203
Silence=Death [print], 16, 23–26, 29, 31–32, 34, 36, 38–39
Silence=Death collective, 15, 24–25, 29, 32, 34–35, 38–39
Silence=Violence, 30, 32
smiley face, the, 36, 40fn3
Smithsonian [American Art Museum], 154–155, 160, 161fn4
social movement culture, 10fn3, 13–16, 20, 122fn1, 145, 203
solidarity, 9, 16, 23, 51, 67, 73, 76, 79, 105, 109, 115, 118, 151, 160, 171, 216–217, 220
Soviet (poster style), 66, 175, 180
square kufic, 82, 92
square-kufic lettering, 89, 91–92
Standing Rock, 17, 159–160
Stencil Pirates, 37
Stop Urban Shield, 17, 160
street stencil, 37
Symbionese Liberation Army (SLA), 33

T
taller, 87, 152, 161fn3
Taring Padi, 212, 220
t-shirts, 9, 23, 27, 35, 72, 89–90, 92–93, 134, 159, 185, 198, 200, 214
Templeton, Rini, 158, 162fn7
Tin Shed Art Collective, 136
Tin Sheds [or Sydney University Art Workshop], 140, 142fn4
Tompkins Square Park Riot, 32

triangle, the, 36–38
Tricontinental, 94, 169, 171–173
Tricontinental: Institute for Social
 Research, 18, 94, 163, 165–166, 171–174,
 178, 180–182, 182fn4, 190–191
Truth and Reconciliation Commission
 (TRC), 196

U
Ukiyo-e, 218–219
Ukraine, 191

V
Vietnam War, 16, 95, 77fn8, 160
Village Creek, 192

W
Walmart, 40fn3, 158
Wheatpasting, 38, 122fn2, 172
Whitney Biennial, 157
Whitney [Museum of American Art],
 10–11, 10fn4, 32, 56, 157
Wight Art Gallery at UCLA, 155
Women's Day, 176, 192
Worcester Group, 32
Works Progress Administration (WPA),
 132
Wumpurrarni, 142

X
Xerox art, 158

Y
Ya'an Forum [on Literature and Art], 178
Young Socialist Artists, 166

Z
Zapatistas, 160, 199
Zuccotti Park, 118

ABOUT THE EDITOR

JOSH MACPHEE has created a composite work life that merges elements of designer, artist, author, historian, and archivist. He is a founding member of the Justseeds Artists' Cooperative (Justseeds.org), the author of <u>An Encyclopedia of Political Record Labels,</u> and coeditor of <u>Signal: A Journal of International Political Graphics and Culture</u>. He cofounded and helps run Interference Archive, a public collection of cultural materials produced by social movements (InterferenceArchive.org). He regularly works with community and social justice organizations building agit-prop and consulting on cultural strategy.

ABOUT COMMON NOTIONS

COMMON NOTIONS is a publishing house and programming platform that fosters new formulations of living autonomy. We aim to circulate timely reflections, clear critiques, and inspiring strategies that amplify movements for social justice.

Our publications trace a constellation of critical and visionary meditations on the organization of freedom. By any media necessary, we seek to nourish the imagination and generalize common notions about the creation of other worlds beyond state and capital. Inspired by various traditions of autonomism and liberation—in the US and internationally, historical and emerging from contemporary movements—our publications provide resources for a collective reading of struggles past, present, and to come.

Common Notions regularly collaborates with editorial houses, political collectives, militant authors, and visionary designers around the world. Our political and aesthetic interventions are dreamt and realized in collaboration with Antumbra Designs.

commonnotions.org / info@commonnotions.org

MORE FROM JOSH MACPHEE
AND COMMON NOTIONS

An Encyclopedia of Political Record Labels
Josh MacPhee

978-1-942173-11-3
$24.95
208 pages

An Encyclopedia of Political Record Labels is a compendium of information about political music and radical cultural production. Focusing on vinyl records and the labels that released them, this groundbreaking book traces the parallel rise of social movements in the second half of the twentieth century and the vinyl record as the dominant form of music distribution.

Just as the Civil Rights Movement leaps onto mainstream headlines in the early 1960s, the 33rpm "Long Player" and 45rpm single invade people's stereos. All the major Civil Rights organizations release vinyl records of speeches, movement songs, and field recordings—setting the pace for the intertwining of social movements and easily distributed sound recordings. This relationship continues through the end of the twentieth century, which marked both the end of apartheid in South Africa and the dominance of the vinyl format.

From A-Disc (the record label of the Swedish Labor Movement) to Zulu Records (the label of free jazz pioneer Phil Choran), An Encyclopedia of Political Record Labels is a compelling panorama of political sound and action, including over 750 record labels that produced political music. Each entry features the logo of the label, a brief synopsis of its history, and additional interesting information. Truly international in scope, over two dozen countries and territories are represented, as well as a myriad of musical styles and forms.

MORE FROM JOSH MACPHEE AND COMMON NOTIONS

Defend / Defund: A Visual History of Organizing against the Police
Interference Archive (eds., Brooke Darrah Shuman, Jen Hoyer, Josh MacPhee)

978-1-942173-88-5
$22.00
168 pages

IN THE SUMMER OF 2020, the deaths of George Floyd, Breonna Taylor, and Tony McDade ignited a movement that led to the largest street protests in American history. Abolitionist grassroots organizers around the country unified around a clear demand: defund the police and refund our communities. Far from a brief moment in history, the summer of 2020 was a resurgence of a movement that stretches to the beginning of this country's inception.

Defend/Defund presents a sweeping and poignant history of how communities have responded to the violence of white supremacy and carceral systems in the United States—told through interviews, archival reproductions, and narrative—and asks what lessons the modern abolitionist movement can draw from this past.

Organized in a series of thematic sections from the use of self-defense by Black organizers, to queer resistance in urban spaces, the narrative is accompanied by over 100 full-color images, including archival materials produced by Emory Douglas from the Black Panther Party for Self- Defense, the Young Lords, CopWatch, the Stolen Lives Project, the Movement for Black Lives, Project NIA, and INCITE!

Defend/Defund shows how contemporary organizing against the police and for community safety builds on powerful Black feminist and abolitionist movements from the past and imagines alternatives to policing for our present.

BECOME A COMMON NOTIONS MONTHLY SUSTAINER

THESE ARE DECISIVE TIMES ripe with challenges and possibility, heartache, and beautiful inspiration. More than ever, we need timely reflections, clear critiques, and inspiring strategies that can help movements for social justice grow and transform society.

Help us amplify those words, deeds, and dreams that our liberation movements, and our worlds, so urgently need.
Movements are sustained by people like you, whose fugitive words, deeds, and dreams bend against the world of domination and exploitation.

For collective imagination, dedicated practices of love and study, and organized acts of freedom.

By any media necessary.
With your love and support.

Monthly sustainer subscriptions start at $15.
commonnotions.org/sustain